Shaping the Assembly

How our buildings form us in worship

Edited by Thomas O'Loughlin

Published by Messenger Publications, 2023

ISBN 9781788126113

Cover photo by Valerie O'Sullivan
Designed by Brendan McCarthy
Typeset in Garamond Premier Pro
Printed by Hussar Books

Messenger Publications,
37 Leeson Place, Dublin D02 E5V0
www.messenger.ie

This, then is our task:
To build churches out of that reality which we experience and verify every day; to take this our own reality so seriously and to recognise it to be so holy that it may be able to enter in before God. To renew the old teachings concerning sacred work by trying to recognize the body, even as it is real to us today, as creature and as revelation, and by trying to render it so; to reinstitute the body in its dignity and to do our work so well that this body may prove to be 'sacred body'. And beyond all this to guard ourselves against repeating the old words when for us no living content is connected with them.

Rudolf Schwarz (1958), 11.

In memory of Placid Murray
1918–2022
Monk of Glenstal
1935–2022
First President of the Societas Liturgica
1967–69

Contents

Abbreviations

ACC	*Alcuin Club Collections* (London)
ACR	*Australasian Catholic Record*
AJL	*Australian Journal of Liturgy*
ANF	*The Ante-Nicene Fathers (Edinburgh, 1867–73; and many reprints)*
AR	*Approaching Religion*
ARQ	*Architectural Research Quarterly*
BLS	*Built of Living Stones: Art, Architecture and Worship*
CH	*Church History*
CSEL	*Corpus Scriptorum Ecclesiasticorum Latinorum (Vienna)*
EACW	*Environment and Art in Catholic Worship*
ESW	*Ecumenical Studies in Worship* (London and Richmond, VA)
FC	*Fathers of the Church* (Washington, DC)
GCS	*Die griechischen christlichen Schriftsteller der ersten drei Jahrhunderte* (Leipzig)
GIRM	*General Instruction on the Roman Missa*
IA	*Irish Architect*
ICEL	The International Commission for English in the Liturgy
IECL	Irish Episcopal Commission for Liturgy
IO	*Inter Oecumenici. The 1964 Instruction on the Proper Implementation of* SC: in Flannery (1975)
JAS	*Journal of Anglican Studies*
JCR	*Journal of Contemporary Religion*
JECS	*Journal of Early Christian Studies*
JLS	Alcuin/GROW *Joint Liturgical Studies* (Norwich)
LA	*Liturgical Arts*
LCL	*Loeb Classical Library*
LG	*Lumen Gentium.* The Dogmatic Constitution on the Church: in Flannery (1975)

LN	*Liturgy News*
NB	*New Blackfriars*
NL	*New Liturgy*
OR	*Orate Fratres*
OT	*Open Theology*
QLP	*Questions Liturgiques et Paroissales*
RCIA	Rite of Christian Initiation of Adults
REA	*Revue des Études augustiniennes*
RHE	*Revue d'Histoire ecclesiastique*
RES	*Review of Ecumenical Studies*
SC	*Sacrosanctum Concilium. The Constitution on the Sacred Liturgy:* in Flannery (1975)
SKO	*Signum katolsk orientering om kyrka, kultur & samhälle*
SL	*Studia Liturgica*
SP	*Studia Patristica*
STT	*Studia Traditionis Theologiae* (Turnhout)

The Alcuin Club: Promoting the Study of Liturgy

Founded in 1897, the Alcuin Club seeks to promote the study of Christian liturgy and worship in general with special reference to worship in the Anglican Communion. The Club has published a series of Annual Collections, including *A Companion to Common Worship*, Volumes 1 and 2, edited by Paul F. Bradshaw; and a new completely revised 4th edition of Jasper and Cuming, *Prayers of the Eucharist: Early and Reformed*, edited by Paul F. Bradshaw and Maxwell E. Johnson (Liturgical Press 2019); also *The Cross and Creation in Christian Liturgy and Art* by Christopher Irvine (SPCK 2013), *Eucharistic Epicleses Ancient and Modern* by Anne McGowan (SPCK 2014), *Dean Dwelly of Liverpool: Liturgical Genius* by Peter Kennerley (Carnegie Publishing 2015), *Ancient Christian Worship* by Andrew B. McGowan (Baker Academic 2016), *The Rise and Fall of the Incomparable Liturgy: The Book of Common Prayer 1559–1906* by Bryan D. Spinks (SPCK 2017) and by the same author *Scottish Presbyterian Worship* (St Andrew Press 2020); *The Pilgrimage of Egeria* by Anne McGowan and Paul F. Bradshaw (Liturgical Press Academic 2018), and *Lively Oracles of God: Perspectives on the Bible and Liturgy* edited by Gordon Jeanes and Bridget Nichols (Liturgical Press Academic 2022).

The Alcuin Liturgy Guide series aims to address the theology and practice of worship. It includes *The Use of Symbols in Worship*, edited by Christopher Irvine; two volumes covering the celebration of the Christian year, *Celebrating Christ's Appearing: Advent to Christmas* and *Celebrating Christ's Victory: Ash Wednesday to Trinity*, both by Benjamin Gordon-Talyor and Simon Jones, and most recently *Celebrating Christian Initiation* by Simon Jones.

The Club works in partnership with the Group for the Renewal of Worship (GROW) in the publication of the Joint Liturgical Studies series, with two studies being published each year.

In 2013 the Club also published a major new work of reference, *The Study of Liturgy and Worship: An Alcuin Guide*, edited by Juliette Day and

Benjamin Gordon-Taylor (SPCK 2013).

Members of the Club receive publications of the current year free and others at a reduced rate. The president of the Club is the Rt Revd Dr Stephen Platten, its chairman is the Revd Canon Christopher Irvine, and the secretary is the Revd Thomas McLean.

For details of membership and the annual subscription, contact The Alcuin Club, 20 Burrows Close, Headington, Oxford, OX3 8AN, United Kingdom; email: gordon.jeanes@virgin.net; or visit the Alcuin Club website at: www.alcuinclub.org.uk.

Foreword

… worship must determine the building, not the building the worship.
James A. Whyte (1962), 189

Space is all around us – and we constantly refer to it. He is taking my space! This place is homely! This room is very impersonal! We need more room! We need to de-clutter! I was lost in the vastness of the hall! I felt locked in and had to go outside!

We also know that how space is arranged affects us: we want 'round table talks' and we do not want to be put in the back row! Churchill captured the importance of built space in a couplet: We shape our buildings, then our buildings shape us.

And in every society buildings have been used to project power and authority, to regulate society, to promote human interaction, and to project an image of how that group sees itself.

Strangely, we do not think very often about this aspect of space when it comes to liturgy – yet every religion (and every Christian denomination) has used buildings as part of their worship: from the megalithic tombs in Ireland's Boyne Valley, to classical temples, to contemporary Christian spaces built of steel, concrete and glass. And it was this concern of the Second Vatican Council that led to the changes in the arrangements in Catholic churches in the 1960s and 70s. But this religious use of space – just as with the changes mandated by the Council – is little appreciated or understood.

This book brings together eighteen Christians – liturgists, pastors, architects, artists – from several churches and from around the world who all try to examine the question of how space affects us in worship.

The topics covered include the role of light in a religious building, the need for space to appreciate dance as part of worship, the varying needs of spaces for different liturgies, accounts of how communities have become creative with space, and questions about how the liturgical renewal begun in the Second Vatican Council should continue today.

The purpose of the collection is to promote deeper discussion about ritual space – and its unnoticed importance.

Converging approaches

That said, one of the problems in promoting a deeper discussion is that it is easy to find any number of books and articles on distinct parts of the topic, but very few that try to draw these issues together. One can buy books on church architecture that pay almost no heed to the liturgy. These are books that focus on 'the church' as one more known kind of building – and the worship of those who enter it is hardly mentioned. There are even books seeking to identify 'beautiful churches', where the needs of the liturgy – or its reform – are seen as a dreadful distraction from the aesthetic satisfaction of enjoying a work of art. Likewise, there are liturgists who write about the activity of the liturgy, yet never notice that worship 'takes place' – and so the space of the activity is as significant an element as the texts used. Other liturgists pronounce on the need for the worship-building to have a specific shape or orientation on theological grounds, yet do not engage with either theologians or historians of architecture about whether their statements can be justified. Theologians – and ritual anthropologists – often address the issue of space/place as a conceptual problem, but fail to engage with the needs of liturgy, the problems of buildings, or the expectations of communities: space needs to be experienced before it is theorised. Then there is the fact that insights tend to follow denominational lines, yet the problems of the spaces of our worship affect all Christians. Likewise, the solutions cross traditional boundaries, as all who worship do so within a secular age where worship is itself seen as no more than a voluntary activity within society as a whole. Our worship spaces are those of particular communities within a larger landscape; we are no longer simply inhabiting the focal building of the village, town or city – even if our worship space is still the most imposing landmark in a locality. Then there are the pastors, those who lead the communities of faith in their worship, who have to try to operate within given spaces each week. Some of those spaces are wonderful, some are counter-productive to community worship, and most could be improved with some discussion and minimal fuss. But how can one get these various groups to talk to one another?

No one has yet succeeded, but a start might be this book, which has architects, liturgists, experts on space and movement, theologians and pastors between its covers. Each contributor was chosen because they could address at least two constituencies – perhaps the seeds of a greater dialogue can be found here. You, gentle reader, are invited to dip into this collection, and then to dip in again. The juxtaposition of approaches – and the many ways you can combine them – will, it is my hope, stimulate not only discussion but actual experiment

… with gratitude

This collection began in August 2019 on the edges of the Durham conference of the Societas Liturgica, when several of us identified the problem of unconnected discourses about the location of our worship. Could there be dialogue between them? While no one expressed a great deal of optimism, some noted that Richard Vosko (2019) had just published *Art and Architecture for Congregational Worship: The Search for a Common Ground*, and perhaps we could take that discussion forward and locate it closer to where we live and worship. This brought generous offers of papers from various people there and then, and the list of contributors steadily expanded. Then came Covid-19 and energy for such a project had to be deployed elsewhere as Christian liturgy saw, in the space of weeks, a greater disruption than anyone had ever seen before. While some who took part in those initial discussions had sent me their papers within weeks, it was not until 2022 that the whole array could be assembled in one place.

Over that three-year period I, who volunteered to edit the collection, accumulated a long list of debts of gratitude to scholars, librarians and friends. My initial thanks is to Tom Elich and Paul Bradshaw, whose combination of wisdom, energy and enthusiasm mixed with generosity got this collection off the ground. At once I realised that any such endeavour would be incomplete without the 1996 essay by Richard Hurley, which attempted to combine the insights of architect, liturgist, theologian and mystic in just the same way as this book desires to do – it would have to be reprinted! So my thanks to Bernadette Gasslein, the editor of *Worship*, and Deb Eisenschenk of Liturgical Press, for facilitating this. Once that was included, the memory of Carlow, which was a place of liturgical conversion for so many, had to be celebrated,

so I contacted Margaret Daly-Denton, who has helped form this collection in more ways than I can count. But no book can come to be without a publisher, and so I want express my gratitude to all at Messenger and to Cecilia West in particular. There is a piece of proverbial wisdom among publishers that 'collections do not sell' and so books like this one are increasingly rare – so it is a credit to Messenger that they saw the specific rationale underlying this book and have offered it every support. Similarly, it is gratifying that the idea was sufficiently attractive – before all the papers had arrived – to the Alcuin Club that they adopted it as one of their sponsored books.

I cannot end this foreword with sharing with you my favourite 'one-liner' on the importance of liturgical spatial awareness. With the opening scene from *Star Trek: The Original Series* echoing in his head, Jaime Lara (2010, 131) wrote:

'Space: the final frontier … '

Sacred Space: the ultimate frontier.

<div align="right">

Thomas O'Loughlin
All Saints Day, 2022

</div>

1

Domestic Ritual, Public Space

Thomas O'Loughlin

You need make for me only an altar of earth and sacrifice on it your burnt offerings and your offerings of well-being, your sheep and your oxen; in every place where I cause my name to be remembered I will come to you and bless you.

Exodus 20:24

There is nothing so obvious about Christianity as churches. While Jews have synagogues, Muslims mosques, and Sikhs gurdwaras – none are so identified within our culture with their buildings as Christians. There is 'the Church', 'the Christian Church' or 'the Catholic Church' – and depending on the context this might refer to a religious organisation or to a community of people or to a building along the street. Christian theologians might point out how inadequate this thinking in terms of buildings is as a basis for understanding, and pastors echo, day in and day out, that the Church is the people and not the building, yet it makes little difference in ordinary understanding. We refer to 'the influence of the Church' and 'going to church' and 'redundant churches'. One can give directions using these buildings as way-markers, as in: 'You will see a church, take that left' – and it is assumed that everyone knows what a church looks like. Churches are as distinct a form of building as factories or shops. They are real and visible: they are really called 'churches' and they serve as perfectly, by metonymy, for the belief system of those who gather in them and for the administrative system – 'the Church authorities' – that organise them. They come in all shapes and sizes and denominational flavours, but they are a basic fact: if you have Christianity, you have churches, and vice versa. Indeed, their ubiquity in Christian

The image of a church is so recognisable it can serve as commonplace icon for our gathering and worship.

practice is the very premise of this collection of essays.

One might be tempted to dismiss this as no more than a play on words: the gathering is 'the church' and by extension the building in which it meets becomes 'a church' and this becomes the metaphor, verbally and visually, for the religion – and every thinking individual can make the distinction between the group, the building and the religion. On the other hand, if one asks a pastor of one of the Reformed churches if he is 'building a church' where he lives, the question will evoke a very different kind of response than if one asked a Catholic parish priest. For the first, the challenge of building a church is immediately linked to mission, for the latter it is providing a building for liturgy. In many denominations 'church building' or 'church planting' is primarily about mission and extending communities, and typically the buildings they might acquire later for worship – they might baulk at the word 'liturgy' – might more resemble a hall than what most think of as a church (building). However, for most Christians the life of faith is almost synonymous with attendance in a building: when we want to know if a person is liturgically engaged with other Christians we ask if they 'attend' a church, and the desire of most growing Christian communities is that they build/have a church that is recognisable as such from the outside and has

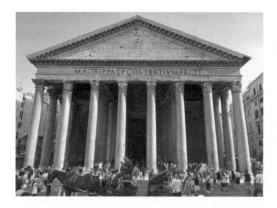

The Pantheon – 'the temple to all the gods' – in Rome was 'christened' by installing the Christian liturgy, becoming *Sancta Maria ad Martyres* and referred to informally as *Santa Maria Rotonda*. That it could house Christian liturgy was seen as the victory of Christianity; the question of its suitability for the Christian liturgy was not asked.

their familiar ritual trappings on the inside.

Given this fact of the ever-present church building – from the smallest wayside chapels to village churches to vast basilicas – it is not surprising that the basic notion has rarely been questioned. Once Christians began to have specific edifices for their liturgy, they adopted the dominant forms of large public buildings (basilicas) and significant urban religious buildings (temples) and into these they planted their liturgy. Significantly, they did not build around their liturgy – thereby forming a building whose form expressed the nature of their liturgy – but rather built recognisable forms (basilicas and temples), and then installed their liturgy such that their worship became adapted to the building.

The most telling influence of this adaptation of the Christian liturgy to

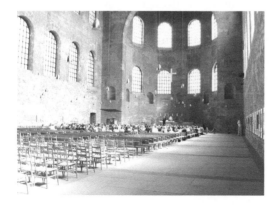

Constantine's basilica in Trier being used for Christian worship, much as it has been used for most of its history.

Greco-Roman religion is that the central object within Christian worship – the table of the Eucharist – is, despite its table-shape, invariably described as 'an altar' (albeit with a complex theological argument that it is a table functioning as an altar for the eucharistic sacrifice), approached (as Vitruvius says is necessary) by an uneven number of steps, and that there are still those who support the notion that Christian worship should be 'towards the east' (as, again, demanded by Vitruvius, forgetting that this too is a legacy of pagan temples).[1]

While some specific spaces were created – mainly for monastic communities – with the needs of the liturgy in mind, for the most part the primary concern was to have a recognisably churchlike building. Once that was available, then the liturgy could be adapted to fit the building. So while one can find many tracts on what a 'good' church building should be – usually these criteria were a mix of the aesthetic values (it should be beautiful), with the 'spiritual' (it should be recognisable as a church and somehow capture the sacred and the numinous) and the practical (it should accommodate economically the number of people it was to serve), one does not find tracts on the ideal space for the liturgy apart from the arrangement of the sanctuary.[2] Significantly, these buildings are seen at their best when empty rather than when they are full of people engaged in the very activity, the Christian liturgy, for which they were constructed.

It was only in the early twentieth century, with the work of Guardini and Schwarz, that the approach of 'making liturgy fit the space' was first questioned.[3] For Guardini the liturgy had a unique place in Christian life, at its very centre, and was not to be seen merely as the *agere* – actual worship – that followed from an *ens / esse* – a doctrinal essentialism imagined as a *depositum* which constituted faith. Guardini focused on the Christian communal act – and then asked how these human bodies, which formed the ecclesial body, could express most fully what they were doing. Experimenting with Schwarz in Burg Rothenfels in the great Knights' Hall (the *Rittersaal*) of the

1 O'Loughlin (2020).
2 O'Connell (1955).
3 Reinhold (1937); and Koenker (1951).

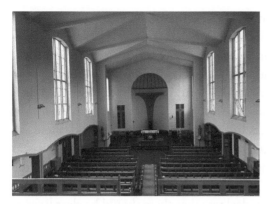

St Joseph's, Durham, built just before the Second Vatican Council, is as rational and effective in its use of space as any building could be, given the understanding of the liturgy that underpinned its design. Hammond (1962) identified buildings like this as the very opposite of form following function.

castle,[4] he created spaces for worship that were based in the very action. The building was then established around this – the liturgy had the primacy – so that it could (1) best facilitate that action, and (2) provide an envelope for that activity. Schwarz noted that the assembly of the people came first: 'it is out of their ordering that the structure takes form'.[5] Now, for the first time in our long history, theologians and architects asked what the building was for, and then sought to shape the building around that.[6]

One might see this whole movement – in architecture and liturgy – as simply an ecclesiastical version of the dictum of US architects in the early twentieth century: 'form follows function' – but this is to misunderstand

4 In much of the literature it is said that Guardini experimented in the chapel there, and this is often illustrated with images of the gatherings from that time. This then produces a confusion, because the liturgical arrangements of people in the 1920s images are not consistent with the form of the chapel – elements of this confusion can be found in Richard Hurley's article in this book. This confusion arose because there were two rooms – back to back – in Rothenfels. The first is a relatively small chapel (whose arrangement and furniture were designed by Schwarz), which, while stretching the rubrics (e.g. on the location of the table and its candles) and customs (e.g. an absence of fixed pews) of the time to the utmost, was a standard, rubrically compliant chapel. Next door to it, but with an entrance at the building's other end (and without a connecting door to the chapel) was the great hall, which was designed by Schwarz to have a numinous emptiness (see Daelemans [2022]) where the liturgical experiments took place. For the overall plan with images of both spaces, see Schwarz (1960), 37–45; and Mogge (2012), 274–83. One suspects that Guardini was being ecclesiastically careful as well as being experimental: an episcopal visitation would find a chapel that, though very modern in style, conformed in every way to the law; but the actual liturgies that were inaugurating a new view of the liturgy were being carried out in the wondrously empty space next door – for which there would be no call for an episcopal visitation since it was formally just a hall. Perhaps Guardini recalled that those sent out by the Christ 'into the midst of wolves' had to 'be wise as serpents and innocent as doves' (Matthew 10:16).

5 Schwarz (1958), 36.

6 Proctor (2014) examines the arrival of this change in perspective in Britain.

it fundamentally.[7] If it were simply a matter of studying the function of a building, one would have examined how an average Sunday Mass was celebrated and how the congregation acted – kneeling, sitting, seeing, and moving up and down to the communion rails, followed by a rapid changeover so that the congregation of the next Mass could take their place – and then finding a form that facilitated this. This is indeed exactly what happened in many of the large urban churches built between 1930 and 1950. Here the function was the inherited liturgy unquestioned, and the building was as rational (and economical) a response to that function as possible. Hence the great barn-like churches built in suburbs around the globe, whose only concession to any explicitly liturgical ideal was that there should be clear lines of sight to what the priest was doing at the altar.

Guardini was being far more radical: he asked about the very nature of liturgy – of which the inherited rites were but one manifestation that might or might not be in harmony with the inner nature of Christian worship – and then he sought out how this made demands upon physical space. In this, Guardini's origin point is not with the need for a church building but the reality of the incarnation: if the Lord's 'tent' – i.e. the tabernacle – is pitched in the midst of humanity and in the midst of human flesh, our physical bodies (John 1:14), then that is the starting place for all holy places.

Moreover, the notion of a holy place in contradistinction to 'mere nature' is theologically problematic: all is holy for it comes from God and without God it would not be. The holy as the *'ganz andere'* is difficult to reconcile with the divine love that enters into every aspect of the ordinary, not only in the creative will that holds it in being, but in the Logos made flesh. A theology of the Eucharist, as with a theology of the creation, must start from this reality of God-with-us in Jesus whom we confess as the Christ.[8] The building is the shelter for this Christ-centred worship of the Father; if it has any claims to its own sacrality, this is accidental and appeals to a religious vision that is less than our conviction that all creation is renewed and transformed in the Christ. So when Peter Hammond set out in 1960 to describe a worship space *after* presenting a theology of the eucharistic assembly, he was of-

7 For an account of how such ideas originated and influenced church architecture, see Torgerson (2007), 49 (and more widely: 47–61). Torgerson does not distinguish between ideas that arose within architecture (such as 'form follows function') and those that arose within theology.
8 O'Loughlin (2015), 96–8.

fering English-speaking church-builders something they never had before.[9]

If we allow that Guardini and Schwarz were searching out the very funda-
mental dynamic of the activity of worship, *and then* seeking to give it liturgi-
cal form *and then* spatial form *and then* architectural form, then in this sense
– but only in this sense – can we say that the form of the building follows
from its function: to provide a place where the liturgy can be celebrated ac-
cording to its own nature. This is why the work done in Rothenfels in those
few short years between the First World War and the rise of the Nazis is of
groundbreaking importance.[10] It allowed the liturgy to express itself, accord-
ing to its own nature, in the actual worship of a community of the baptised.
Seen in this way, we can well understand why Karl Rahner could later state
that: 'It is a widely known fact that the Rothenfel [*sic*] experience was the
immediate model for the liturgical reforms of Vatican II.'[11]

Basic question 1: a church?
However, it might be useful if we could step even further back from our
inheritance of buildings and ask if such a specific building as 'a church' is re-
ally needed. The obvious answer is simple: we do not need churches, for the
community can assemble anywhere, any suitable shelter can be the wrapper
around a eucharistic assembly, and, in any case, on many occasions in the
past (before Constantine and in periods of persecution) Christianity lived
without special buildings. But this emphatic 'no' is also deceptively simple.
Not only has Christianity evolved over the last seventeen hundred years with
specific buildings – our architectural legacy for better or worse – but every
religion we study has had dedicated locations, structures and buildings. They
may be holy sites such as groves, buildings such as temples – however they
are named – or designated religious structures such as Newgrange in Ireland
or Stonehenge in Britain. Something deep within our humanity wants these
holy places. Moreover, as we see a diminishing number of people in our
buildings – whether through total departure or through an option for a vir-
tual assembly over the Internet – we do not see any falling off in the desire
for people to gather together for that which brings joy and meaning into

9 Hammond (1960); and Hammond (1962), 22–8. See Proctor (2011) for an assessment of the
 contribution of Hammond to actual practice.
10 For an overview, see Dirks (2021).
11 Kuehn (1990), 47–8.

their lives at, for example, sporting venues. Human beings want to gather. We want to assemble in 'our special places'.

Rather than the binary responses derived from the question 'Do we need these buildings?' Christians need a far more nuanced answer, indeed one that fosters ambivalence. A starting point is that 'legislative basis' for Israel's worship, Exodus 20:22–26, placed within the text just after the giving of the commandments. The passage seems to brim with contradictions. The people must offer burnt offerings and peace offerings on an altar – as was supposed in every religion in the ancient Near East, but it is simply an altar of earth (it could, for instance, be an altar of mud) which could be anywhere. Unlike the religions around them, the God of Israel is not limited: all the earth belongs to him as its creator. One place, and the soil of one place, is just as good as any other. This God does not need special epiphanic locations: from anywhere the people can offer praise and petition. A god who can only be contacted and worshipped in a 'special' place is locked into the system of the universe – and limited. The God who is unlimited and who holds every place in his creative will is not circumscribed by our sense of the 'sacred' – the 'sacred' is but a reminder of his Mystery. This vision of worship as necessary *but also* free of a ritual necessity for its reality is reinforced in the second element of the commandment:

> Now if you make an altar of stones for me, you must not build it with stones shaped by tools; for if you use a chisel on it, you will defile it. And you must not go up to my altar on steps, lest your nakedness be exposed on it (Exodus 20:25–6).

There might be a desire for a stone altar – vast numbers survive in the archaeological record – but if so, the cult must not be seen to depend on the made form of that altar: any stones, undressed, will do. Nor does worship need the cultic elaborations of steps and special buildings. The God who creates is not to be confused with our images of the divine which seem to enmesh the holy within the system of society and worship. This tension – acknowledging the need to worship in having an altar, acknowledging that God is infinite by its being made of earth or rough stones, and located anywhere – was a theologian's ideal. The people built elaborate altars and many temples, until, by 70 CE, the temple in Jerusalem (what we call 'the second temple', and of which we hear in the gospels) was considered one of the ar-

chitectural wonders of the world.[12]

We see the same tension about epiphanic places in the gospels. Jesus is presented visiting the temple (though he would never, as a non-priest, have been within its sanctuary[13]),[14] expressing care for the temple,[15] but, in John, is presented as setting the value of the temple in absolute perspective:

> Woman, believe me, the hour comes, when neither in this mountain, nor in Jerusalem, will you worship the Father. You worship what you do not know; we worship what we know, for salvation is from the Jews. But the hour is coming, and is now here, when the true worshippers will worship the Father in spirit and truth, for the Father seeks such as these to worship him. God is spirit, and those who worship him must worship in spirit and truth (4:21–4).

There are no sacred places for worship: for the Lord's is the earth and its fullness, and, from a Christian perspective, the Spirit is ever present to all who call on the name of the Lord. We do not *need* churches, but we must worship as the People of God and celebrate who we are as disciples – and so we *need* assembly places where we can seek to 'worship in spirit and truth'.

We must carry this theological reflection one step further. In the prologue to John's Gospel we find the coming among us of the Logos, 'through whom all is brought into being' (John 1:3), being described in this way:

> Now the Word became flesh and took up residence among us. We saw his glory – the glory of the one and only, full of grace and truth, who came from the Father (1:14).

This too-familiar phrase, 'dwelt among' or 'lived among' or 'made his dwelling among', renders a word, '*eskenosen*', that was rich in memory for those who looked back upon God's presence within Israel, for it means 'he pitched his tent', and the word 'tent' was rendered in Latin as '*tabernaculum*'. The tabernacle was 'the tent of meeting' – see the wondrous but imaginary details for its construction in Exodus 24:12–29:9[16] – where God would be

12 Hollis (1934), 6–7, which collects what pagan authors said of it. On its significance within Judaism, see Hayward (1996).
13 Very simply, the temple had four areas of decreasing sanctity: the sanctuary with the Holy of Holies at its centre, which was reserved for the Levites; the court of the Jewish men (where Jesus could have entered); the courtyard of the Jewish women; and the courtyard of the Gentiles. See Meyers (1992).
14 Two Johannine examples would be: John 5:14 and 7:14.
15 See the Johannine cleansing: John 2:14–21.
16 See Friedman (1992).

present among his People.[17] The tabernacle was imagined to be the precursor and core of the temple; and now, for John, there is a new tabernacle in Jesus. He is the living tent of meeting and in seeing him we see God's glory – his *Shekinah*: the glory of God that invested the temple in Jerusalem with his presence – for that glory is now present wherever his People assemble and call on his name.[18] There are no places that have sacrality, no 'thin' places, no sacred groves nor powerful shrines, but rather communities who gather and among whom God's glory is present in the Christ. It was from this perspective that one of the early apologists could call out to the Greco-Roman world that Christians 'had neither groves nor altars'.[19]

This tension – perhaps more often forgotten than observed – must stand at the heart of any thinking by Christians about buildings for their assembling. The building is a sacred one not from its shape or design or some sort of symbolical decoration, much less any appeal to some vague perception of the numinous – here lies the theological flaw in those who wish to have so-call 'celebrations *ad orientem*'[20] – but from the presence in the gathering-engaged-in-calling-upon-his-name of Jesus, who is our tabernacle where we behold God's glory.[21]

Basic question 2: a place at table?

It seems so obvious, it escapes our notice: the Christian liturgy is multiform. Our attempts to deal with 'the sacraments' as a system with some coherence – *de sacramentis in genere* – obscures this, as does ranging of its various aspects systematically around either the Eucharist or the life-cycle. But we have only to consider the two great pillars of the Church's liturgy, the Liturgy of the Hours and Liturgy of the Eucharist, to see that here – despite any number of common theological elements we might list – are two fundamentally distinct forms of worship. When we add other elements such as processions and vigils, events like the burial of a sister or brother, or recognising the love between two Christians in marriage, or the various steps of initiation, we see that the liturgy is more akin to a wondrous display of multicoloured variety

17 O'Loughlin (2019).
18 See also – demonstrating that the theme is wider than the Johannine tradition – *Didache* 4:1; and Matthew 18:20.
19 Menucius Felix, *Octavius* 10,2 or 32,1.
20 O'Loughlin (2020).
21 Lathrop (2022).

than to some carefully shaped monolith. We can see this variety within our earliest memory of liturgy amongst the followers of Jesus, when Luke – who probably had never seen the temple when it was functioning – wrote:

> Every day they continued to meet together in the temple courts. They broke the loaf in their homes and ate together with glad and sincere hearts, praising God and enjoying the favour of the whole people (Acts 2:46–7a).

This is one of the ideal summary visions of the first disciples that Luke places in Acts, but its setting forth of an ideal makes it even more valuable for our understanding than if it were simply the recollection of an accidental historical fact. There was a place for the temple in the life of the disciples, but they also had a domestic ritual: the breaking of the loaf in the manner of Jesus.[22]

Our eucharistic action does not come to us as a decontextualised ritual for sacrifice or praise or even for the making present of the Christ, but is in its fundamental form a way of making the prayer of thanksgiving at a meal. This meal format cannot be dismissed as a matrix or an external form – Jesus gathered his disciples at table, there he formed his communion of his followers with himself, and there he showed them how, in blessing the Father, they were to share in a broken loaf and a common cup. To negate this meal significance would be tantamount to denying that eating and drinking have any role in our ritual. But this ritual takes place at a table; hence this, interpreted as an altar, is central to our eucharistic spaces. Here lies the paradox: to be a participant in a meal requires a place at the table, and such a gathering is domestic in scale rather than on the scale of a public meeting. While there are exceptions to this – great banquets such as those at weddings – it is the exceptional nature of these events that show that a much smaller scale is our normal meal-sharing experience.

The space of the Eucharist, if it is to be formed on the nature of the gathering, must therefore be such that it is focused around a table. That table must have the dimensions that allow each to experience that they have been called to have a place there. And the whole environment must be small enough such that its intimate domestic scale – that the Lord is at one's elbows – is manifest.

22 Proper attention to the role of the temple in Luke–Acts is beyond the scope of this paper, but see Head (2004), and Smith (2016).

St Mary's Abbey, Glencairn, has distinct spaces adapted to distinct liturgical needs. In the foreground a space for gathering at the eucharistic table, in the middle ground are choir stalls for the antiphonal celebration of the Liturgy of the Hours, and beyond that the place of eucharistic reservation for the sick and for private devotion. Utilising an inherited chapel space, this arrangement is a deep example of form following function.

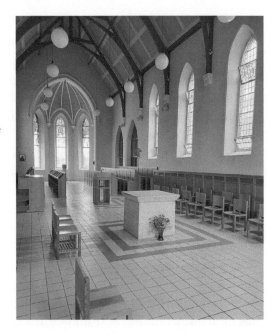

This is radically different from the vast spaces that have been created in many modern urban buildings – but that size was not determined by an examination of the Eucharist's intrinsic form, it was rather a logistics-driven response to the number of clergy available combined with economies of scale in building.

Two spaces
Once the multiformity of our liturgy is appreciated, it becomes clear that we must conceive two basic forms of liturgical space: a liturgy room and, as a subset of such rooms, a eucharistic room.

Every liturgy space should take account of the activity of the community that it is to house. Its primary quality is that it draws attention to the celebrating assembly: they are the Church. Likewise, since every place is holy as the work of the Creator it must affirm that the whole creation is work of God and into it has entered the Logos – it is him as our tent of meeting, rather than the building, which must be our focus. So attempts to create an otherworldly, numinous, 'recognisably sacred' space runs the risk of leaving God's creation for one created in our imaginations. The ordinary is the holy because it is held in its being by God and has come to being through the Lo-

gos. We are, after all, not called to escape from this world, but to transform it into a place of his manifestation.[23] And as the tabernacle of meeting became a living human being in Jesus, so our manifestation of him is our calling to become a living community rather than to fabricate a material presence. Every eucharistic room has to reflect this domestic nature of our thanksgiving: a group of sisters and brothers – made so by the Spirit – who have been invited to sit at the Lord's table now liturgically in anticipation of being called to the heavenly banquet.[24] So the intimacy of our activity, expressed in being really gathered around a table, must be apparent. Here the centre is the table and it must be both our table and a banqueting table. In this central action of Christian *anamnesis*, understood as experiencing anew our table fellowship, we praise the Father in sharing the Lord Jesus' meal, and sharing that with one another in the manner that is distinctive of Jesus. This table must be our common possession. The table must say to us that we are welcome, that we have a place set for us, and that we are not only in the presence of our Church but of its Head – then, and there, we can offer blessing and thanks to our Father. So what is a eucharistic room? It is a church's dining room – the place of their common table with space for each of the baptised around it.

Conclusion

> If, from the start, we do not identify theology with a theology that uses words, but understand it as the total human self-expression, insofar as it is backed up by God's self-communication, religious phenomena in the arts themselves would be constituent elements of an adequate theology.[25]

If our space adequately allows for our worship, then that space becomes in itself our theology. Thus it is a space that is not 'a church', but what facilitates a community to be a church. The table is not an item of ecclesiastical furniture, but our table, our family's focal point, while on our pilgrim journey. Viewed in this way we can appreciate anew the expressive and intended

23 Loudovikos (2019), 161–203.
24 The Eucharist cannot be imagined without its eschatological dimension: it is the *pignus futurae gloriae*, when 'people will come from east and west, and from north and south, and recline at table in the kingdom of God' (Luke 13:29). See O'Loughlin (2022).
25 Rahner (1992), 163.

emptiness that Rudolf Schwarz sought to capture in his liturgical spaces,[26] and the significance of the majestic table in the eucharistic room like that in Carlow. But it should also alert us to this paradox: while most Christian architecture has sought monumental public spaces, our central ritual, the Eucharist, is domestic in nature and scale.

26 See Caruso and Thomas (2020), 47–109.

2

Shaped by an Architecture of Transcendence

Christopher Irvine

Let us start with a question: What is a church building for? Most accounts of modern church building and the ordering of worship spaces have taken the needs of the worshipping community as their base line and recounted how architects have utilised modern technologies and materials in the design and building of new churches to allow the form to follow function.[1] This focus on the function of the worshipping community, and the role of the church building in the wider community, has led to an emphasis being placed on what has been styled the architecture of immanence.

But let's ask the question again: What is the church building for? The question is raised rather rhetorically by Oscar, the somewhat sad, yet gifted character in Peter Carey's novel *Oscar and Lucinda*. When he asks himself what a church is for, he immediately answers his own question: 'a shelter for Christians to meet'. On further reflection, Oscar avers that a church building is also 'a celebration of God'. There is no doubt that a church building must serve the needs of a Christian community, but the building itself must also articulate something of the God who is both immanent (present with us) and transcendent (greater and beyond ourselves and the spaces that we inhabit).[2] If the church building is, in Oscar's words, to celebrate God, it needs to be more than a convenient and utilitarian meeting place. At one level it is absolutely true that Christians can gather and worship anywhere,

1 See Giles (1997), and Torgerson (2007).
2 Torgersen (2007) admits that most church buildings will have some reference to transcendence (117); he speaks of immanence and transcendence as being opposites and oppositional truths (3 and 208). Another voice articulates a deeper and more theologically satisfying view: 'All good art and literature begin in immanence. But they do not stop there … it is the enterprise and privilege of the aesthetic to quicken into lit presence the continuum between temporality and eternity, between matter and spirit, between man and "the other"' (Steiner [1989], 227).

but if we are to build churches, then the physical structure must speak of the God who calls Christians together to be the Church in every place, and should be a visible sign of God's presence in the built environment and wider landscape.[3] In its very solidity and permanence, the church building is to stand as a sign (one could almost say a sacramental sign) that 'the kingdoms of this world are called into the kingdom of our God and of his Christ' (Revelation 11:15), so that every place may be safe and at peace (Zechariah 8:4–8) and every inhabited building a *domus Dei*, a house of God.

A basic axiom of sacramental theology is that a sacramental sign should contain some feature of that which is intended to be signified by that sign, and if this principle is applied to the church building, we could say that it should point, direct and invite the worshipper to step out into a wider space, into a wider world. This stepping out is not to escape from the buzzing confusions and demands of our everyday world, but to bring that world into the wider and deeper space of God's infinity, in and through the prayers and ritual gestures of our corporate worship. In saying this, it may seem as though I am suggesting that the church building is similar to the wardrobe in C. S. Lewis's *The Lion, the Witch and the Wardrobe*, the place where one can step through into another world. However, in this case, as we focus on the primary purpose for which a church is built, the 'stepping out' is less a stepping *away* from, and more a question of *being drawn into* a greater reality. The purpose of the church building is to be a vestibule of heaven, and even if, as the poet Philip Larkin says,[4] the purpose is increasingly obscure, it is one that remains in so far as Christians gather in that space and consciously place themselves before the triune God in worship.

What I am suggesting is that the physical church building can, and probably should be more than a setting for worship, the place where it happens, and its walls more than an envelope to contain the worshipping community. My contention is that sacred space conspires, through its architectural lines and lighting, to draw the worshipper into a larger world, and what I aim to show in this chapter is how this may be variously achieved in a church building. I will look specifically at these two key architectural elements in sacred buildings:[5] first, the volume, or spaciousness of the building, and secondly,

3 See Hebert (1935); and, more recently, Jenkins (1999).
4 See Philip Larkin's richly nuanced and suggestive poem, 'Church Going'.
5 See Bohm (2014).

the ways in which light enters the building. But before I attempt to examine these two architectural elements, let me turn to art by way of illustration. The example I have in mind is the little-known and introverted Danish artist, Vilhelm Hammershøi, who was born in 1864 and died mid-career in 1916.

Pictorial art is only two-dimensional, and yet Hammershøi's strangely silent paintings of interiors could be described as architectural in their composition. He was also fascinated by the effect of light streaming through windows into a contained space during the hours of the day. Because of Hammershøi's focus on the architectural lines and the effects of light, his paintings of interiors provide apt illustrations of the points I want to develop later in this chapter in relation to the transcendent features of sacred architecture. In an interview the artist opined that what really matters is getting the lines right.[6] And architecture, of course, is a geometric art and is precisely about getting the lines right! The evident motif of architecture is matched in Hammershøi's art with his fascination with the fleeting quality of light, and how it breaks into an enclosed space.[7]

In Hammershøi's paintings of interiors, the usual accoutrements of domestic space, *objets d'art*, potted plants, pictures and books are removed, and the rooms are stripped of excessive furnishings and furniture to accentuate the architectural lines of the connecting domestic spaces. The artist was evidently fascinated by how we see, inhabit or, more precisely, how we *are* in our homes (as in the literal meaning of the German word '*da-sein*': being there). These uncluttered paintings of domestic spaces are poetic and entrancing interiors that evoke the kind of stillness that is so often associated with the places where the divine is encountered. This is not a forbidding or intimidating silence, but one that holds the promise of presence. Indeed, these paintings invite the viewer into the frame of the picture to look through the depicted spaces. By his signature muted, almost monochrome grey-toned palette, the artist shows the artful play of natural light, shade and sightlines in a way that effectively reveals the sources of light, opening new and longer perspectives as the viewer sees intriguing glimpses of other rooms through open doors to other doorways and windows.

6 Bonett (2008).
7 In an interview in 1907, Hammershøi described the key elements in his paintings as the architectural space and natural light. See Vad (1997), 28.

Two examples come to mind (and more about the artist may be read on-line[8]). The first example, in the Aarhus Kunstmuseum, is simply entitled *White doors*[9] (1905), 39.5 x 42 cm, and shows a sequence of spaces, and the second example is *Sunlight* or *Dust motes dancing in the sunbeams*[10] (1900), 70 x 59 cm, which is in the Ordrupgaard Kunstmuseum, Charlottenlund. This second painting shows how the daylight illuminating the architectural space has something of a sacramental intensity; and the first example, *White Doors*, like the more frequently reproduced *Interior, Strandgaarde 30* (1906), shows architectural spaces opening, through a series of doors, to further spaces, as the light itself invites us to step forward into another, further space.

This same visual sense of a space leading into and opening to another space, and of light streaming into a space from beyond, is surely what is required in the design of a church building if it is to signal the transcendent, or that which is larger than ourselves and is beyond and above us. There are, of course, many styles of church building, and many have architectural features, such as domes, barrel vaulting and heightened elevations at the termination of an axial building, which all create an interior sense of spaciousness. Richard Kieckhefer speaks suggestively of the height of a church interior as a sign of aspiration, of how the experience of those who enter the worshipping space can be one of spiritual elation and expansion, giving perhaps, what one might say was room for the soul to breathe and expand.[11] This sense of the building as signalling a transcendent reality may also be seen in how it looks within the wider context of the built environment.

In relation to the exterior of a church building, it was the spire, the tower, turrets and spirettes, which literally point to the sky, the expansive beyond, that were the traditional signals of transcendence. The most celebrated of church spires, and still the tallest spire in England, is Salisbury Cathedral. Here, the combined tower and elegantly tapered spire, built in the 1320s, rises to a height of some 123 metres.

A contemporary building that does not so much 'point to heaven' as pierce the sky, the Shard building, south of the river Thames in Southwark, is al-

8 https://www.smk.dk/en/artist_profile/vilhelm-hammershoi/.
9 https://artvee.com/main/?s=Hammershoi+%27white+doors%27&tc=pd.
10 https://www.artsy.net/artwork/vilhelm.hammershoi-dancing-in-the-sunbeams.
11 Kieckhefer (2004), 104.

most a parody of the spire at Salisbury. This glass and steel construction,[12] designed by the Renzo Piano workshop and built in 2012, dominates the skyline as you look across London from Parliament Hill. It is clearly seen from the Eurostar and HST1 trains as they thunder around the northern arc of track towards St Pancras Station. The Shard, a dazzling glass iceberg, soars to a height of 310 metres. It does not so much point to as lacerate the sky, puncturing the heavens.

The Shard, the tallest building in Europe, is a thrusting assertion of market economy, and arrogantly dwarfs the sacred landmarks of London's urban landscape. The theologian Miroslav Volf describes the modernist project as the banishment of the sacred, and wonders if the construction of sacred space is possible under the conditions of late modernity.[13] But this view is rather pessimistic, and again, perhaps an artist can come to our assistance and moderate our point of view. The artist I have in mind is the contemporary American artist, James Turrell. Turrell is fascinated by the effects of light breaking in from above and beyond us. Many of his installations are designed to make us stop and look, and, in looking, to see the shifting patterns and density of light. Here, indeed, is a contemporary artist who is open to how the sacred may reveal itself. Turrell's expressed artistic aim is to make an inviting situation, usually an intervention into the natural environment that enables the viewer to see. He admits that his preoccupation with light is based upon his interest in the spiritual nature of human beings and has claimed that his art 'deals with light itself, not as the bearer of revelation, but as revelation itself'. Further, if we are to see the light when we take shelter and enclose ourselves, we need, Turrell has said, windows of transcendence.[14]

Turrell's fascination with light certainly matches that of the builders of the Romanesque churches, with their clerestory windows, and resonates with the project of the later Abbot Suger (1081–1151) who installed the jewel-like stained glass in the royal Abbey of St Denis, near Paris. The abbey church was rebuilt by Suger between the years 1140 and 1144, and this innovative project is often credited as being the first example of French Gothic church

12 In its shape, the Shard is remarkably similar to the tower of the so-called Crystal Cathedral, built in 1980, in Garden Grove, California.

13 See Volf (2010), 61.

14 James Turrell, press conference, Yorkshire Sculpture Park, 27 April 2006.

architecture.[15] The great achievements of this style of architecture were a heightened spaciousness within the building and the larger windows, made possible by the increased elevation of the building and ribbed vaulting bearing the weight of the roof to produce what has been described as chambers of light.[16] Alongside these building achievements, there were also the developments in the artistry and production of painted or stained glass. Much has been written about the influences and resulting controversy of Suger's rebuilding scheme, but suffice to say here that the production and installation of the glass at St Denys produced a luminous effect, as was achieved in modern times by Henri Matisse, the unrivalled modernist master of colour, in the Chapel of the Rosary for the Dominican Sisters at Vence (1947–51). Matisse, then in his eighties, was responsible for every detail in the design and decoration of the chapel, and he regarded the project as the most original work of his entire career. His aim was to construct a building around light from the floor to the ceiling.[17] Here, as at St Denys, the light of the sun streams through the windows, causing pools of colour to appear on the floor, bathing the worshipper in a warm glowing light.

What Suger wanted to achieve at St Denys in the mid-twelfth century was not simply a programme of beautification or adornment, but to serve two purposes; the elevation of the individual soul to commune with the God 'who dwells in unapproachable light' (1 Timothy 6:16); and the soul's spiritual illumination as the worshipper apprehended the depicted saints in light and the Lord who is 'Light of light'. Over the main portal of the abbey church were inscribed words inviting those who entered the building to perceive the luminous beauty of the church in order that they would be transported to heaven. Far from simply serving a utilitarian purpose in providing light during the hours of daylight, these windows were also considered to function as metaphysical *thresholds*. All this rested on a complex aesthetic of light and understanding of optics.[18]

In his theoretical schema, constructed from his reading of *De divinis nominibus*, a work attributed to Dionysius the Pseudo-Areopagite (*c.*500),

15 See Speer (2006).
16 Kieckhefer (2004), 107.
17 See Pulvenis de Séligny (2013), ch. 3: 'A Creation of Light'.
18 On the larger context of this twelfth-century vision of spirituality, see van' t Spijker (2022).

Abbot Suger distinguished between three kinds of light.[19] The first was *lux*, the natural light from the sun, and the second was *lumen*, the light that shone from the figures and symbols depicted in the jewel-like glass that shone into the interior of the church. This light was understood to yield the third kind of light, *illumination*, when it was perceived by worshippers in the gemlike light. The stained-glass windows not only brought the biblical figures, types and mysteries of faith alive, but powerfully conveyed their inner meaning to the viewer.

To look at the painted windows in St Denys, in the Cathedral at Chartres, or at Canterbury Cathedral, was not so much to see what was depicted there, but to be illuminated by the typological meaning of the mysteries and the saints whose names were sounded in the scripture readings and echoed in the chant and prayers of those who offered their prayer and praise in the space below. Here then was a highly sophisticated art of light, and one that, though rooted in the scriptural references to light, was understood in the most complex of metaphysical terms.

Since the Romans constructed the Pantheon in Rome, architects have seen architecture as the art of capturing the play of light on solid surfaces.[20] Light can certainly bring an enclosed space alive, and although the ways in which it features and functions varies in the different historical styles and idioms of sacred architecture, it can articulate its shape and reveal the form of architectural space. Shafts of light from high clerestory windows cut into dark Romanesque churches, and the insertion of large windows in Perpendicular churches during the high Middle Ages flooded the nave with a clear light. The late eighteenth and nineteenth centuries saw the return of dim religious light in the interiors of neo-Gothic churches, especially those with high-pitched roofs and Victorian glass. In more recent times, light has become an increasing feature in the design and building of modern churches.[21] The most monumental modernist example of this is the baptistry window at Coventry Cathedral, where we can see a perfect symmetry between the play of light and an understanding of the ritual actions performed below in that space. When the window, designed by John Piper, and made by Patrick

19 See Lieber Gerson (1986); and also Eco (1986), ch. 4, for a summary of the medieval aesthetics of light.
20 This was strongly argued by Le Corbusier (1927).
21 See Torgerson (2007), especially 98, 105, 114 and 121; and Seasoltz (2005), 282 and 341.

Reyntiens, was installed in 1961, it was the largest stained-glass window in the world, measuring 30 metres in height and 17 metres in diameter. In his critique of Coventry Cathedral, Kevin Seasoltz has expressed the opinion that the window rather overshadows and dwarfs the font,[22] but perhaps this judgement overlooks the significance of the motif of light in the theology of baptism. Baptism itself was often referred to in the early Christian writings as enlightenment or, more precisely, illumination, and in one of the earliest accounts of Christian Initiation written around 150 CE, Justin Martyr says: ' … this washing is called *illumination*, because those who learn these things are illuminated in their understandings'.[23] Looking at the modern baptistry at Coventry, one sees that in daylight the abstract pattern of richly coloured glass panels frame what has been described as 'a blaze of light'[24] at the centre of the window, and as such signals the dramatic meaning of Christian initiation as the occasion when those being baptised are transferred from the realm of darkness to the Kingdom of light to become the children of light (Ephesians 5:8; and 1 John 1:7). The sense of initiation as enlightenment is also embedded in the mature Pauline theology of the Letter to the Colossians in which 'the apostle' speaks of those incorporated into Christ through baptism as 'those called to share the inheritance of the saints in light', and then goes on to say: '[God in Christ] has rescued us from the power of darkness and transferred us into the kingdom of his beloved Son, in whom we have redemption, the forgiveness of sins' (Colossians 1:13 and 14).

Notwithstanding Edwin Heathcote's warning that the use of light in a building can become something of a cliché,[25] the sense of light as a sign of transcendence is to be welcomed, and one notable example is the so-called Chapel of Light in the city of Ibaraki in the Osaka region, designed by the Japanese architect Tadao Ando (b. 1941).[26] This chapel, a simple rectangular shape, was constructed in a constricted space at the intersection of two roads, and it has a stark and imposing simplicity. The interior is basically a

22 Seasoltz (2005), 263.
23 Justin Martyr, *First Apology*, 61. 'Light' is a major theme in the description of baptism in the third century: see the apocryphal *Acts of Thomas*, 25–7.
24 Spalding (2009), 37
25 Heathcote and Moffatt (2007), 76; see also Moffatt's comment on how light may inform architectural spaces (191), and the example, on 138, showing random portholes punctured into the walls of a nave.
26 See https://archello.com/project/church-of-light for a series of images of the chapel. For a full study of the chapel and its underlying conception of being and space, see Baek (2009)

The interior of the Ando's
Chapel of Light

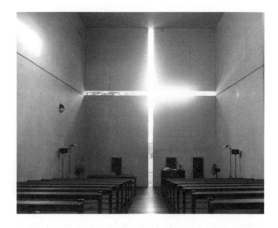

reinforced concrete box, and being minimally furnished with short bench-
es in serried ranks it gives the impression of being an empty space.[27] But
the remarkable and distinctive feature of this building is the horizontal and
vertical bands of glazing, cutting across the whole length and width of the
terminal elevation, forming a cross of natural light that shines into the wor-
shipping space of the congregation, casting light onto the interior surfaces
and worshippers alike.

The effect of this cross-shaped light breaking into the church is concisely
caught by Murray Rae, who writes of how the light enlivens the interior:
'The stark and colourless emptiness of the concrete enclosure is replaced by
warmth and richness as the natural light falls upon the natural wood of the
furnishings.'[28] The light also causes the sign of the cross to be reflected on
the ceiling, and here we may recall that the sign of the cross in the decorative
mosaic schemes of the apse in ancient churches, famously in the sixth-cen-
tury Church of St Apollinare in Classe, was originally taken to be a sign of
Christ's appearing and presence. The One who comes brings light into the
darkness, exposes human sin and breaks into human lives as divine forgive-
ness and the resurrection life of God's new day.[29]

We have seen through a variety of examples, both medieval and modern,
that within the enclosed space of a church building, light carries a symbolic
religious resonance, and this has been forcefully stated by Richard Kieck-

27 Heathcote and Spens (1997), 129–35.
28 Rae (2017), 168–9.
29 See Irvine (2013).

The Abbey Church of St Sixtus
in Westvleteren.

hefer who claims that, whatever the degree of luminosity, or kaleidoscope
of colour within the enclosed space of a church building, the play of light
on its floors and walls has a significance well beyond the architectural.[30] In-
deed, the shifting patterns and intensity of direct and diffused light may well
combine to signal the breaking-in of transcendence, and be an invitation to
the worshipper to engage with the triune God in the unfolding mystery of
Christian worship within the worshipping assembly.

To illustrate this point, one can look at the interior of the Abbey Church
of St Sixtus of Westvleteren, in Belgium, which was designed by the re-
nowned Flemish architect bOb van Reeth.[31] The project began in 2005 and
was completed in 2012. The chapel is austerely simple and, apart from the
image of Our Lady, lacks all coloured decoration. In this regard this contem-
porary building is entirely consonant with the stark style of the reforming
Cistercian spirit and its emphasis upon the cultivation of the interior life of
monks. The first impression of the chapel is of a large empty space, and, giv-
en the expansive width of the building and its tall bare brick walls, one might
be forgiven for thinking that it is more like a warehouse than a sacred space.

And yet, a band of patterned glazing above the suspended wooden frame
of the ceiling allows the constantly shifting direct sun and diffused daylight
to play on the brick walls and floor of the building through the hours of the
day from dawn to dusk. The constantly shifting pattern of light in the chapel
makes it a most appropriate space for the marking of time, the celebration of

30 Kieckhefer (2004), 109–10.
31 The typographical form 'bOb van Reeth' is this architect's usual signature.

the regular monastic hours of prayer. In this sacred space it is as though every changing moment of time is taken up into eternity, through the regular monastic hours of prayer punctuating the movement from night to day, and through the day into the silence of the night.[32]

And so, through the celebration of the Liturgy of the Hours, the chapel becomes a kaleidoscope of the turning world; as James Turrell would say, the colour is in the light, and the monastic art of light is no less than the dissolving of the finite into infinity, and the folding of time into eternity.

Bathing the worshipping space in light is commonplace in sacred architecture, and a particular feature that facilitates this is the lantern, or corona, and, because of its shape and positioning at the apex of the building, it not only allows the natural light to shine down into the worshipping space, but also represents a kind of funnel, drawing the church's sacrifice of praise heavenwards.

An exquisite historical example of this is the fourteenth-century so-called lantern of Ely Cathedral.[33] This remarkable feature has its counterpart in modern church buildings, the most notable of which is the lantern of the Metropolitan Cathedral of Christ the King, Liverpool, which was built between the years 1960 and 1967. The glass at the Roman Catholic cathedral in Liverpool was designed by John Piper and made by Patrick Reyntiens, both of whom, as already noted, had collaborated earlier on the design and making of the striking windows for Coventry Cathedral.[34]

The inclusion of a lantern became something of a signature of mid- to late twentieth-century church building in England,[35] and a particular mention could be made here of the RIBA award-winning design by Michael Blee at Douai Abbey in Berkshire, which was dedicated on St Benedict's Day 1993. The lantern not only adds to the verticality and volume of the building, but also, as I have suggested, focuses the light into the centre of the worshipping space.

This sense of the rising of prayer and the ascent of praise is accentuated in

32 For a historical exposition of the theology of the Liturgy of the Hours, see Woolfenden (2004).
33 See Maddison (2003), 127–30.
34 Proctor (2014), 116 and 153–5
35 A lantern was included in the Chapel of Virginia Episcopalian Seminary, designed by Robert A. M. Stern Architects of New York and consecrated in October 2015. The interior of the chapel, a fusion of styles, classical and neo-Gothic, based on a Greek Cross plan, was intentionally designed by the architect to be flooded with light as a metaphor for the mystery of life.

the internal decorative scheme of the classic octagonal lantern at Ely Cathedral, built between 1322 and 1328. This landmark feature, which makes the cathedral look like a stranded ocean liner on the Cambridgeshire Fens, was heavily restored in the Victorian period (1873–5). The lower interior panels of the lantern are decorated with a band of thirty-two angels,[36] and it is possible that the original medieval decorative scheme, concealed by the Victorian restoration of the lantern, also featured the figures of angels. In terms of Christian imagery, angels are figures or 'signals' of transcendence, the traffic between the human and the divine, and thereby connecting what occurs in the worship space with the infinity of heaven. And so, whether it is a lantern, as at Ely, or a corona of lights placed over the altar, these features both focus the physical 'centre-point' of the worshipping space and signal the layered meaning of the *Sanctus* in the Eucharistic Prayer. This worship text reaches back to the earliest centuries of Christian worship[37] and not only articulates a sense of the divine ineffable transcendence, expressed in the repeated word 'holy', but also indicates that whenever and wherever a Christian community gathers for worship, it is joining something that is ongoing, and goes on eternally, the very worship of heaven itself (see Revelation 4 and 7). And so, when worshippers raise their voices in the climax of praise 'with angels and archangels and with all the company of heaven', earth is joined to heaven.

The voicing of praise returns us again to the importance of the dimensions or spaciousness of a place of worship, and, in terms of the architectural volume of the building, one could say that a church should be an acoustic building for both the spoken and the sung word. Indeed, sound could be said to complete the architecture, especially through music and song. If music is sound in time, then in worship it often leads to silence, that other, often neglected language of worship, and yet the one in which an echo of the Word may be heard. As the biblical prophet Elijah discovered, God is more often to be heard in the thin voice of silence (cf. 1 Kings 19:11–3), so perhaps our places of worship need to be relatively lofty and resonant places as well as places that hold the silences of worship. In relation to our church buildings, this is what is meant when we speak of resonant buildings. To add to this we could also consider another sense of spaciousness, of what Albert

36 Meadows (2003), 322.
37 See Spinks (1991).

Rouet has described as the amplitude of the building.[38] Generous pathways, aisles and ambulatories, around and through the building, not only allow for liturgical processions and less formal movement of worshippers within the building, but add to the sense of spaciousness, as does an 'empty space' immediately around an altar, font or other focal point of liturgical action.

The division, or zoning of sacred space is another key element in the design of sacred architecture that signals how the transcendent breaks into the physical envelope of a church building, and this has been articulated in different ways in different epochs of the Church's history. A classic Anglican example is found in Anthony Sparrow's commentary on the *Book of Common Prayer*. In this work Sparrow proposed an allegorical typology of the church building and claims that the whole church is a type of heaven and goes on to differentiate between the different spaces of the building, suggesting that the bounded physical building is contiguous with the infinite. The nave, he claimed, represented the visible world, and the chancel the invisible heaven and things 'not seen by the eye of flesh'.[39]

In architectural terms, light and space are coordinate concepts, and, as we have seen, both reveal the form of a worshipping space and signal that glorious exchange between heaven and earth, between the human and the divine, the temporal and the eternal, which lies at the very heart of the mystery of Christian worship.

The doyen of Brutalist church building, so-called because of the use of reinforced concrete, Le Corbusier (1887–1965),[40] as he called himself, described ineffable architecture as that which, though enclosed and bounded, suggested an expanse of space, and he once described an experience of seeing a wall that had lost its limits and appeared to open on to boundless space.[41] The sense of a wall that has, as it were, lost its limits, recalls the apse wall of the Great Chapel at Kelham. Alas, many decades have passed since this building was a chapel, but according to Peter Hammond, whose landmark book on mid-twentieth-century church architecture was published in 1960, it was a remarkable building built in advance of its time in England, and with an

38 Rouet (1997).
39 Sparrow (1672), 323.
40 His original names was Charles Edouard Jeanneret-Gris; and he was famously the architect of the pilgrim chapel at Ronchamp (1951–5). See Anne Dixon's essay in this book about her visit to Ronchamp, and the Dominican monastery of La Tourette, near Lyons (1953–63).
41 See Britton (2010), 13–14.

Photograph of the architect's
drawing of the east elevation.

interior of real quality.[42] The chapel, designed from the altar outwards with
a square plan, was dedicated to St Michael and All Angels and was built,
though never fully completed, in 1927/8 at a cost of over £24,000.[43] The
monumental concrete dome and the internal sweeping arches constructed
with golden-yellow bricks reveal its Byzantine inspiration, and, like other
domed church buildings, it had a resonant acoustic and a heightened sense
of spaciousness.

The great arch spanning the width of this basic square-plan building
supported Charles Sargent Jagger's famous rood figures,[44] but behind was
a semi-circular apse with two small lancet windows. The architect Charles
Clayton Thompson (1872–1932) provided the specifications for the rough
render finish and the colour of the paint to be used in the painting of the
apse wall, which can only be described as an indeterminate purplish-grey
tone. The intention was to give the sense of infinity stretching out beyond
the sanctuary, of boundaries being dissolved, and of the stone altar standing
on the very brink of eternity. A priest who attended the dedication celebra-
tions at Kelham recorded his impression of the sanctuary and the place of
the altar as the meeting place of two worlds, the world in which Christians

42 Hammond (1960), 71–2.
43 The chapel was dedicated and the altars consecrated on Tuesday, 20 November 1928. Bishop
 Charles Gore CR preached at the service, and the Michaelmas hymn 'Sons of the Holy One
 bright with his splendour' was written by Frank Judd, a former Kelham student, especially for
 the occasion.
44 Now located in the church of St John Divine, Kennington, in south London.

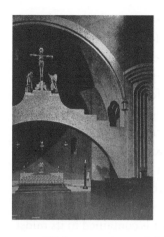

The interior of the Great Chapel, Kelham.

are called to serve, and 'the unseen world of the angels and the saints'.[45] 'Looking into the body of the chapel from the narthex or from the visitors' gallery, the visitor was struck by a sense of an expansive space. The area of the square plan choir was 70 ft in each direction, the sanctuary had a depth of 30 ft to the furthest part of the curved wall, and at its highest point the dome was 68 ft high.'[46]

The combination of scale, the hint of infinity in the apse wall, and the glistening, highly polished black tile floor evoking the poetic image in Revelation of the floor around the throne in heaven (4:6a) conspired to invoke the quintessential Christian hope 'not of things seen, but of things that are unseen' (2 Corinthians 4:18).

The architect of the Great Chapel at Kelham deliberately wanted to create a visual illusion of the space extending into infinity. However, behind this architectural conceit is a vital principle in sacred architecture, namely, that architectural lines and the arrangement of internal spaces should facilitate an openness to the transcendent on the part of the worshipper and visitor. What I am nudging towards, and it will take some further work to illustrate this, is the view that when a church building is 'live' with the celebration of the liturgy, it may be seen to be a place where the categories of (bounded) space and time are, even just momentarily, suspended.

The increasing prevalence of a square or circular ground-plan design in

45 Anon (1928), 101.
46 Anon (1928), 104.

new churches, and reordering schemes to facilitate a more corporate liturgi-
cal celebration and provide clear sightlines to the loci of liturgical action, is
a story that has been frequently told.[47] Without denying the validity of this
reforming agenda of facilitating the active participation of worshippers in
the liturgy, the question of the relation between form and function in our
church buildings needs a more nuanced, and, I might also add here, a more
historically responsible attitude towards our church buildings.[48] On a more
theological track, I take a slightly critical view of Richard Vosko's preference
for the circle plan for the worshipping space.[49] A circular seating arrange-
ment may well facilitate a greater sense of the worshippers being close to
the ritual action, but there is the danger of a premature foreclosure, of the
worshipping community thinking the transcendent is contained in its midst.
For this reason, I would propose that the closed circle is best avoided, and
that however a congregation is configured within the building, worshippers
need to have a sense of God being both above and beyond them. These spa-
tial metaphors have their limitations (and dangers), but what is suggested
here is that Anselmian sense of God being 'greater' than our sense of the
divine presence with and between us in the embodied worshipping assembly.

To ask how a church building may be adapted and reordered to better
serve the liturgy is a valid question, but a preliminary question to be asked
on entering a church building is the question about what the building may
teach us about the meaning of worship from its architectural lines and spac-
es.[50] Good and sound liturgical principles concerning both an imaginative
ordering of the worship space and the performance of the liturgy within it,
can be applied even within the perceived constraints of a neo-Gothic build-
ing. Sound advice on this is again offered by William Whyte in his erudite
study *Unlocking the Church,* a book in which he dismantles a number of
preconceptions and easy schematisations, not least that the neo-Gothic style
was nostalgic in looking to some imagined past, and that it was solely the
architectural template for 'high-church' worship.[51] Neo-Gothic Victorian

47 See, for example, Yates (2008) and, more recently, Proctor (2014).
48 Whyte (2015) is very instructive on this point.
49 Vosko (2006) and (2019).
50 Underlying the point here are examples of reordered churches, particularly where the worship-
 ping space has been domesticated, where new arrangements are incongruous and do not fit the
 architectural style and character of the building.
51 Whyte (2017).

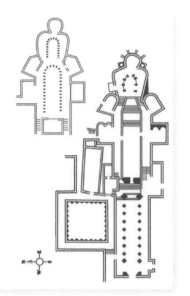

Ground plan of the cathedral church and insert of the undercroft (crypt) in Canterbury.

churches can be overdecorated and may have inadequate and outdated lighting schemes, but these worship spaces can be uncluttered and the sightlines improved with an imaginative reordering of the seating and a thoughtful positioning of the foci of the liturgical action, such as the lectern, font and altar, that are congruent with the architectural lines of the building; that is, of simply working with, rather than against the architectural lines of the building.

In all this, we are not speaking of 'space' as an abstract, or strictly as a Kantian category, but as a measurable and material enclosure, a 'room', as we might say. In looking at churches we might ask if the 'rooms' are simply adjoining spaces, or, as in Hammershøi's paintings of interiors, visually connected spaces, so that one space opens and leads into another room. But what of the simple single-room church?

In a highly influential lecture published in 1971 the eminent medieval historian Christopher Brooke argued that the original and pristine church building in western Christendom was a single unified room, and he attributed the increasing complexity of church buildings to developments of Eu-

charistic doctrine and piety.[52] Whatever the theologian may make of this, one architectural consequence of this was what Brooke disparagingly called a 'jumble of rooms'. In many cathedrals, the east–west longitudinal axis was extended, and radial chapels with their altars were built into apse and transept spaces. Even so, if we open our eyes to see what is there, there was a discernible differentiation of space even in the single-rectangular Anglo-Saxon churches, and a good example of this type, in which a space or zone leads to another, can be seen in the frequently cited tenth-century church of Deerhurst in Gloucestershire.

The most articulated example of worship spaces leading from one space to another in order to extend a sense of pilgrimage and intensify the true pilgrim's desire to deepen his or her sense of communion with holy things and people, is the Cathedral Church of Canterbury. From the west end of the building as it now stands, it could be said that the pulpitum screen acts as a barrier to terminate the space of the nave, but its soaring archway draws the eye and leads it into another space, the quire. From here, one's sightlines are again raised and drawn forward towards another space, the apex of the building, the Trinity Chapel, the site of Becket's shrine, now marked by a single burning candle. At this point it may seem as though the Canterbury pilgrim has reached their destination. However, another space now becomes visible, the Corona Chapel that is now dedicated to the Saints and Martyrs of Our Own Time.[53]

A deliberate differentiation of space is seen in the more recent completion of the west end and the reordering of the interior of Portsmouth Cathedral, in the late 1980s. This major project was led by Bishop David Stancliffe, who was then the provost of the Cathedral, and the architect Michael Drury. The interior of the cathedral, with its four distinct spaces, is unified in its design and intention by a theology of Christian initiation that sees baptism as being the incorporation of an individual into the Paschal Mystery of Christ's death and resurrection as celebrated at the Easter Vigil on Holy Saturday.

The first space is the gathering space of the nave; the second, under the tower, is the place of baptism; the third is the choir with its twin focus of Word and Sacrament, lectern and altar; and, beyond that space, in the

52 Brooke (1971).
53 For an account of this chapel, see Irvine (2020).

original twelfth-century chancel of the church dedicated to Thomas of Canterbury, beneath a tester hangs the pyx containing the sacrament of Christ, who calls us forward in our journey of faith, surrounded by a 'great cloud of witnesses' (Hebrews 12:1), of those who have gone before us marked with the sign of the cross.

However, the reader and the experienced worshipper may well ask if it is necessary to have a succession of 'rooms' to give the embodied worshipper a sense of progression and pilgrimage. History attests to the variety of architectural styles of our places of worship, and each one may well articulate an important aspect of what Romano Guardini once described as the serious playfulness of the liturgy. What matters most is the recognition of the importance for the worshipper of visibility, physical movement in procession and dance, and light and shade, and this can occur as much in a building based on the circle in the square plan, as in a series of connecting rooms, or possibly even in the 'multiplex', a model for future church building recently proposed by Richard Vosko.[54] Whether delineated physical spaces, or zones within a square or circular architectural plan, each can provide the space in which the worshipper may encounter and meet, or, more precisely, be met by the divine.

An alternative to a multi-room interior is a zoned single space, and this has been achieved in the recent reordering of the church of the Anglican Community of the Resurrection at Mirfield (more fully described by George Guiver CR in his chapter in this book). Here the floor is now level. Wrapped around the open horseshoe of monastic stalls are the seats for theological students, retreatants and visitors, and the ambo and the imposing stone altar are visible to all. The altar is set, slightly off centre, in a circle of lighter, white tiles, and at the administration of communion communicants move to stand around the perimeter of this circle to receive communion, returning to their seats after receiving as others take their place to form the circle until all have communicated. This very arrangement not only draws the communicants towards the circle, but, in standing on its perimeter to receive communion, draws each of them together in a way that inculcates a sense of being a single body.

So, what may be said as we begin to draw together the observations that

54 Vosko (2019).

Sketch of the ground plan of the Church of the Resurrection, Macedon Ranges.

we have made and move towards a conclusion regarding the transcendent features of church architecture? The interior design of a church should invite us to join with others and to step out beyond the self, and within an expansive space raise our hearts in prayer and praise. Spaces and sightlines should lead us to join the 'festal assembly' (Hebrews 12:22), and there to encounter the very mystery of the God who meets us when we step forward into that liminal space, the worshipping space that is the vestibule of heaven. The metaphor of stepping out into spaces that open into other spaces is given physical expression as the embodied worshippers, both individually and together, move from one space or zone to another as God's pilgrim people. Such movement and reconfiguration of worshippers requires physical space, and often, it is the light shining into the building that defines the space and draws worshippers into the wider world of the God's Kingdom.

As an example of a church building that succeeds in articulating these principles of an architecture of transcendence, and by way of a conclusion, I return to where we began in this chapter, Australia. The building I have in mind is the Church of the Resurrection, in the Macedon Ranges in the State of Victoria, designed by Canberra architect Brian Dowling. The church was built to replace two Anglican churches that were destroyed in the devastating bush fires that swept across the States of Victoria and South Australia on Ash Wednesday, 16 February 1983, and was completed in 1986. I choose this as my final example precisely because it is a comparatively new building. Its design is theologically imaginative and the building innovative as new mate-

rials and building techniques were utilised in its construction.[55] The ground plan, built up as a series of diamond shapes, is intentionally fish shaped, evoking the monogram *ichthus*.[56]

The interlocking roof-line of this multiple-roomed building undulates, replicating the skyline of the nearby hills beyond that are known as the Macedon Ranges. The material of the narthex roof is a Teflon-coated fibreglass fabric, and this tent-like shape and fabric recalls the dominant biblical metaphor for the meeting place of God and humankind, the tent, or tabernacle (see, for example, Exodus 40:34–end, Numbers 9:15–end), and one that has inspired much of Richard Giles's work and writing about the arrangement and ordering of the worshipping environment for God's pilgrim people.[57]

Returning to the Church of the Resurrection, we can see from the ground plan that the worshipping space radiates from the sanctuary where the altar is centrally placed directly opposite the font that is at the entrance to the nave from the narthex. A single east window is set in the highest interior point of the building complex. The dimensions provide a generous sense of spaciousness and this striking window by the distinguished Australian artist Leonard French (1928–2017) provides the backdrop behind the free-standing altar. This *dalle de verre* window (10.5 metres tall x 3 metres wide) is constructed with blocks of thick moulded glass made in France and Belgium and is set in epoxy resin. The resurrection-themed window, arranged in twenty-seven panels, has three registers. The lowest depicts the devasting fire in red flames and memorialises the five people who died in the fire. The second register depicts a suffering Christ hanging on the cross and wearing a crown of thorns, and above this the colours become lighter and the emergent green regrowth of the trees following the fire bears a radiant abstract Celtic-style cross representing the resurrection as God's re-creation.

Again, as the eye of the viewer is drawn from one open space to another in the interior paintings of Hammershøi, so the worshippers in this church are drawn from the gathering social space of the narthex into the worshipping

55 I am grateful to Greg Campbell, who served on the original rebuilding committee, for providing some of these details.

56 The Greek word literally means 'fish', but from ancient times it has been recognised as an anagram of 'Jesus Christ, Son of God, Saviour'. In a treatise on Baptism, Tertullian (c.160–c.225) spoke of the newly baptised as being 'little fish following Christ, our *icthus*', in the waters of baptism.

57 See his hugely popular and influential book: Giles (1997).

space of the nave by the ascending light of the resurrection window, and, as they do so, they pass on either side of the baptismal font. Remarkably this very contemporary church building sits well in the landscape and surrounding natural environment, and again we can see how the elements of light and space have been artfully combined in the interior of the building to celebrate the resurrection God who cannot be contained within time and space. And yet, as vividly shown by the configuration of worshippers in the nave and the subject of the towering east window, the triune God invoked and encountered in worship is one with suffering humanity and is present with the people as the transcendent in their midst.

This chapter has ranged broadly over church buildings of very different styles and epochs, and although there has been a focus on the architectural elements of light and volume, the sheer multiplicity of church buildings transcends any single design template, theological disposition, or aesthetic agenda, rendering a conclusion impossible as to what makes for transcendent architecture. We can, though, identify the signs of transcendence, and in the final analysis, what counts above all else is the experience of the person who crosses the threshold and whether what they come to see and to feel is a building that is, in the words of the poet, 'a serious house on serious earth'. However, at the beginning of this poem Philip Larkin indicates that he checked that nothing was going on in the building before entering. The poet recognises that the fittings and furniture in the building speak of the primary purpose for which the church was built, even if the knowledge of that purpose in a secular society was rapidly declining. Nevertheless, the font, the lectern and the altar-table speak of a place where the liturgy is celebrated, and perhaps that is a good reason why these items should have a solidity and a permanent place in the worshipping environment. For they speak of a building where the liturgy is celebrated, even when at other times the space is used for purposes other than worship. So, in the final analysis, what really counts in crossing the threshold is joining with others in the serious business of worship, and it is this that validates the building and makes the worshipping space a sacred space. But that is really the subject of another essay.

3

Shaping the Assembly: A Process of Formation in Faith

Thomas R. Whelan

It is common for US churches to make use of the services of a 'liturgy consultant'. These people, starting from an understanding of the best practice of the choreography of ritual, a sense of spaciousness and potential, and with a deep knowledge of liturgical theology, work creatively with a local assembly to ascertain how best to manipulate available space in order to serve their worship needs. The consultant will often be the person responsible for supplying the architect with a 'design brief'; larger projects often use a design team, of which the consultant is an important member. Working from the obvious principle – inexplicably not always honoured – that every liturgical building and space is different, they know that the worship of each assembly constitutes to some extent a unique gathering. There is no template that must be applied and adapted to every church building. The space that is being manipulated is *not* that of a church (as understood in common parlance), but one that will serve to create a home – an assembly hall – for the church community: a *domus ecclesiae*.

While a student at the Pontifical Institute of Liturgy in Rome, I had the privilege of studying liturgy and architecture with the great Italian architect Professor Eugenio Abruzzini, widely known for his more adventurous approach to design and the use of space. While I do not claim the title of being a liturgy consultant, I fell into providing such a service at an early stage of my work as a liturgical and sacramental theologian both in West Africa, where I worked for many years, as well as in Ireland. Insights I had gained from Eugenio Abruzzini proved to be an invaluable guide and supplied a clear sense of what a starting point might be. I carried insights gained from

this to many other projects relating to liturgy.

The Process

Abruzzini instilled in his students of liturgy the solemn requirement not to work in isolation from worshippers but to operate in dialogue with them: a space is being newly 'created' (or, in the case of a renovation, reconceived) in order to serve *their* worship needs rather than the fanciful desires of designers or architect. He was often called upon to build or radically re-cast summer houses of wealthy Romans in the hillsides. His preliminary meetings/'consultations' with them were not so as to propose a basic design, but to get to know them by inviting them as his guests to a meal in a restaurant of *their* choosing. He would try to pick up a sense of their character – of what made them tick – from the menu chosen, from the conversation, their manner of dress, something of their lifestyle preferences. Over a period of time, and after many meals and conversations on *their* chosen topics (theatre, music, literature, sport, business … and food), he would begin to acquire a sense in himself of how best to draft a possible initial design of a new home for his clients, something that would respond to their lifestyle, expectations and assumptions – and always working within the parameters of the physical terrain, space and finance available.

It was obvious from the very beginning that the only way to engage with any design project for liturgy was to understand the vital importance and necessary role of the assembly. While the general tendency among liturgy consultants is to work with the clergy, the architect and leading members of the parish community (often through a committee), experience suggested a different approach: an involvement with a voluntary and varying group of people from the parish. A direct engagement with those who would worship in a building was essential. They, and those who would follow in the years ahead, are the people whose worship space is being explored and designed. They needed to be actively at the centre of all decisions being made. The process used also ensured that there was a catechetical dimension whereby everybody got to learn of the role of the various elements of the space, not least the role of the assembly itself, the Table of Banquet and the Table of the Word, the place for baptism, and about other aspects of their worship.

The consultation took place over a period of time (in many cases up to a

year), as we discerned, together, how best to move towards a suitable design of a new worship space or for the refurbishment of an existing liturgical place. It was important that I be clear, both to myself and to others, as to what my task was: I am not a designer and would be completely incompetent working in that arena. While I had opinions, my design-preferences were not important and could not dictate. Rather it was imperative that the desires of the assembly, discerned over a period of time in a prayerful process, would find expression in the final shape of the worship area. The *design brief* would offer orientations to the architect and not supply the outline of a floor plan, this latter function falling within the competency of the architect. My job was simply to assist the assembly to frame a clear design brief that would then be handed over to the architect. Architects deeply appreciate a clear brief and it is their task to propose how best to give a physical form and shape to the design brief. Any agreement I entered into when being taken on to assist in the process would have included the stipulation that I remain part of the team advising the architect as the project developed.

The worktime engaged with the assembly normally extended to approximately one year (twelve months rather than the eight–nine-month school year), generally meeting for two hours a week. The group was 'open' in the sense that it had to be known that this was not a 'design committee', but a gathering of interested people from the parish community whose number might vary slightly week by week. The weekly guided discussion would often involve a broad array of opinion and a deep level of commitment from those present. Nobody could later complain that they were not invited to participate.

We would work in a systematic way, keeping away from discussions around 'where the altar should go' and other specifics. Rather, we held discussions on questions such as 'being a Christian community/church'; *why* worship; the function of the various pieces of furniture used in liturgy; and what they expect from the new building in terms of their Christian lives and mission. Each session would generally involve a twenty–thirty-minute input on a related topic followed by open discussion. The starting place for discussions was faith and an exploration as to how best this might be expressed in spatial terms, and how this is shaped in stone and wood. The fruits of a discussion would be summarised in rough copy and returned to the group the

following week to be tweaked slightly as we progressed, often recasting the gradually expanding 'design brief' as revisions were proposed in the light of subsequent discussions. In truth, these sessions are not unlike exercises in mystagogy whereby an assembly, familiar with general liturgical practices, is now called to reflect critically on these in the light of their own faith – and then in relation to their emergent needs. Ultimately, the exercise of creating/ re-creating a new worship space is to assist the assembly to articulate ever more fully its collective faith in the mystery of the crucified and risen Lord present and active in their midst.

A faith community relating to the world

At some stage in the process, it is important to help an assembly to discern how it sees itself in relation to the world around it as this will help shape the new building. Should it define itself in relation to contemporary society? Or as an entity that is innately part of the world around it, of which it is called to be a leaven? Or as a community that seeks its identity in contrast to and against the world around it? Is this building to be the *domus ecclesiae* – the house of the community of believers – an assembly hall that facilitates the church community to carry out its worshipful business? Or should it, like Gothic buildings of old, direct the minds and spirit of all who enter upwards towards 'heavenly things'? How a building relates to the streets-cape or broader landscape is part of an important public statement of how the local community might see itself in relation to the world. The building constitutes a statement that is constructed in stone and structure, normally unconsciously, but nonetheless one that becomes a proclamation made in the name of the Gospel. This will influence (and be influenced by) how it de-cides to use glass and windows. Do the windows of clear glass look out into the world, uniting the assembly with its wider environment and society? Or will this world be filtered through stained glass, allowing incoming natural light to permeate the space through colour and imagery?

The material used for the building, both internal and external, is vastly im-portant. The outlook of the local church community is reflected by whether the building blends with other neighbouring buildings or, by its use of brick, stone or other material, is designed to stand out prominently, almost as if a 'witness' to the Gospel. (Today, not to engage with architects who prioritise

eco-friendly buildings would be irresponsible. The use of environmentally sustainable material will include the appropriate use of solar energy and heat pumps.)

Architects, designers and artists can go on self-referential trips that exhibit brilliantly their own design, artistic and engineering skills – but that serve their own pride in their skills rather than an assembly's deeply embedded evangelical aspiration of how church might be situated in the world, negotiating with the world, serving the world, and exhibiting humility in its more public statements of self-understanding. Should a building speak loudly of the artistic and design capabilities of the architect and team, or should it be a clear uncluttered statement about God incarnate, who invites engagement with a reality that enhances encounter with Mystery, which grounds divinisation, while at all times exuding beauty in form?

Functioning worship space
Attention needs to be given to the need for participation in the liturgy. This relates to the oral, the aural and the visual. Given the non-negotiable importance of music in liturgy, attention must be given to ensuring that a good acoustic can be created by the design – one that does not rely on electronic amplification. The nature of a worship space necessitates that appropriate free movement is facilitated (while respecting the requirements of fire and other safety measures). The need for general access to the entire space by all worshippers needs to be stated clearly in a design brief as many architects may not themselves be regular participants in Christian worship and therefore might not be sensitive to the needs of the entire assembly.

Challenges brought to the design by auditory and visual aspects must be resolved but it cannot be forgotten that communication is not reliant solely on the audio (even if helped by a good amplification system) or on a suitable use of both natural and artificial lighting. Ensuring that appropriate sight lines are considered is important. Communication is an experience that is fully corporal and corporeal, and involves gestures and movement as well as the olfactory, tactile and other sensory dimensions intrinsic to all human interaction. It is estimated that no more than approximately 7 per cent of communication is verbal. Consequently, presiders and other ministers in public roles realise that over 90 per cent of communication is non-verbal

and this includes body language, posture, gestures, movement, proxemics (to the assembly and/or other ministers) and general deportment. The physical locations from which different ministers operate need to be so placed that a proper and more complete form of communication takes place. The effectiveness of non-verbal communication diminishes greatly after approximately 10 metres, and can become ineffective after a maximum of 19–25 metres. People make the great mistake of assuming that just because there is a good sound system that enables everybody to hear nothing else needs to be done. The olfactory is also important in liturgy. Worship spaces will respect the significance of the generous use of incense, with its biblical and anthropological referents, without compromising the need to accommodate the safety requirements relating to smoke detectors. The visual and sensory are vastly important parts of the communication system and serve, not just to *interpret* what is being said, but to greatly nuance and/or give added force to what has been communicated verbally.

However, to distinguish an area reserved for priest and ministers (forming part of a 'sacred area' shared with altar and ambo) through use of colour, floor design or floor surface can unhelpfully create a sense of clericalism. This happens when ministers are differentiated from the general assembly by means of a design pattern. The unintended statement here relates to the exercise of ritual power rather than service.

Important consideration must be given to the need for physical access of all to the central worship area. Apart from the general need to have easy ingress/exit to and from the building, attention needs to be given to the facilitation of all baptised members of the assembly who have a right to be able to accept the community's call to ministry. When there are physical hindrances (for example, steps) in the internal space people with certain mobility challenges must be facilitated to serve the assembly fully as readers, eucharistic ministers, leaders of music, ministers of welcome and animators. The element of free movement of the assembly, within the assembly, cannot be overlooked. Those who are hard of hearing need to feel fully involved in the work of the assembly.

The worship area
The entire main body of the interior of the building constitutes the worship

area. A number of observations need to be made here.

The first relates to what has traditionally been referred to as the 'sanctuary'. In the official liturgical books in Latin, the term used for this area is, in fact, '*presbyterium*' (translated in both Italian and Spanish as *presbiterio*). This is the area in which presbyters (ordained priests) gather and from which they function; hence its Latin name. The Roman preference is that the English term 'sanctuary' is used to translate this (it is *sanctuaire* in French). This is clearly a misnomer. A sanctuary is a holy place, set aside for sacred things. Since New Testament times, Christian understanding was clear that it was the presence of the baptised faithful that constituted a place or thing as 'holy' or 'sacred'. If we need to designate an area set aside for the sacred, then this is the space as created, defined and occupied by the baptised assembly, i.e. the 'worship area'.

Within this is an area towards which attention is drawn during liturgy, especially the eucharistic celebration. This does not require that some of the central furnishings, such as ambo and chair, need to be in the vicinity of the table of the Eucharist. It is often the case that architects and people who work on interior liturgical space do not understand the theological questions that the idea of 'sanctuary' introduces. In a project in which I was involved, the artist commissioned to work on interior elements for worship created a space for the tabernacle that was marked off by a physical structure that was of high artistic merit, but which spoke to an older, priest-centred, sense of a sacred space that is separated from laity. The community whose chapel it was had previously discussed their requirements and worked from a different sense of what might best serve. Artistic merit of new church design needs to be measured according to its theological appropriateness.

A theological desiderium and the consultant

In the creation of a new worship space, different from the renovation of an existing older building, there can be a palpable tension between function and theology. Every arrangement of space makes a theological statement – whether we are conscious of this or not. This cannot be 'the' theology out of which an architect or a liturgy consultant might work. It must somehow embody, as a theological *desideratum*, an understanding of what the assembly who will worship in this space seek. This will also serve to 'form' a theo-

logical frame of reference (normally unconscious) in the assemblies who will worship there over the years to come.

After many months of regular meetings, the group involved in preparing the initial brief for the architect will, without realising it, acquire a 'theological *desiderium*', a faith-vision of what they hope to achieve. The vigorous conversations, week on week, that might take place in this group must function as an indication of the design preferences of the assembly. The liturgy consultant cannot impose their opinions on the content of the discussion but must faithfully *serve* the needs of the group, bringing the best of current thinking to bear on this. Of course, this means that the liturgy consultant must be privy to some of the best architectural and liturgical design available in different parts of the world, but most especially in the region in which the new or renovated building will be located. This is not a task for the general practitioner. The liturgical principles embedded in the documents of the liturgy reform of the Second Vatican Council need to be interpreted and find expression in the new project,[1] and consideration might need to be given to incorporate expressions of forms of piety that will resonate strongly for a significant section of the assembly. The architect's and designer's jobs are to make sure that while these elements (which are of secondary or even tertiary importance in relation to the liturgy) do not dominate or interfere with the principal movements and liturgical action in the assembly but are nonetheless integrated in such a way as to continue to allow the central focus of worship to be unhindered while satisfying the legitimate needs of the community.

All of these are important but more difficult to hold in place when an older building is being renovated. The renovation possibilities will depend on whether this is a protected structure in law, as well as on the finance available

1 The work of revising IECL (1994) by the Bishops' Advisory Committee on Sacred Art and Architecture is ongoing. This revision and updating must take into consideration changes that have taken place over the past almost thirty years, not least new requirements to uphold regulations relating to the safeguarding of vulnerable people, as well as the Planning and Development Act, 2000 (as amended) of the then (Irish) Department of the Environment, Heritage and Local Government (now the Department of Housing, Local Government and Heritage). This later and central piece of legislation is accompanied by Architectural Heritage Protection for Places of Public Worship. 'Guidelines for Planning Authorities', published by the Department of Arts, Heritage and the Gaeltacht in October 2011, after a consultation of the four main churches on the island: Roman Catholic, Church of Ireland, Presbyterian Church in Ireland, and Methodist Church in Ireland. That excellent document, US Conference of Catholic Bishops (2000), is well worth consulting.

to enable the desired changes to be made following the consultation process. (Making changes to an older building will nearly always invite challenges from those who prefer that nothing would change. Hence the importance of a long process which permits those so interested to enter into structured discussion on the merits or otherwise of introducing significant alterations, especially if these changes are to be of a permanent nature.) It is a truism to say that when architecture and liturgy come into conflict, architecture always wins!

Some design issues
Architects and designers are often attracted to organising the worship space around a central axis. This can work well from many perspectives, not least the implied creation of a space suitable for inclusion and participation. In the majority of post-Conciliar churches in Ireland and the UK (both for new buildings as well as renovations), the presbyterium area (the so-called 'sanctuary') is retained. It now contains more than what might have been found there before the Council: altar, ambo, presider's chair, tabernacle and, often, a baptismal font (along with functional items such as a utility table and a book stand for the presider). Sometimes items of a tertiary nature, such as posters, wall hangings, flower displays, decorative icons and pictures, chairs and all sorts of peripheral artifacts, are also found. These are, frankly, a distraction. As a general rule, if the ambo or altar need banners, with or without citations or images from scripture or elsewhere, then there is either something lacking in catechesis or wrong with the artistic design of these central pieces of furnishing. All of this – concentrating everything of the liturgical action in the one small space – serves to reinforce a clericalist centre to the visual impact of the liturgy and ensures a *performative relationship* with the assembly (i.e. stage and audience), which, as a result, instinctively assumes a passive and generally silent role of those gathered, and clearly militates against a *participative relationship*.

To get away from this, some designs, possible when renovations are taking place for a somewhat reduced assembly, create a place for the 'table of the Word', around which the assembly sits – often with the presider sitting with them. The assembly later move to another related space to gather around the table of the banquet. The movement from one space to the other takes on

The chapel of the Redemptoristine
Monastery in Dublin.

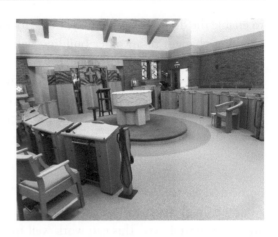

an element of 'procession', which can assume a significance. Other ways of
organising space (often dictated or influenced by available space) can include
placing the two tables in different articulations with the assembly seated
around the sides, or in a horseshoe shape. While a number of renovations (as
well as new spaces) might prefer to organise the entire worship space around
a central axis, this solution can be fraught with difficulties as architects, while
acknowledging the attraction and strength that such a design renders, do
not always appreciate the liturgico-theological problems caused by the axis.
One case in point is found in the otherwise superb renovation made to a
church outside of Dublin by a leading and innovative architect. The central
axis contains, in order, the tabernacle, chair, altar, ambo and organ console.
The presider's back is to the tabernacle – inappropriate no matter how ac-
customed we have become to this. Having the organ console as part of this
central axis gives it an undue prominence as a theological statement, as its
function is to support the all-important chant of the assembly during the
liturgy as well as to supply musical commentary at appropriate junctures in
the liturgy. It is of a totally different order to the sacramental action associat-
ed with the two tables. The wonderful architectural symmetry of the design
works against what ought to be a clear catechesis in liturgy.

One interesting example is that of the Redemptoristine Monastery in
Dublin,[2] where the seating of the assembly forms an oval shape around the
two tables which, together, form an axis.

2 See their website: rednuns.com.

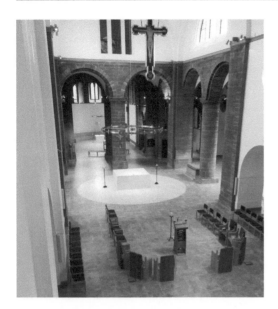

The church of the Community of the Resurrection in Mirfield.

The focus is clearly on eucharistic action and on the proclamation of God's Word from the scriptures. The monastic community meets six times a day to pray the Liturgy of the Hours, and the *lectio divina* is at the heart of their daily life. The presider's chair is not part of the axis but is placed to the side, associated with the assembly/community, as much of the liturgy of the day is led by a member of the community. This serves to shift the centre of attention during the Eucharist from the presider to the community as being, itself, the subject, in Christ, of the eucharistic action, and to the two tables around which the sacramental action is centred. (A similar idea is found in the Augustinian Church in Würzburg, pictured below.) The monastic assembly welcomes visitors to join them for the offices and Eucharist, but, as in the tradition of enclosed monasteries, the assembly takes its place in an area that is distinguished from that of the nuns by a different style of furnishing. A similar approach is found in the church of the monastic Community of the Resurrection in Mirfield, Yorkshire.[3] So much of their day is centred on Daily Prayer that this area becomes the natural centre for gathering with the altar commanding its own area. The same ambo is used for both the Hours and the Eucharist.

3 See their website: mirfield.org.uk.

The Augustinian Church in
Würzburg.

Sometimes the question arises as to the physical relationship of the ministers with the assembly. Roman documentation requires that the assembly can clearly see (and hear) the reader and presider. However, there is no requirement that these ministers be able to see the entire assembly, so it will often be the case where, depending on the position of people in one or other part of the assembly, ministers have their back to them. Similarly, the presider at the eucharistic table serves 'in the midst of' the assembly rather than assuming a *performative* stance in relation to them.

The all-important sense that the worship area belongs to the entire assembly is found in the Augustinian Church in Würzburg, Germany.[4]

This building was renovated in 2011 and has organised the two tables around a central axis, with the baptismal font (in the former 'sanctuary') forming part of this. While it is quite traditional to have the place for the baptismal bath in some significant location in the building, it is sometimes associated with the entrance to the church building, as in the Church of the Divine Word in Marley Grange, Dublin, which is served by the Servite Order.

Baptism is the entrance to the church community. As the remains of a de-

4 See their website: augustinerkirche-wuerzburg.de.

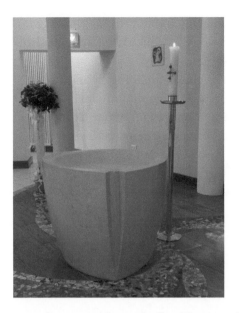

The baptismal font in the church building in Marley Grange, Dublin.

ceased person is brought for Christian funeral the coffin can be blessed with the baptismal water at the door. No explanation or commentary is required.

The renovation of the Würzburg building was guided by the theological understanding of the Church as a discipleship of a community of equals (their website cites Galatians 3:28). The division of the assembly into lay and clerical is minimised: there is no fixed chair for the presider who finds a place for himself in the front row of seats on either side. The flexible individual seating permits multiple articulations of space, as special events might require.

A process of formation

What has been described here is not inconsistent with aspirations expressed in the Apostolic Letter of Pope Francis on Liturgical Formation, *Desiderio Desideravi* (2022). In its long process of meetings and discussions leading to the creation of the design brief for the architect, the assembly will consider who it is as a faith-community and how best it wishes to articulate this faith in terms of its liturgical worship in a given space. In this sense the assembly *forms* the design in order that they and future generations may be *formed by* the design. All involved in 'shaping the assembly' must realise that every

element of the space – what is where, and why, and how the assembly (who, in Christ, constitute the subject of the liturgy by which they are nourished) functions in worship – screams 'theology'.

> The worship environment of our new church building should itself articulate something of our beliefs as a faith community as well as help us express and celebrate the deepest aspirations of our faith. We believe that the very design will either enhance our faith or work against it.[5]

This truth cannot ever be missed. The assembly is significantly formed in its Christian outlook by the space which it helped shape and in which it regularly worships.

5 This is taken from the Design Brief for Huntstown Church (p. 7).

4

Relational Churches of the Future: As the Tide Turns

Richard S. Vosko

'How can we be sure of anything the tide changes?'

That is what the American artist Rod McKuen wrote in one of his poems during the 1960s.[1] It was about the same time theologians and pastors were beginning to implement the teachings of the Second Vatican Council. Although McKuen was not even thinking of the Council, his poem, in hindsight, provided a premonition regarding today's religious climate in the US. Mainline religions in this country, as in other nations, are struggling today to stand firm against strong winds and turbulent seas. How will these storms affect church buildings?

The church tide turning

Rocked by clergy scandals, beguiled by politically partisan pastors, and dismayed by administrative corruption, every Christian denomination is experiencing dwindling numbers. Surveys report that both older and younger generations are searching elsewhere for spiritual sustenance or have stopped going to church altogether.[2] Many young adults reject the hardline stances of conservative clergy on a variety of cultural and ethical issues. They say they are not coming back.

One of the reasons major religions are not as effective as moral anchors in society has to do with perceptions about many clergy leaders as dishonest, divisive and secretive. More than one generation has asserted it simply does not trust patriarchal hierarchies. Rabbi Abraham Joshua Heschel, another

1 McKuen (1967), 27: 'Fourteen.'
2 See two studies: McCarty and Vitek (2017); and Barna Group (2014).

prescient voice, commented long ago on why people ignored the prophets in pre-Christian times: 'When religion speaks only in the name of authority and rules rather than the voice of compassion, its message becomes meaningless.'[3]

The ongoing departure of countless members from their religions, for whatever reason,[4] has another ramification: maintaining a church structure is costly. When revenue from the members drops administrators must decide if they can afford to keep their buildings. The alternatives include selling, merging or razing them.

To offset the problem, and to maintain a presence in the community, many congregations have already established relations with other faith groups to share property, programmes and personnel as a cost-effective strategy. This interreligious approach makes sense especially in terms of environmental sustainability. Sharing facilities will reduce waste, carbon footprints, and the cost of utilities. Other factors are also affecting church membership – the Covid-19 virus and the Internet.

The pandemic and technology

The global spread of Covid-19 and its variants has exacerbated the church exodus problem that started well before the pandemic. However, studies show there is no certainty about the long-term impact of the virus itself on church membership.[5] While many people have moved beyond the confines of organised religion, others continue to rely on their faith communities for sustenance, especially during unpredictable times.

The restraints caused by the pandemic have affected church members especially regarding worship. Not having access to the sacrament of the Eucharist and not being able to meet their friends in person has bothered many Catholics. Digital technology offered a palliative. Billions of people across the globe already use the Internet to connect with co-workers, family and friends, using social media platforms such as Facebook, TikTok, Instagram and Twitter. It would be an obvious way to stay connected to a congregation.

3 Heschel (1975).
4 Memberships in congregations are also affected by demographic shifts, retirement plans, employment opportunities or a desire to live in more temperate climates.
5 See Hartford Institute for Religion Research (2021).

During the pandemic many people linked up with old members and met new ones by means of Zoom, Google Meet, Skype and other communication applications. They prayed, shared spiritual insights, studied the Bible and participated in Sunday liturgy. Many parishes created their own websites or apps to live-stream liturgies. Others started using services such as Constant Contact, MailChimp and Klaviyo to keep in touch with members. Homilies were also posted on blogs and websites.[6]

It seemed, temporarily, that there was no need to be in a church building to associate with a congregation. Now, many are wondering if a more hybrid form of worship is 'the new normal'. It is also reasonable to ask if a structural place for worship will matter in the future? If the answer is 'yes', then physical and technological adaptations to the space will be required.

The factors that are challenging the definitions of what a congregation is and does will eventually alter the definition and function of a house of worship. We have learned from the pandemic that staying in touch with our families and friends and reaching out to those who need our help is a common human yearning. Research tells us that social media creates 'real' communities and that younger generations are living and working in that culture. Relationships, both virtual and real, are vitally important in every culture on earth.

Relational churches

This paper builds upon my recent publication on art and architecture for congregational worship.[7] In the last chapter of that book, 'A Vision for the Church Buildings of Tomorrow', I inferred that the Eucharist and social action are interdependent. I imagined that an interreligious centre for worship and community services could generate a new relational model of Church, where a spiritual cooperative would be home base for various ministerial functions. The doors would be wide open daily to all people, regardless of sex, gender, colour, education or income. It would be a meeting house built on interdependence. People would gather to support one another, celebrate life cycle events, worship and serve the needs of the community, especially those who have no food, clothing, housing or support systems.

6 See Collamati et al. (2016), 254.
7 Vosko (2019).

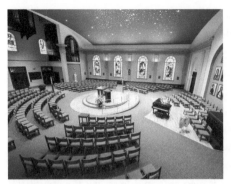

Reordered St Vincent de Paul Church, Albany, New York.

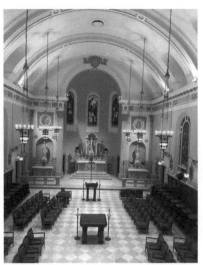

Reordered Butler Memorial Chapel, Religious of the Sacred Heart of Mary, Tarrytown, New York.

Reordered Floor Plan St Vincent de Paul Church, Albany, New York.

Churches, like synagogues, shrines and mosques, are symbols in society. They signal the presence of partnerships dedicated to making a difference in the community. The edifice itself reveals the identity of a cohort and the ways in which it advocates for peace and justice. It is in this sense that the building, especially the interior space, shapes the people into a united whole, sustained by their communion and their intention to serve others. These congregations understand that worship and social action are inseparable.

Although not often perceived as such, older and even newer Catholic church buildings, often open only on weekends, are not relational. Most interior layouts continue to divide the clergy and laity during liturgical actions, disclosing the embarrassing existence of a religious caste system. For centuries church buildings have focused on the clergy, who preach and administer

New Floor Plan St Theresa
Church, Little Egg Harbor,
New Jersey.

New Floor Plan St John the
Evangelist Church,
West Chester, Ohio.

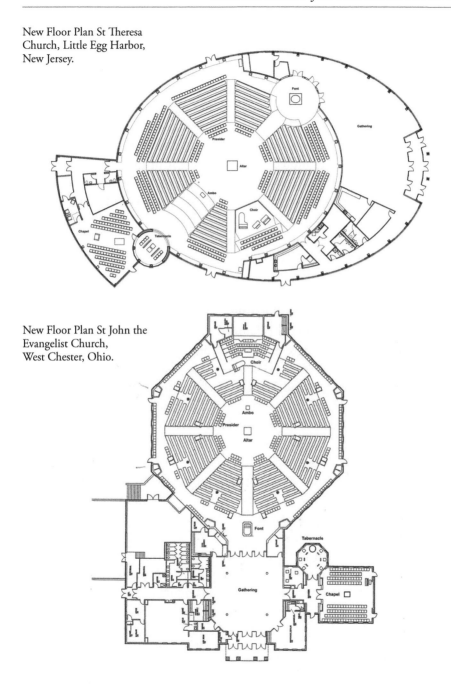

sacraments from lofty separated areas called sanctuaries or chancels (an old English word that means 'fence'). This architectural emphasis disjoins and eliminates the role of the entire assembly as performers of the sacrament.

On the other hand, an egalitarian house of worship does not compartmentalise the membership according to rank or privilege. The position of the altar table, a symbol of Christ, in the true centre of the space, establishes that all the members of the assembly, some with different roles, are gathered around the altar and are united in the enactment of their own eucharistic memorial. Catherine Vincie wrote: 'When we gaze at one another [across the altar], we are gazing at the Body of Christ.'[8] *SC* declared that liturgical services are not private functions and are performed by the entire mystical body of Christ, the head and its members.[9]

Before we go any further, let us look and consider these examples of relational liturgical spaces.

Post-Conciliar designs that still matter
Many changes occurred after the Council, but the most transformative one had to do with rearranging existing churches or building new ones to accommodate the updated liturgy. Chapter 7 of *SC* offered no specific details on the design of sacred art and furnishings. Later instructions for the correct implementation of *SC* offered more clarity. Episcopal conferences and local ordinaries soon issued their own guidelines to reflect regional customs and cultures.[10]

None of these directives mandated a certain style of architecture. The focus was always on the interior arrangement and furnishings necessary for the celebration of the Eucharist and other sacraments. What mattered most was that a place of worship be designed as a relational space that treated worshippers as celebrants, not spectators.

Today, many houses of worship feature spatial attributes that promote interdependence and a sense of belonging among members and visitors. Larger lobbies are used for greeting people. Baptismal fonts with 'living' water, now part of the main entry area to the church, accommodate Christian initi-

8 Vincie (2007), 144.
9 *SC*, nn. 7 and 26.
10 Two documents were published in the US: see US Conference of Catholic Bishops (1978); and replaced by US Conference of Catholic Bishops (2000).

ations by different methods. The Rite of Penance takes place in a chapel, not a closet. The tabernacle for reserving the Eucharist is conspicuous in an accessible chapel. However, more bishops are demanding that the tabernacle be returned to the altar area in full view of the congregation. This action is curious, since the reserved sacrament is not required for the celebration of the Eucharist.

The most enduring feature of contemporary church design is the location of essential liturgical furnishings. The altar table and the reading desk (ambo) occupy a more central area, with the assembly arranged around these furnishings. Presiders are taking a seat in the front row of the congregation rather than in a remote location. In cathedrals, the bishop's cathedra is a dignified chair that does not resemble a throne.

Devotional images, e.g. the communion of saints, are incorporated on the walls of the church.[11] There are fewer sumptuous displays of the decorative arts. Musical instruments and choirs, in acoustically tuned spaces, are part of the assembly. A mix of colourful art glass and clear windows emit more natural light, supplanting former dark interiors. Engineers are incorporating sustainable materials and energy-efficient measures in the designs. They are also integrating advanced digital technologies to support reliable links to social media platforms and to enhance the worship experience in the church. Various support spaces provide a friendly ambience, making members and visitors feel welcomed.

What the sources say

Although these relational components in church design are becoming more normative, the tide is turning again as a more traditional approach to liturgical practice takes root in some dioceses. In 2007, Benedict XVI sided with traditional voices and allowed the liberal use of the 1962 Roman Missal that pre-dated the Council. This permission split the Church into two liturgical camps.[12] History will document how the sacrament of unity divided the Church.[13]

In July 2021 Pope Francis curtailed the use of the 1962 Roman Missal,[14]

11 See Vosko (2019), 153–60.
12 Benedict XVI (2007).
13 See Vosko (2019), 22–9.
14 Francis (2021).

but the consequences of Pope Benedict's apostolic letter are apparent. Many bishops have authorised the use of traditional, non-relational architectural and artistic plans that are more suitable for the 1962 Latin Mass. It is as if the Second Vatican Council never happened.

The 2010 ICEL translation of the *GIRM* of the 2002 edition of the Roman Missal states that places of worship built or renovated prior to the promulgation of the 2002 *GIRM* were not affected by the new 'norms which are not retroactive'.[15] However, because local bishops have the final word on liturgical matters the interpretation of this instruction is subjective.

The debates surrounding the Catholic place of worship are usually about the style of architecture and the placement of the tabernacle. However, the most unresolved issue is the location of the altar table and the arrangement of the assembly around it. One theological school claims that the altar and the tabernacle belong in the east sanctuary to symbolise a new Jerusalem. The hierarchy presides over this symbolic location and protects its gateways. The other school of thought supports the altar as the symbol of Christ who is the high priest of every liturgy and who is present among God's people today. I agree that the altar table correctly belongs in the centre of the liturgical space with the congregation surrounding it. There are no boundaries to keep the mystical body of Christ away from the symbol of Christ.[16]

Two authoritative instructions are important. The 2010 ICEL translation of the 2002 *GIRM* reads: 'The altar should, moreover, be so placed as to be truly the centre towards which the attention of the whole congregation of the faithful naturally turns' (n. 299). Dominic Serra commented: 'This follows from the conviction that the altar is one of the chief manifestations of the presence of Christ in the midst of his church.'[17]

The Order of the Dedication of a Church and Altar, revised in 2018, reiterates the location of the altar table. The bishop prays: 'Here may your faithful, gathered around the table of the altar, celebrate the memorial of the Paschal Mystery and be refreshed by the banquet of Christ's Word and his body.'[18]

In the English language the words 'truly the centre' and 'gathered around' cannot be mistranslated. The word 'centre' is a point or part that is equally

15 Wedig and Vosko (2007), 352.
16 See Vosko (2019), 36–42.
17 Serra (2007), 127.
18 US Conference of Catholic Bishops (2018), ch. 2, nn. 62 and 56.

distant from all sides, ends or surfaces of something. The expression 'gathered around' means to surround someone or something.

An ecclesiology of relational liturgical spaces

In this article I have stressed that a relational environment for worship embraces all peoples. And, I noted there are factors like Covid-19, its variants and technology, that are affecting not only the way we worship but where we worship. Although the Internet and advancements in digital technology continue to shape the way we learn and work, the yearning to gather together in real places will not disappear.

That relational places of worship will unite communities and stir a new interreligious awakening is plausible, especially in a universal context. In one of her books, scientist and theologian Ilia Delio builds on the work of Teilhard de Chardin and acknowledges the unprecedented work of Pope Francis, *Laudato Si'*. Delio writes: 'We are not simply human beings; we are human interbeings and share in the interrelatedness of all cosmic life.'[19]

The human eco-system is not separate from divinely infused multiverses. It is one with them. The same elements and forms comprising the cosmos also exist here on earth in sea life, forests, bird's nests, weather systems and human features. These circular shapes are the most natural forms that we can use to design liturgical spaces. They connect us to everything and everyone else.[20] As Oglala Sioux Black Elk claimed, 'The power of the earth always works in circles.'

Liturgical rituals that occur within boundaryless concentric circles link human beings to one another and to a divine, creative and perpetual force. The Christ of the universe pervades everything and everyone, all the time. This interdependence heightens our responsibility to care for this planet and one another.

Our interdependence makes us mindful that no one of us is superior or dominant over others. All people, regardless of gender identity, sex, partnerships, colour, ethnicity, nationality and income, are equal. Relational places of worship are models of egalitarian sensitivity.

The same is true for religious institutions. Given the ongoing, unfolding

19 Delio (2021), 59.
20 I explore these fractal equations and spiral patterns in Vosko (2019), 145–52.

mystery of God, no one belief system can conclude definitively that it has all the answers. Looking beyond doctrinal borders that separate religions we do not surrender personal spiritual foundations or creeds. Rather, we embrace and absorb what other faith traditions and cultural systems offer us that might satisfy our spiritual hungers.

Inclusive interreligious places of worship designed to help underserved communities manifest a relational ecclesiology. They are coordinated expressions of the human family united in the search for a common ground in a fractured world. They are the churches of tomorrow, both really and virtually.

5

The Conference Room as Sacred Space

James G. Sabak OFM

We are shaped by space. Where we live, work and choose to spend our free time are all conditioned and guided by the role that space plays in shaping not only the decision to inhabit a locale, but also, and more importantly, what occurs or will occur in such a space. Space, therefore, can become a vehicle for a variety of experiences, which in turn shape the quality, vibrancy and direction of human life. Space is above all a liminal environment where the potential for acting in the realm of what might or what can be is activated.

Such a definition of space is no truer than of the space in which gathers the assembly that calls itself 'Church', and of what can and ought to occur to, in and for the assembly in that space. In the *Rite of Dedication of a Church and an Altar*, a powerfully moving and profoundly transformative ritual creates out of a collection of furniture, furnishings and spaces a 'House for the Church'. The rite consecrates and enacts the functions these material articles will serve in the daily worship practice of the community. The space and what constitutes it become instruments for experiencing the ever-present transformational encounter with God in and through the experience of one another.

And what of a space that does not experience a formal consecration as a site of liturgical assembly? Is such a worship space of a lesser degree? It functions in the same manner and yet is only temporary. How does this space become and behave as sacral? How is it liminal and how does it shape the assembly gathered within it? Therefore, it is important to define and interpret the way a space not formally designated as a sacred space can nonetheless provide for

an assembly at worship.

Space that is specifically and purposefully designated for liturgical activity – space that becomes 'a church' in the proper sense – serves and fosters the liturgical life of the community. Liturgical law and canon law dedicate the celebration of certain sacraments, like Marriage, to this specified space; but there is no restriction on the type of space for celebrations of the Eucharist, which is permitted in a variety of contexts. The fact that these places and contexts are not reserved solely to liturgical worship naturally expands the horizon of our understanding of sacred space. In our inquiry we discover that this expansion is really a retrieval of the ancient understanding of the use of space in which to enact Christian worship.

The often-quoted perspective of the third-century Christian apologist, Marcus Minucius Felix, that the defining characteristic of the Christian was the lack of specific temples or altars, as was the custom for the other religions of the Roman Empire,[1] shaped and freed the Christian understanding of sacred space. Felix echoed the earlier position of Clement of Alexandria (*c.*150–*c.*215 CE) who clarified, when speaking of the 'temple within Christianity', 'what I am calling a temple is not a building but a gathering of the elect'.[2] For both, Christians are the living stones of the new Temple, indwelt by the Holy Spirit. Early Christians may have gathered in buildings, yet while some of these might purposefully be built for worship, some were also borrowed for the occasion of liturgical celebration. Only after the Peace of Constantine does a building programme begin for structures purposefully dedicated as centres of Christian liturgical engagement. It can be said with a degree of certainty that for most of our early history as Christians the space in which we gathered was borrowed rather than designed purposefully for worship.

What made any space in which Christians gathered for worship sacred was what was engaged or enacted therein. The early Christian community utilised whatever space was available to conduct liturgical ritual, avoiding those places known for more notorious or scandalous affairs that did not correlate to the Christian Gospel. The embrace of the space of creation as a means for celebrating ritual gave support to the sacramental understanding of creation:

1 *Octavius*, 32.
2 Stromata, 7,5.

that all creation has the potential for revelation of God to us and of God's purposes for us.

A challenge to enacting the Eucharist in the early Church as well as today is the tension that exists between the limits within which human communication can adequately express itself and the reality of God within Godself. Faith does not always provide an easy or compact method for this communication, nor should it. 'Our human material tools can never fully envision or illustrate the communication of Godself, nevertheless they can serve as icons through which we may encounter the face of God.'[3]

Environment as facilitation of encounter

Environment becomes one of these material settings, which facilitates the encounter between God and human beings. This encounter begins with the space itself and how space – its shape and character – can affect and nurture the action of the assembly that takes place within it. It serves the principal means for this encounter and operates on a variety of levels, communicating the nature of liturgy and liturgy's role in the lives of believers. Environment is also shaped by the cultural context and circumstances of the time and age in which believers live. These serve to interpret the understanding of our relationship to and with the divine according to the influences that create culture. The result of this influence can mean that liturgical environment can either impede or foster what is meant to be experienced, achieved or accomplished by the liturgy celebrated in a particular space. Too grand a setting, which seeks to create some idea of the heavenly realm on earth, while beautiful and extraordinary, can severely hamper the immanent experience of 'God-with-us'. Alternatively, an environment that communicates nothing more than several individuals gathered in a particular open space can fail to enact liturgy as an encounter with the God who 'always walks with humanity on the journey of life'.[4]

Two contending notions

Two differing ideas contend today with communicating the purpose served

3 US Conference of Catholic Bishops (1978), 1–2.
4 The *Eucharistic Prayer for Various Needs and Occasions.*

by space and environment in Christian worship. The first idea describes sacred space as 'hospitable, it both invites and needs an assembly of people to complete it. It brings people close together so they see and hear the entire liturgical action and helps them feel involved and become involved. Sacred space works with liturgy and not against it.'[5] In this way space functions to enhance the desire of 'full, conscious and active participation' desired by *SC* of the Second Vatican Council. The sacredness of the space is implicitly derived from the sacred action of the faith community that uses the space.[6]

A second idea defines sacred space by the rites that are celebrated within it, and as a place to pray before the Blessed Sacrament or to pray various devotions.[7] This definition gives emphasis not to the assembly gathered and welcomed who enact the liturgical rites, but more to the rites themselves that take place within the space. It further accentuates a separation of space between the assembly and the ministers. In this way the sanctuary serves as a type of barrier between two different, but complementary, actions within the liturgy. A desire to prompt attention to adoration and reverence, at times thought lacking after the liturgical reforms, appears to motivate this approach to interpreting sacred space.

These two impressions of sacred space do not necessarily contradict each other, and both have the potential to provide appropriate settings for the celebration of the liturgy. Many churches are constructed with one or the other idea in mind. A problem arises when one becomes an absolute for the setting of the liturgy. The Congregation for Divine Worship's *Circular Letter on Concerts in Churches* states that: 'a church remains a sacred place, even when no liturgical celebration is taking place'.[8] The letter interprets the inherent sacredness of the space coming from its demarcation as a place removed from and set aside for a purpose outside the secular sphere. Sacredness is found in this place apart from other places, creating a preserve whose relationship to the rest of creation may seem tenuous and disparate. Such an opinion gives rise to the idea that churches are refuges from the world, mystical and supernatural spheres of location, which can offer protection and/or escape from the world.

5 US Conference of Catholic Bishops (1978), 24.
6 US Conference of Catholic Bishops (1978), 41.
7 US Conference of Catholic Bishops (2000), 46.
8 Congregation for Divine Worship, *Circular Letter on Concerts in Churches* (5 November 1987), 5.

This type of interpretation seems to work against an understanding of sacred space as a place where Christians 'gather to celebrate their faith and vision, what is most personally theirs and most nobly human. A place that gives witness to the great deeds of God throughout history and confirms again and again the covenant God has made with humankind. In such a place the Lord is encountered through the encounter of one another where the faithful make everything ready for Christ's return in glory.'[9]

Given this more dynamic understanding of sacred space, how might we broaden it further to include those spaces utilised for liturgical worship, which are not specifically consecrated for such purpose? Most notably among such spaces are convention centres, conference rooms or banquet halls. Gatherings of believers on a grand scale for a eucharistic congress, a general chapter of a religious community, an academic conference on religion or theology, or a diocese-wide event for a significant anniversary or celebration of the local community necessitate spaces larger than any church or any typical cathedral might provide. Planners and preparers of these events turn for a solution to the use of civic and non-religious spaces.

The choice of venues
The choice of these venues harkens back to the foundation of Christianity, which utilised any suitable space for a liturgical assembly. Homes and apartments functioned in this way during clandestine times, and public civic spaces were used as toleration for Christianity grew in the Roman Empire. Reiterating the perspective of Minucius Felix it was not the building itself that imparted sacrality, but rather the assembly and what was enacted therein that made the place sacred. The focus lay on the assembly and the enactment of memory, thanksgiving and hope undertaken by the body of believers. The space would have lent itself to a liminal experience, not because of any inherent power believed contained therein, but from the faithfulness of the believers gathered at the command of Christ. In essence, sacredness derived from the sacred action of the faith community that used the space.[10] It is only after the legalisation of Christianity and its rise to prominence within the empire that a particular style of building believed better suited to Chris-

9 US Conference of Catholic Bishops (1978), 107.
10 US Conference of Catholic Bishops (1978), 41

tianity's prestige and the performance of its rituals begins to evolve.

Still, what made the space sacred for a gathering of the faithful was not necessarily a series of complex rituals, as comes to be norm for dedication rites in the Middle Ages. In the early Church the celebration of the Eucharist in a particular place made that place sacred. There was no need for further elaboration.

The question arises, perhaps, if any thought was given to the perpetuation or preservation of an idea of sacrality in these spaces that were temporarily used for liturgical worship. Unlike the practice of some where a glass or cup used as a chalice for Eucharist is put aside, never to be used again because it contained the Precious Blood of Christ, this was not the case with space used for worship in the early Church. Temporary space employed for liturgy returned to its originally intended purpose once the liturgical rites concluded. One might return again and again to a place to celebrate Eucharist or another Christian ritual, but the place was never once and for all set apart as a 'sacred place'.

So, to return to the question of a conference room or a banquet hall serving as a locus for a liturgical event – how does use of such a space shape and challenge an idea of the sacred? Fundamentally, the choice of a place in the public's square as the setting for liturgy reveals a profound characteristic of Christian ritual, simplicity.

For example, on its most basic level, what is needed for a celebration of the Eucharist are bread and wine and the necessary texts for the liturgy. It is helpful to have a table of some type to serve as an altar; seating for the assembly; a lectern or reading desk for the proclamation of the readings; and reserved seating for the ministry like that for the assembly. All these can be found in or provided for in any setting in which the liturgy takes place. All the requisites for the space should convey that the place serves 'for praying and singing, for listening and speaking, for human interaction and active participation where mysteries of God are recalled and celebrated in human history'.[11]

This does not mean to say that beauty or creativity are absent or of little account. For aesthetic purposes one might embellish upon the space to create that sense of beauty appropriate to and reflective of the action to take

11 US Conference of Catholic Bishops (1978), 39.

place within the space. There is no need, however, to recreate a cathedral or basilica in a hotel conference room; nor should there be. The use of a public space calls to mind and affirms that space for liturgical worship is 'a shelter or skin for a liturgical action and does not have to look like anything else, past or present'.[12]

Still, attentiveness to the space chosen for liturgical worship and its appointments does matter. At a conference or convention, if the room chosen for the public business meeting and keynote addresses is of a certain size and shape, the room selected for worship ought to mirror and complement it.

Alternative venues: affirming the work of God

At a recent assembly of my religious community in a conference hotel there was a noticeable and frequently critiqued discrepancy between the room that held our general business meeting and the room for our communal worship. The business meeting room was arranged in a way to permit comfortable seating around tables with enough space for movement and places to get refreshments and beverages. Sufficient space existed between the doors inside the room and the beginning of the bank of tables and chairs to allow for gathering within the room without being intrusive on the work done at the tables. The facilities people of the hotel erected a large platform and staging area for the speakers complete with a podium, chairs and a table for multi-person discussion and presentation. Two large screens were also set up to allow for greater visual experience of the speakers as well as to allow for video presentations and the like. The room was adequately furnished to allow for a conducive meeting and to facilitate discussion and inquiry among the participations.

In contrast, the room marked for our communal prayer and worship was a third of the size of the meeting room. Whereas the assembly hall was proportionally large and square, the room for liturgy was narrow and more rectangular, with entrance to the room on one of the shorter sides. A platform and staging were set up on the longer wall opposite the entrance and chairs were placed in two sections of eight rows with a middle aisle separating the sections. Chairs were placed side by side, fifteen to a row, and spread out in front of the staging. Seating was not flush against either wall on the smaller

12 US Conference of Catholic Bishops (1978), 42.

sides, permitting two slender side aisles. There was little room between the staging and the first row of chairs, and similarly between the entrance and the general seating area. On the floor to the left of the platform an area was reserved for the choir, a piano and other instruments, all in a tight array. To the right of the platform was a pillared table, which would serve as a repository for a tabernacle, and a smaller lower table that would function as a credence table.

In all, the room was cramped and difficult to manoeuvre, both for any type of procession and, especially, for the distribution of Communion. Because of the seating arrangement many participants chose to stand in any open space they could find rather than make their way to a seat. The resulting crowding made it impossible for the ministry to use the middle aisle for procession and so approached the platform via the slender aisle on the right side of the room. The result was a clumsy procession that lacked whatever dignity one could muster in a hotel meeting room.

On the platform were chairs for the presider and attendants, a banquet table and a lectern provided by the hotel. Again, due to the shape and size of the room the platform was also narrow and the furnishing on it looked crowded. The table and lectern were dressed in cloths in a variety of colours. Candles were allowed, only two, and that was a rare permission in a public building. A processional cross was placed in a stand behind the altar. Floral arrangements and settings afforded the space some environmental elegance, but again made the area look tightly packed with too many elements.

Essentially, with the seating arranged as it was in long rows of several chairs the room was more fitting for a lecture or viewing a film than expressive of 'the invitation to journey, a journey involving recalling and practicing who the assembly is: the body of Christ'.[13] The assembly was focused solely upon the platform and the action occurring there to the exclusion of any sense of mutual engagement among the participants. The lack of creativity and imagination with defining this important space for the liturgical activity of my religious community at this conference communicated a dissonance between the value laid upon the business meeting at hand and the value of the prayer, which ought to have undergirded it.

The sacred nature of space is contingent upon the activity of the people

13 Mauch (1989), 6.

who occupy that space, however briefly. Conference rooms, banquet halls and lecture halls all possess the potential to become centres of the sacred in the ordinary and the everyday. They affirm the work of God through this potential and celebrate the sacramental nature of the daily and domestic in human life.[14]

At Hebrew Union College in New York City religion and academia are united in the chapel, which functions as both sacred space and lecture hall. The dual use of this space creates a liminal marker of transition, which enables two separate functions under the banner of a united purpose.[15] The use of a public space for liturgy should not be dismissed or minimised as merely a temporary or expedient decision because available 'sacred' space is too small or too inconvenient to be useful. Public space harkens the faithful back to a principal premise of Christianity – that 'every spot on earth is potentially sacred by what God has done there or history has done there, or our own artistic conversion of the ordinary into the holy'.[16] We use what is at hand in the celebration of liturgy to witness to the fact that there is no dichotomy between the secular and the sacred, between the temporal and the eternal, between heaven and earth. And if, as the *Sanctus* proclaims, 'heaven and earth are filled with [God's] glory', then use of the hotel meeting room or the concert hall for liturgical praise and worship is fitting evidence of that that truth.

14 Irwin (2002), 199.
15 Hoffmann (1991), 19–20.
16 Hoffmann (1991), 22.

6

Versus Populum: A Misnomer?

Paul F. Bradshaw

The early church

Influenced by Leonardo da Vinci's portrayal of the event, people often imagine that Jesus and his disciples would have sat along one side of a long table to eat the Last Supper. However, if they conformed to the cultural practices of their own times rather than those of the Renaissance, both at the Last Supper and at subsequent Christian eucharistic meals there very probably would have been no dining table at all. Instead, participants would have reclined on couches (see John 13:23–26) arranged around three sides of the room, with the host at one end, and food would have been served on a number of small tables placed nearby. It is true that sometimes a semi-circular couch around a central table was used for dining, but while this arrangement might have just about accommodated the participants at the Last Supper, it would not have sufficed for any larger groups of Christians. In communities that lacked a wealthy patron to provide such formal settings, meals would have been eaten sitting on the ground, as is still the practice of some in the Middle East.

Even the Greek word for table, '*trapeza*', does not mean primarily a common dining table, but any flat surface, usually with four legs. Moreover, in some of the instances where 'table' is used in English translations of the New Testament the word '*trapeza*' is not even present in the original Greek, but a verb for lying or reclining, e.g. '*anakeimai*', occurs instead (see Luke 24:30; John 12:2; 13:28). Similarly, expressions such as 'eat and drink at my table' (Luke 22:30) and 'share in the Lord's table' (1 Corinthians 10:21) do not refer literally to a single common dining table but metaphorically to the food provided to the diners, as also in Acts 6:2, 'to serve at tables', and 16:34, 'he

prepared a table'. Subsequently, *'trapeza'* became the most common term for the altar-table in Greek-speaking churches, either alone or with a qualifying adjective such as 'holy' or 'mystical'.

Thus, it would not have been until Christians began to replace their evening eucharistic meal with a morning assembly that things would have changed. Because of the lack of evidence we do not know exactly when this momentous development took place. There are signs that it might have happened first in Asia Minor early in the second century. On the other hand, it might not have been adopted in North Africa until towards the end of that century. Certainly, our earliest explicit witnesses to morning eucharistic gatherings emerge only in the third century. Justin Martyr's well-known account of a Eucharist at Rome in the middle of the second century is ambiguous. He could be describing a morning celebration, as is often supposed, but it might equally likely have been an evening meal, as bread would have been the principal – and sometimes the only – foodstuff at meals of the poor. Although the bread and wine are said to have been 'brought to the presider',[1] no details are given as to where precisely they were then placed, or where everyone else sat or stood.

We can safely assume that at morning Eucharists there must have been some kind of table upon which the food brought by the people was deposited, but it is not until Cyprian of Carthage in the middle of the third century starts to use the language of 'altar' in a more literal sense that we have confirmation of that. Even so, there is still no indication as to where the clergy and people might have stood in relation to it. On the other hand, we do know that early Christians faced eastwards when they prayed, whether in a communal setting or for their daily prayers at home,[2] and so it would be reasonable to assume that this was the direction in which they faced for eucharistic praying. Certainly, by the time we begin to get archaeological evidence for churches, the focal point of the building is commonly towards the east end. This is the case, for instance, in the assembly hall of the third-century church complex at Dura-Europos in Syria, the oldest extant archeological remains of a building adapted for Christian assemblies;[3] and in some later examples there is evidence of a bench for the clergy against the east wall, sometimes

1 Justin, *First Apology* 65.3; 67.5.
2 See, e.g., Origen, *De oratione* 32; Tertullian, *Apologeticum* 16.9–10.
3 See Peppard, 2016.

set into an apse there. This arrangement is supported by the late third-/early fourth-century Syrian church order, the *Didascalia Apostolorum*:

> The presbyters are to be seated in the eastern part of the house with the bishop, and then the laymen, and then the women, so that when you stand up to pray the leaders should stand first, and then the laymen and subsequently the women. For it is required that your prayers should be directed towards the east, as you know what is written: 'Give glory to God who rides upon the heaven of heavens, towards the east.'[4]

Although this quotation clearly indicates that the people should face east during the eucharistic prayer, it is not made clear that the clergy necessarily did the same.[5] Did they come round the altar-table to stand on its west side and face in the same direction as the people, or did they simply step forward to the table on its east side to pray? Although different individuals may favour one or other answer, there is no explicit testimony to settle the issue. We need also to recall that in certain places, particularly North Africa, the altar was placed, not towards the east end, but part of the way down the church building.[6] We ought not to assume that in these and other cases the people would have behaved like modern Western congregations and stood in neat rows all facing in the same direction. It seems more likely that they would have followed the custom of other times and places and simply surged forward to position themselves as close to the clergy and altar-table as possible, flooding down the sides and perhaps behind, as well as in front.[7] Nor would those at the sides and behind the altar-table have necessarily turned eastwards, and away from the altar-table, to face the wall during the prayers.

Furthermore, the fourth century onwards reveals examples of church buildings that were not oriented towards the east. One of the most famous of these is the Church of the Holy Sepulchre in Jerusalem. The principal entrance was from the street on the east end of the building and the apse was at the west end. It might be argued that the topography of the city forced this

4 *Didascalia Apostolorum* 2.57 (Stewart-Sykes, 175). The biblical quotation is from Psalm 68:33.
5 Even the apocryphal *Acts of Thomas* does not provide this detail. It tells of the Apostle ordering his deacon to prepare a table, and of them spreading a linen cloth on a bench or stool that they found there and setting bread on it, but it says only that the Apostle 'stood by' and prayed (Ch. 49) (Attridge, 2010, 53).
6 See Jensen (2015), 104–8.
7 Augustine certainly criticised his congregation for pushing and shoving and thronging the apse in order to get close to him and hear his sermon better: *Sermo Dolbeau 2*, 3.

layout or that it was done so that the assembly would face towards the tomb of Jesus that lay to the west of the church (though some scholars believe the church was erected before the discovery of the tomb[8]). However, this latter explanation could not have applied to those churches that face in directions other than eastwards, except perhaps for some of the earliest churches in the city of Rome, which appear to have imitated the orientation of the Jerusalem basilica.

It has been argued by some scholars that even in these churches the whole assembly, clergy and laity, would have turned east to pray, but that would have meant turning their backs on the altar and the bread and wine on it, which seems highly unlikely. In any case, even if the people continued to face west, where would the clergy have stood? Would they have come round the altar to stand in front of the people, also facing west, or would they have remained on the east side of the altar and faced the true east? We simply do not know. In the centuries that followed, facing east for the eucharistic prayer became normative for the clergy, although there were still some church buildings where to do so was not possible because of the presence of a tomb on the 'west' side of the altar, as at St Peter's in Rome. Thus, historical study alone is unable to settle the question as to which of the two positions was the earlier (if indeed there ever were a single standard practice, which is far from certain), and hence equally unable to settle the question as to which is the 'correct' position that those presiding at the Eucharist today should take.

Twentieth-century developments

The emergence of unofficial experiments in the early twentieth century with the altar moved away from the east wall of the building to allow the presider to stand behind it were part of the Liturgical Movement's attempt to foster active participation by congregations in the action of the Eucharist, along with such other developments as the dialogue Mass. In Germany the practice appears to have begun at the Abbey of Maria Laach in 1921, and from there it was taken up at all annual Catholic congresses in the country.[9]

8 See, e.g., Borgehammar (1991), 100–1.
9 Pecklers (1998), 6–7; for a fuller account, see Trapp (1940), 14–189.

Another leading proponent of this arrangement, particularly in youth ministry, was Romano Guardini (1865–1968). The result of his efforts was that it became quite widespread in German-speaking areas.[10]

Similar unofficial practices developed elsewhere in Europe and in the US.[11] In France and Belgium this repositioning of the altar and presider became the subject of much discussion, and later its adoption within the Worker Priests' Movement brought it to wider attention. Even Pope Pius XII, in his closing address to the Assisi Congress for Pastoral Liturgy in 1956, commented that 'the question of how the tabernacle could be placed on the altar without interfering with celebration facing the people admits of several different solutions'.[12]

It is to be noted that none of the liturgical pioneers introduced a free-standing altar with the presider positioned on its east side out of a desire to restore what was imagined to have been the practice in the early Church – that rationalising argument came much later. Its aim was to promote the active involvement of the laity in the liturgy, something that was difficult to achieve when all that was visible to them was the presider's back, and sometimes at a considerable distance from them. Nor were they defying any rules in making this change: although treating the presider facing east as the norm, the Tridentine Missal still preserved instructions for what to do when the architecture required the presider to face west across the altar. Indeed, in at least some of these experiments the traditional rubrics were so closely observed that the crucifix and six candles remained on the altar, thus limiting to some extent the laity's vision of the eucharistic action.[13] It was only after the Second Vatican Council that proper rubrical provision came to be made for this practice, and its use strongly encouraged.

The question of nomenclature

To describe the position of the presider in this changed arrangement as *versus populum*, 'turned towards the people', has a long history, but may not be the most appropriate or helpful way to name it. In the first place, it is literally true only in those, mainly older, buildings where the laity are all located

10 O'Donoghue (2017), 33.
11 See, e.g., van Doren (1931); and Lord (1931), 68–9.
12 *Assisi Papers* (1957), 223–36, at 234.
13 See, e.g., Ellard (1948), plate facing p. 173, depicting solemn high mass at the eighth National Liturgical Week, Portland, Oregon, 1947.

directly in front of the altar-table: in more modern settings the people are generally arranged on at least three sides of it, and so the presider is actually facing only some of them. Also, to anglophone ears, whatever its true derivation, the word *'versus'* carries the connotation of 'against' rather than 'towards'. Much more seriously, the Latin expression does not convey the true purpose of the arrangement of the presider within the assembly.

Joseph Ratzinger, later Pope Benedict XVI, criticised those descriptions of facing *ad orientem*, 'towards the East', as facing 'towards the altar', 'towards the holy of holies', 'towards the tabernacle', 'towards the wall', or 'turning your back on the people'.[14] He argued that there was 'only one inner direction of the Eucharist, namely from Christ in the Holy Spirit to the Father', and that 'priest and people were united in facing eastward; that is, a cosmic symbolism was drawn into the community celebration – a factor of considerable importance'.[15] Or, as Uwe Michael Lang has put it, all those expressions criticised by Pope Benedict miss 'the crucial point that the Mass is a common act of worship where priest and people together, representing the pilgrim Church, reach out for the transcendent God'.[16]

However, even the use of the expression *'ad orientem'* is not strictly accurate.[17] As we have seen, early Christians seem to have attached great importance to facing east when they prayed. Origen, for example, dealt with the hypothetical case of someone whose house opened on an attractive view in another direction, and insisted that even so, prayer must be made towards its east wall.[18] The importance of the geographical east continued to exercise some influence on the orientation of churches, and also on the direction of the bodies in Christian burial. However, from the fourth century onwards, as we have seen, not all church buildings conformed to this rule, but instead were oriented in other directions, a trend that became increasingly common as centuries passed by. Thus, in many cases what was faced in eucharistic worship was a symbolic east, or, as it came to be called, a 'liturgical' east, while in all other forms of prayer specific orientation was abandoned altogether. This contrasts with the practice of Jews and Muslims, where the geographical direction of Jerusalem and Mecca respectively remain absolute

14 Ratzinger (1986), 139–45, at 139 and 141–2; and Ratzinger (2000), 79.
15 Ratzinger (1986), 140.
16 Lang (2007), 91; his thoughts also appear in expanded form in Lang (2004).
17 On its origins in classical architecture, see O'Loughlin (2020).
18 Origen, *De oratione* 32.

The principal altar-table in
Maria Laach today.

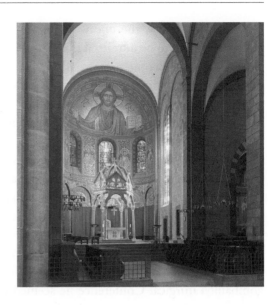

for prayer.

In a similar way, *versus populum* is not primarily about the presider facing the people nor the people facing the presider. The practice developed in modern times as part of the movement of liturgical renewal that wanted to unite presider and congregation more closely in the eucharistic action. Although Ratzinger believed that 'priest and people were united in facing eastward', that was not how it was experienced by many, and this led to the growing popularity of so-called *versus populum* celebrations in which presider and people experienced greater union when gathered all around the altar-table.

In this arrangement all participants – presider and people – are focused on the altar-table and what takes place on it. Ratzinger acknowledged that this position, which he called 'a dialogue relationship', expressed '*one* aspect of the Eucharist. But the danger is that it can make the congregation into a closed circle.'[19] This was presumably the reason why he stressed the 'cosmic' dimension of the *ad orientem* position, and why Lang spoke of it reaching out 'for the transcendent God'. However, if that is the case, then celebration *versus populum* may be described as symbolising the immanent Christ, the

19 Ratzinger (1986), 142 (italics in original); and Ratzinger (2000), 80.

Christ in our midst, the one who comes among us in the mystery of the Eucharist. It has to be admitted that this arrangement fails to make its point clearly when the people still remain a long distance from the altar-table, or when its physical dimensions constitute more of a barrier than a means of access to participation, and above all when the laity cannot – or sometimes will not – gather round it, but even these obstacles do not entirely negate its intended purpose.

It seems surprising that modern advocates of the *ad orientem* arrangement do not seem to regard the altar as the primary focus of eucharistic worship; indeed, as we have seen above, Ratzinger explicitly rejected the description of 'facing the altar'. Surely the altar-table is the heart of the eucharistic assembly, and the eucharistic action on it the direction in which presider and people face, in both the so-called *ad orientem* and *versus populum* arrangements. On the other hand, in Ratzinger's closing address to the 2001 Fontgombault Liturgical Conference he seemed to recognise something of this when he proposed, as a corrective for what he saw as the weakness of the *versus populum* position, the placing of a visible cross on the altar 'as a point of reference for *everyone*, for the priest and for the faithful, then we would have our east, because in the end the Crucified Christ is the Christian East'.[20]

While it is of course true that the cross is a primary symbol of Christ, during the celebration of the Eucharist it is the Christ present in the sacrament of the altar on whom hearts and minds should be fixed. Both liturgical articulations, *ad orientem* and *versus populum*, in spite of their unfortunate nomenclature, are really focused on this, or more precisely, as John Baldovin has said, 'Whatever the stance of the priest, both priest and people need to be oriented towards God in prayer.'[21] The two postures symbolically express a fundamental truth about the Christian God, who is both transcendent and immanent. They complement each other liturgically and theologically. Why then do they so often seem to evoke such bitterness between their proponents? The argument is not fundamentally about the historical primacy of one over the other: as in so many other liturgical disagreements, history is brought in simply to bolster positions adopted on quite different grounds. Nor is it merely about tradition versus perceived innovation, although it has

20 See Reid (2003), 151–2 (italics in original). See also Ratzinger (1986), 142 and 144.
21 Baldovin, (2008), 113.

to be acknowledged that this is an element in it. Nor again is it wholly about whether the symbolic expression of immanence should dominate over the symbolic expression of transcendence.

It is, however, about symbolism. As the Liturgical Movement developed in the Roman Catholic Church, one of its principal theological emphases was on the concept of the whole Church as the Mystical Body of Christ, which was symbolically expressed in greater active physical participation in the liturgy, including the more frequent reception of communion. Much more recently, in popular discourse even if not in official documents, this has led to a widespread vision of the Eucharist as Christ feeding communicants sacramentally from the eucharistic table, rather than the more traditional concept of the sacrifice of the Mass. Indeed, new altars are often designed with more obvious characteristics of tables. The consequence of all this has been that celebrations *versus populum* have come to be seen more as a symbolic expression of gathering around the Lord's table rather than it being viewed as a representation of the altar upon which Christ was sacrificed for us, which celebrations *ad orientem* have traditionally emphasised. While theologians may insist that it is both, disagreement over these two modes of liturgical expression is really a proxy for a debate about which is the primary nature of the Eucharist: is it altar or table, sacrifice or meal?

7

Convention, Perception and Interpretation in Shaping the Assembly

Bridget Nichols

In an article on audience perception of dramatised action on the early modern stage, Erika Lin uses *Love's Labour's Lost* to make a particular connection between the church and the theatre.[1] The focus of her attention is the play's – on the face of it improbable – garden scene. Here, three young men who have made a pact to give up worldly pursuits and lead a studious and semi-monastic existence make extravagant protestations about the young women with whom they have inconveniently fallen in love. Each believes he is alone at the time he speaks, since they enter the garden one by one, with a short interval between each arrival. Of course, only the first lover to appear in the garden is genuinely alone. With each addition, the supposed sole occupant hides to enjoy the spectacle of a friend's indiscretion. For the theatre audience, who can quite clearly see all three characters, the fun lies in simultaneously accepting the terms of the plot and knowing more than the protagonists themselves. There is no need for convincing hiding places to reinforce this double consciousness. In fact, the methods of concealment devised by producers often exploit the inadequacy of items like spindly trees, small bushes, flowerpots and garden benches in an exaggerated way to enhance the comedy.[2]

1 Lin (2011).
2 The Royal Shakespeare Company's 2015 production of *Love's Labour's Lost*, directed by Robin Lough and available on film, takes every advantage of these conventions. Lough gives the play a wartime setting, with the young men appearing as officers on leave at an English country house c. 1915.

Lin takes the relationship of audience, actors and plot a stage further to consider other experiences that might have equipped playgoers to interpret what they saw. Her proposal is that members of late Elizabethan and Stuart audiences who went to church regularly (either voluntarily or to comply with the law and avoid fines) were accustomed to making sense of actions occurring simultaneously, and of words that announced happenings only partly or not at all visible to the congregation. The consecration of the eucharistic elements, Lin suggests, is a splendid example, though the mystery of bread and wine becoming Christ present among worshippers demands more than the parameters of her argument allow. More compelling is her reading of the use of positions on stage to encode hierarchies in ways not dissimilar to the Church's placing of clergy and those with visible roles according to their status. Jacobean theatre choreography used not just the horizontal dimension, but also the vertical, for instance situating actors in upper galleries. The parallels take on an almost cosmic dimension when Lin introduces the religious drama – a form with a stake in both church and theatrical performance. The stage plans for passion plays produced in Lucerne and Donaueschingen in the late sixteenth century show a spiritual hierarchy: God appears at the top of the page, and Hell-mouth and the devils at the bottom.[3]

The question that might conceivably arise for a liturgically minded constituency is whether the relationship in Lin's argument is reversible. In other words, would frequent attenders at the theatre in the early modern period have been better interpreters of liturgical action because they had learned how to deal with complex plots and logically unconvincing, yet persuasive stage devices in the world of entertainment? Enticing though this enquiry might be, it quickly proves problematic. The business of assembling a body of evidence that represented the voices and experiences of those responsible for animating the liturgy and those lay people who attended services at this distance in time would be near impossible.[4] Any attempt to shift the investigation into church and theatre practices in the present would have to reckon with different conventions in both spheres, different patterns (or absence of any patterns) of churchgoing and cultural exposure, and a much wider range of media, some of them (especially film, video and television) requiring a

3 Lin (2011), 97–9.
4 The complex relationship between theatres and the scrupulously religious in one area of early modern London is glimpsed in Highley (2016).

different set of interpretative skills.

A more containable exploration might nevertheless draw on Lin's insights and treat public liturgy as a form with its own dramatic conventions and motifs. Ways of moving through a space to communicate solemnity, ceremonial dress to reinforce hierarchies, vessels and artefacts with a sacred function, and designated speaking parts in a script that is probably familiar to many of those present and, for some, even committed to memory, are still part of the experience of liturgical participation for Christians of all traditions. These claims need some qualification, though, lest it appear that a certain kind of ceremonial homogeneity is being assumed. Many worshipping communities, from megachurches to house churches, do not observe a formal liturgy. Their acts of worship take place without distinctive clothing, processional patterns, or a layout of space that has permanent features such as altars, pulpits, lecterns and fonts. These communities certainly do not lack conventions. The roles of music groups, periods called 'worship' and consisting of extended performances of 'curated' series of songs, provision for personal testimony and spontaneous prayer, and even the styles of informality in the dress of leaders bear inspection. Some of the principles that I will offer from rather traditional Anglican settings are capable of extension into other contexts.

What makes conventions of any kind apparent, is not their successful application, but their vulnerability to misapplication and misinterpretation. Here, I have benefited from the work of the ritual theorist Ronald Grimes. His critical response to a collection of ethnographic studies of 'ritual risk' raises a number of questions about what has also been called 'infelicity' or 'failure'.[5] He points out that not all rituals are inherently risky in the sense of posing danger to participants, nor is risk necessarily borne by all involved. There are, furthermore, different kinds of risk, ranging from embarrassment, to disruption, to failure to achieve an outcome, to real physical harm. Different risks can affect different participants in the same ritual. And there is an ever-present risk that ministers of rites and other participants will interpret what they have done in divergent ways – this is not necessarily a bad

5 Grimes (2016). Grimes refers to the work of J. L. Austin on speech acts that can be 'infelicitous' if they do not fulfil the criteria for valid performance. He himself has sometimes termed this phenomenon 'ritual failure', but acknowledges that both terms are provisional and not exhaustive. See Grimes (1988).

thing and can bring useful critical reflection. All of these considerations are relevant to reflection on the series of scenes that occupy the next part of this essay.

The episodes I describe were witnessed in the course of acts of worship that took place over a period of about twenty years (2010–21). More than half of them have been gathered from acts of worship in Anglican cathedrals, which happen to have been prominent in my own experience over that period. They have not been systematically collected as part of field research: it would be truer to say that they have been *recollected* in response to the questions just outlined. This exercise has offered the opportunity for juxtaposing events, but with the mutual illumination that can bring there is also the danger of authorial manipulation by a single observer who controls the retelling. A further weakness is that the accounts are only slightly supported by the voices of participants, and usually they were participating as leaders of the acts of worship. While notions of performers (those with visible roles) and audience (congregation) are now firmly discouraged in favour of the whole assembly as participants in liturgical action, a tension can arise between what those with defined ceremonial roles believe they are conveying, and what the rest of the assembly actually sees or apprehends.[6]

Scene 1: an episcopal retirement

The diocesan bishop was retiring. A farewell service took place in a packed cathedral one Saturday afternoon. After pronouncing the final blessing, the bishop handed the ornate silver pastoral staff belonging to the diocese to the dean, removed his cope, mitre and rochet, laid them on the altar, and stood before the congregation bareheaded and dressed simply in a cassock. While this extension to the formal ending of the liturgy had been agreed in advance and the logistics carefully worked out, it was not scripted in the order of service. The members of the assembly were tangibly affected by seeing their bishop giving up the ceremonial paraphernalia of office and facing them in this way. For a time, there was silence, broken only when chairs were brought into the space at the front of the nave and speeches and presentations of gifts began.

This visible laying down of episcopal power in the diocese worked as spec-

6 See Lathrop (2022).

tacle for several reasons. First of all, there was the unconventional and even shocking nature of what was happening. Habitual attenders at the installation of new canons or the admission of choristers were used to seeing people putting on additional garments to signify a change in status. They were not used to seeing people taking off clothes. For many of those present, contact with the bishop was most often a handshake at the cathedral or church door after a service – Christmas, Easter, a confirmation, or the institution of a new priest. They had a fixed image in their minds of someone perpetually dressed for an important liturgical event. For a short time, it seemed as if they were unable to find an appropriate reaction. The bishop, for his part, looked strangely exposed and vulnerable. Liturgies do not normally end like this (unless you count Maundy Thursday evening, and that is not an ending but a transition from one part of a three-day drama to the next).

The whole action could have misfired, for several reasons. Had the bishop been disliked and mistrusted, the outward signs of status being laid aside would not have carried conviction. Humility on the part of someone who was liked and respected, on the other hand, commanded credibility. Equally, this could not have been the absolute ending without leaving the assembly in a subdued and uncertain state. In fact, it lasted just long enough to convey what needed to be said about the limits of authority, the ownership of power and the consistency of personhood that continues when the visible trappings of office are removed. The warm speeches, presentations of gifts and flowers and applause that followed were framed in that larger realisation, and restored the emotional equilibrium required for a proper ending.

Scene 2: an innovation in the ordination of deacons

A subsequent episcopal occasion attempted a different dramatisation of humility and service. It was the day of the annual ordination of deacons, and both diocesan and suffragan bishops were present and robed in gold chasubles. Once the diocesan bishop had ordained all twelve candidates, they were ushered into a semicircle of chairs in front of the cathedral's nave altar for a new element in the service which was being encouraged by several bishops in other dioceses. From opposite ends of the semicircle, the two bishops, each attended by two servers carrying jugs, basins and towels, advanced to wash the deacons' feet. This time, what was intended to give visible expression to

103

the Johannine teaching on leadership and service (John 13:2–11) was subverted by the disequilibrium between barefooted deacons in black cassocks and white surplices and bishops with small but stately entourages. There was no verbal explanation of the footwashing for the assembly, and unless they were alert to the scriptural allusion and the larger association of footwashing with service, they would have found this action lengthy and unintelligible.

Many people who attend ordinations will do this once or twice in a lifetime. They come to support a person who is entering a new role in the service of the church and may not themselves be regular attenders at church services. Additional ceremonies apparently unrelated to the main business of praying and laying on of hands, especially in buildings so large that only those in the front rows can see anything at all, require extremely careful integration. If people with prominent and hierarchically defined roles in the action undergo an apparent change of role and status, and enter an interlude with different rules, that should be marked in a way that avoids didacticism. Anyone who has attended a Maundy Thursday footwashing will have observed the president negotiate the clumsiness of kneeling, moving a basin, drying feet and avoiding tripping over an alb or a cassock. Perhaps the same kind of awkward progress would have enabled those watching to hold the double knowledge that ordained ministry can exercise ceremonial and other kinds of authority and at the same time keep service at its heart.

At the staff debriefing a few days after the ordination, only the bishops were unable to understand where communication of a Christlike pattern of service to others had failed. It took almost a year of campaigning to ensure that the next time deacons were ordained, their feet were washed quietly and unostentatiously during the pre-ordination retreat.

Scene 3: hospitality and public safety invite gender stereotypes and caricature

Another ordination took place a few years later, at a point during the Covid-19 pandemic when communities could gather for worship in well-spaced, well-ventilated settings and receive the eucharistic elements, provided that wine was distributed in small individual cups and not from the common cup. Having ordained the candidates, the bishop moved aside to allow the priest acting as master of ceremonies to prepare the table before the

eucharistic prayer began. Shortly after this, a second priest appeared from a recess in the chancel, carrying a tray of small shot glasses. Liturgists have noted the capacity of parts of the liturgy that are essentially practical (like bringing up offerings and eucharistic elements) to become elaborate in their own right.[7] This purely functional interlude was elaborate for no discernible reason. If it conveyed a message, it was that a temporary measure for the safe administration of communion was fast developing its own ritual.

The unintentional references embedded in the interlude demand more attention. Both members of the clergy were robed in cassock and surplice, normally the least likely garb to attract attention. But here, gender played a determinative role. The priest carrying the tray happened to be a woman, and her black and white 'uniform', in combination with a tray that would not have looked out of place at a drinks party, conjured up an irreverent caricature of a parlour maid in a three-act farce or a costume drama. I would like to say that for the assembly, it was a case of seeing too much when a less cumbersome and distracting presentation, or better still, a strategically positioned table could have served the purpose. Without interviewing as many of the people present as possible, however, that remains speculation.

Scene 4: applying the symbolic imagination to the liturgical action

At the other extreme, it is possible to see too little. A new priest was to be instituted as rector of a rural parish with a very large medieval church. The building retained the stone structure of its chancel screen, and from there it was some distance to the high altar in the sanctuary, where the officiating bishop moved to give the final blessing. The assembly remained in the large nave on the other side of the screen. Only those nearby – the bishop, the bishop's chaplain, the new rector and the churchwardens – were able to see, tastefully arrayed on the altar, a large silver Elizabethan chalice, a loaf of bread and a tin of sardines. The churchwarden responsible for this arrangement had a men's outfitting business and was skilled at eye-catching window displays, but this wealth of symbol was entirely lost on the congregation, who could see nothing. Those who had time to identify the sardines before the procession moved out of the chancel were astonished and then gently amused to find the household store cupboard in an incongruous setting.

7 Stevenson (1991).

Yet this brief scene deserves a second reflection before being patronisingly dismissed as the country church's misunderstanding of symbol. The intention behind the presentation of eucharistically significant objects was both good and theologically sophisticated. It understood that the whole human sensory apparatus has a part to play in the liturgy, and it saw a range of reference in eucharistic practice that stretched beyond the Last Supper narratives of the Synoptic Gospels and 1 Corinthians 11 to the feeding miracles, and especially John 6. Admittedly, it would have been difficult to move a whole assembly from the nave into the chancel for the final blessing. Even with movement, making the sardine tin visible to all and allowing it to find its own dignity alongside the chalice and the loaf would have presented a further ritual challenge. Perhaps this is an instance where conventions of good taste needed to be confronted in example and discussion, and even in preaching. The age of food banks and worldwide food shortages has a claim on liturgical practice, which in most places has still to be recognised.

Scene 5: liturgical accidents and the usefulness of convention

So far, the examples from practice have drawn on events that do not occur frequently in the experience of people who go to church. While they might happen more regularly in the programmes of church leaders, they belong in the category of special occasions. That does not necessarily make the impact of what they can reveal irrelevant to the rhythm of ordinary Sunday or weekday attendance at acts of worship. Well-judged and well-integrated innovations, careful use of symbolic elements in configuring space, and economy of movement to avoid distraction are important in any setting. The difference is the size of the canvas.

A final illustration draws on a Lenten evening Eucharist with a small number of people seated around a nave altar. All was proceeding according to the expected order, until the presider dropped the priest's host while preparing the table. This largely escaped the notice of the assembly, except for one or two people, including the priest's husband. His face became rigid with anxiety and remained so until the penultimate paragraph of the Eucharistic Prayer. At this point, the priest genuflected according to custom, gracefully retrieved the wafer, and elevated it with the cup as the Great Amen was said.[8]

8 For other examples see Nichols (2013).

Ritual action is open to accidents and mistakes, but it can also provide camouflage. By maintaining familiar speech rhythms, using the words and gestures associated with particular events, and avoiding unexpected or ostentatious movements, or even using a familiar and conventional movement in order to do something unusual, presiders and others with assigned roles can control their own panic or that of others, and ensure that the action remains focused and coherent.

Conclusion

In his reply to the ethnographers who invited him to respond critically to their approaches to Christian ritual, Ronald Grimes took issue with their emphasis on 'ritual risk' or 'risk in ritual'. Perhaps what Grimes was really warning against was too narrow a focus on success or failure in evaluating rituals. Working with the evidence provided by the ethnographers, he demonstrated how a ritual can be satisfying and effective for one participant, yet 'fail' for another person participating in the same ritual. While he does not rule out risk as a fruitful line of enquiry and looks forward to its methodological development, he chooses to keep the field more open.

It is in the light of Grimes's reservations that I retrace the examples considered in this essay. The first illustration drew on an additional element inserted into a fairly standard order of service, which unpicked the external trappings of ecclesiastical position as part of the symbolic laying down of office at retirement. The reactions of the members of the assembly indicated that the whole liturgical action had achieved what it set out to communicate. Part of this depended on well-designed choreography, but there were other factors – chiefly existing attitudes to the person who was retiring – that determined what might be called the success of the rite.

Was it fair to contrast this with an attempt to model episcopal humility that turned unintentionally into a display of pomp? The juxtaposition would certainly be invidious if it were implying judgements of popularity or credibility of bishops, but its interests are precisely not in the personal. Here is a case where the central element of the liturgy – the ordination, with its focus on those to be made deacon – became displaced by pageantry so as to appear to be about the bishops. Accounting non-pedantically for what was happening and matching this to an appropriately simple visual presentation could

have brought something moving and eloquent into being.

Two further examples reflected on what should and should not be seen as part of creating the environment of the liturgy. In the first, an action with a purely practical function could have been performed inconspicuously. Instead, it came near to being a caricature both of emergency measures for administering holy communion under pandemic conditions and of women's ministry. In the second, we saw an opportunity wasted. A potentially eloquent array of eucharistic symbols, which would have been appropriate as part of welcoming a new priest, remained invisible to all but a very few of those present. The flaw was not in the intention, but in the understanding of space, visibility and corporate access to the texture of meaning in liturgy. Even the unusual presence of the tin of sardines, which seemed comical at the time, could have been developed powerfully within a different choreography to address the Church's responsibility in the face of widespread poverty.

Finally, we considered the role of convention in containing the accidental or unplanned. A eucharistic presider kept a cool head and continued the Eucharistic Prayer to the point where she would ordinarily have genuflected, using this moment to retrieve the priest's wafer dropped earlier. Nothing changed outwardly. The pattern of actions that always prevailed provided its own corrective. An interested observer might ask, though, what could have been done had circumstances been much less formal and not dependent on recognisable patterns and actions. Would the priest have paused, explained that she had dropped a significant item, picked it up and continued? And would this have been greeted with a combination of shuffling and suppressed laughter, or would other conventions have presented themselves as restorers of normal order?

Grimes encourages the group of scholars whose work he reviews to refine the methodological implications of ritual risk. But, above all else, he urges them to strive for a more animated description of the rituals they observe, and to provide a thicker narrative based on as much indigenous evidence from all participants as can be gathered. In addition, he recommends greater boldness on the part of the ethnographers in voicing their own disagreements and in commenting analytically on the events they study.[9] The de-

9 Grimes (2016).

scriptions and reflections offered in this essay are, I am well aware, no substitute for the sort of well-designed series of interviews that could conceivably have followed each of the events described. A research programme of this kind would have investigated a wider range of acts of worship in a broader selection of settings. It would have collected evidence from those leading worship, those with visible roles, and those participating as members of the assembly. It would also have drawn systematically on the knowledge and experience that assemblies may not know they possess.[10] For instance, both the first and the second scenes described carry resonances of Maundy Thursday. How might latent understanding of the stripping of the altar and hasty removal of vestments at the end of evening liturgy, or the footwashing in the context of a reading of John 13 have been brought into critical conversation with liturgically different events?

Seen in this light, shaping the assembly becomes, first of all, an act of attention. Consultation is now acknowledged good practice when churches are re-ordered, but seriously reflective reviews of the liturgy that go beyond pro forma worship audits or the liturgy planning team's assessment of what went well, and involve a whole community, are uncommon. Discussion of what people did and didn't understand or make sense of, together with openness to the observation of mistakes and discordant alignments of action and intention, could profitably become a part of the life of any assembly. This would not be helpful if treated as a theatrical review or a marking of the clergy's performance. It could only build up the life of the community as something owned by all and acknowledged as part of a work in progress. Not all action requires the whole assembly, yet all action must ultimately be in the interests of the whole assembly.

10 See Astley (1992).

8

The Process of Shaping Space in One Community

Judith Courtney and Peter Murphy

The prospect of designing a church and bringing the design to fruition is a fraught one. People are eager. The sense of something new, perhaps exciting, generates enthusiasm. Limitations of the present situation can be keenly felt and the opportunity of doing something about it is welcomed with optimism. But gathering people on the same page, with a shared vision, is much more difficult.

It is appropriate to mention at the start, in case one thinks this text might provide a silver bullet for community cohesion in the design and building of a new church, that this story is unfinished, the church unbuilt, the process, nevertheless, valid.

Our parish, St Mary's, in Papakura, Auckland, was established in 1927. A church was built in 1954. It had a small foyer opening into the body of the church with an aisle down the centre and the sanctuary marked off by altar rails, the altar against the wall. A familiar pre-Second Vatican Council shape, conventional for its time.

An increasing population meant the church had to be extended in 1959. An addition, running the length of the church, was added on the west side of the existing building, to provide seating for the growing numbers.

If one imagines a bus, this church was similar. One entered at the back, took a seat on either side of the aisle, the priest at the front, 'driving'. The newly added side was much like a pillion seat looking towards the front of the bus and, from there, people had a limited view of the 'action' in the sanctuary. This was the shape of our parish church when the Second Vatican Council, with its deep theological discernment and reflection, began in

111

1962.

In the 1970s the parish was blessed with a priest who undertook his own rigorous study of Vatican documents. This rigour spilled over into the Liturgy Committee of the day. As well as developing a strong interest in liturgy, it was a bonus that some members of this committee had deep artistic appreciation.

Together, realising the inadequacy of the space they had, they prepared for change, which they knew they would need to approach slowly and perhaps in stages. The eventual plan was to move the sanctuary from the north end of the church to the centre of the eastern side and raise it two steps above the floor level on which the assembly stood and sat. The tabernacle would be placed to the left side of the sanctuary and the organ console to the right. The shape of the church, a long rectangle with its addition on the side, lent itself to this change. Effectively, everyone turned 90 degrees clockwise. Those seated in the addition (pillion) were now included and could see the sanctuary, except for four pillars that held up the extension, and which still remained obstacles to lines of sight!

Initially, the change caused deep divisions. Eventually, however, with continued education, formation and hands-on experience, people came to see that this design encouraged their active involvement. It was as though people had to experience change before they could appreciate it. This reoriented church could seat 320 people.

By the 2010s, forty years on from that modification, the city had more than doubled in size, many new migrants were coming into the district and numbers attending Mass were increasing again. Once more, we were faced with the need for a bigger church. Should we demolish or expand the current building, and how should we go about it?

It is useful to compare the two periods when these liturgical changes were considered. In the 1970s we were in a period of some excitement, in the throes of implementing the changes of the Second Vatican Council. Altars were brought out from the wall almost immediately or, in cases where they were immovable, a second altar was placed in the sanctuary closer to the people. Altar rails were removed. People began to receive Communion standing. The rationale behind the changes that was often given to people was, 'This is required by Vatican II.' Little more seemed necessary.

Parishes approached the changes differently. Levels of reflection varied and change, perhaps, outstripped understanding. The approach was frequently top down, led by the parish priest. This was a time when those who filled the pews still thought the Church, with its hierarchical structure, could do no wrong. Furthermore, those in positions of authority in society, and similarly in the Church, were generally trusted and respected and, those with extensive expertise, knowledge or skill were celebrated.

Forty years on, initial arguments for change no longer had any force. There had been years of stagnation, and little guidance or direction from within the Church's leadership. The 'reform of the reform' movement had gained momentum, attempting to rectify 'abuses' from the earlier creative period. Liturgical statements from Rome emphasised the separation of roles of the priest and the people. The energy and excitement created by the Vatican Council had dissipated. The New Zealand-European proportion of the congregation was thinning out. New migrants, whose spiritualities were deeply devotional, were becoming part of the community, which was swelling to much larger proportions. We had three Sunday Masses, each of which, at times, spilled out onto the footpath.

In our situation, the size of the church became the central concern, not the need to redesign the liturgical space, as happened earlier. The impetus came from the community, but it was a community motivated to meet physical needs without having developed a sensitivity to the demands of liturgical space, without an appreciation of the need to acquire an understanding of liturgy and the demands of liturgy on the space.

Where could a process of change start now? It seemed important to ground ourselves in liturgical principles. We needed to go back to first principles, the theology behind the reform and restoration sought by the Vatican council. The Australian Catholic Bishops had just published *And When Churches Are to be Built*.[1] This document collected in one place documents and texts relating to church design and architecture. It placed relevant quotes together under numerous given headings, for example: Gathering Place, Outdoor Liturgical Space, Place for the Assembly, … Ambo … .

But there were dilemmas to be faced. The twentieth century was one of unprecedented change, fuelled by an explosion of scientific knowledge, the

1 Australian Catholic Bishops' Conference (2014).

rate of which has increased in the twenty-first century. People crave certainty, but certainty is evasive in times of change. Abstract ideas generated in the world of academia, whether those ideas relate to science or liturgy, can for some people seem inaccessible and untrustworthy. It is difficult to be certain about things one doesn't understand. Trust is not easily won. Whereas once, what knowledge society had accumulated was known by a significant portion of the population, now we have thousands of experts who know vast amounts about their own sometimes minute fields, which means that most people know very little about most fields of knowledge or expertise. This applies to liturgy as well as to every other field of knowledge. In our situation, people did not necessarily have the will to consider, explore or trust sources of knowledge available to us.

To function as a society or as a Church, trust is necessary. This is not to deny the validity of personal experience, but it is to say, unreflected personal experience is not sufficient. Personal experience needs to be informed by wisdom and knowledge. How do we prepare ourselves to listen to the voices of those who bear the heavy burden of knowledge, even liturgical knowledge? So difficult to do, especially in the current climate when, in the Church, layer upon sexual abuse layer of scandal has been unearthed. It is no wonder people prefer to cling to the infallible religion they learnt as children: a religion that doesn't change, that sees the priest at the front saying Mass, the rest of us watching respectfully. A rose-tinted perfect past is so much more reassuring than the shifting sands of new meaning.

Further to this, people of faith arrive in their pews from different starting positions. For some, faith is about holding fast to an unchanging truth. It's about watching the important action taking place on the altar, adoring and receiving the precious body of Jesus.

For others, faith is a journey that involves learning, relearning, taking on new information and being shaped by the times as well as by the Gospel. It involves gathering as a community to pray, and, in communion, becoming a sacramental sign that we are the Body of Christ, disciples sent into a needy world.

While for some, a journey into Church documents might shine light on new vistas of understanding, for others, they received a faith early in life that they trust, which has shaped them and which letting go of could only be

seen and experienced as failure.

Adding further complication is our saturation in a consumer society. In a generation, perhaps two, we in Western society have become the most rampant consumers the planet has ever known. Wardrobes overflow with clothes that are seldom used, pantries bulge with food that is tossed when use-by dates pass, and new trends lead to continual updates in home entertainment, technology and white ware. Our consumption is much less about what we need than it is about what makes us feel good. Our consuming is so much about getting things or activities that please, satisfy or make us feel good. The long tendrils of consumerism can too easily wrap themselves around our Sunday liturgy, making it too a commodity that we expect will please, satisfy, or simply make us feel good. Not uncommonly, people talk about the success of a Mass in terms of whether or not they liked it. The appearance during the pandemic of drive-by Eucharist and watch-it-online liturgies has unwittingly strengthened this notion that Eucharist is a commodity that gives you something, a product you get, something to be watched, a spectator opportunity. The Vatican Council's rich notion of participation does not find a comfortable home in a strongly consumerist society.

This mindset spills over into the way we design a church. A church in which people come to 'do' Eucharist will look very different from a church in which people come to 'get' Eucharist. When these two mindsets are present in the same room, it is difficult to find common ground from which to begin a conversation.

New churches in our diocese had been built since the Second Vatican Council but they tended to follow a pre-conciliar pattern, with a large place for the assembly who looked straight forward towards the sanctuary. Some churches had made the bold move to create a Blessed Sacrament Chapel, though it was not always well positioned and there later came a pushback to return the tabernacle behind the altar to 'where it really belonged!' Despite sixty years having passed since the beginning of the Council, in the minds of many, the 'adoring-Jesus-in-the-tabernacle' theology still prevailed more strongly than the 'participating-eating-drinking-becoming-in-dwelt-by-Christ' theology.

For us, the challenge was to bring these different views into the same room, open the possibility of a journey together and create enthusiasm for the project. Our task was to develop a plan for the development of our site, which

could take shape in stages and over several years, though it was important that the plan should have a sense of coherence, which the existing arrangement of buildings and offices did not have.

Our congregational singing was good and a sense of celebration prevailed in our Sunday Eucharist. Those who read took their ministry seriously. Extraordinary ministers of Holy Communion, who may at first have felt a great sense of unworthiness, accepted their role and took it seriously. The parish had a lively St Vincent de Paul group, an active food bank, a strong ecumenical relationship with churches of other denominations in the area and a commitment to environmental care which had taken shape over many years.

Our planning, or pre-planning, began over a two-to-three-year period, when regular meetings were held fortnightly or monthly. These were open to all and, though all viewpoints were welcomed, we focused our attention on the contents of the book, *And When Churches are to be Built*, with its collation and organisation of all relevant documents. It gave us a common ground from which discussion could start. Each meeting focused on studying a section under one of the given headings of the book. While this tested the patience of the practical minded (who already had a blueprint of what a Church should look like, and who thought perhaps we should just get on with it), there was growth in our collective understanding of liturgy and liturgical principles, especially among those who attended regularly. For the most part, there was no sense of urgency: people were walking the walk.

The opportunity of exploring Church documents, asking questions, and having conversations about them was fruitful on many levels. There were signs that a consciousness of participation was more deeply appreciated, that our gathering as one was significant, that gaining a sense of mission was pertinent and that trust in Church teaching was rekindled.

As this process continued, feedback was given to the parish via a blog that was set up. Meetings continued with an 'all welcome' approach. When we completed our study of the book *And When Churches are to be Built*, a substantial booklet reflecting and summarising our thoughts was compiled and distributed widely within the parish. Further comments and feedback from people were invited and welcomed. All feedback was collated and included in a second draft of that booklet.

From this, a more specific architectural brief was developed. Architects

were interviewed, one selected, the brief handed over and a concept for the development of the site was prepared.

It was important to gather all feedback and to ensure that this feedback was reflected in the booklet that we handed to the architect. Though it was clear that there were extremely different understandings and theologies present in our community, it seemed important to work with all of that, not to leave anything or anyone out. If we did, we could easily become a divided community with some thinking they had a correct view of church design, leaving others to feel that they had not been heard or listened to. Listening to all and maintaining some sense of unity was paramount.

The concept plan delivered to us by the architect was met with delight by most people. There were, however, two sticking points that remained major obstacles. One was the placement of the tabernacle within the church. The other was the way in which the seats were to be organised. It was notable that those who had done the work of studying the documents were prepared to be more creative than those who had not.

One variation to the architect's plan that was considered was a circular arrangement of seats, the community standing or sitting around the altar/table, the purpose being to strengthen a sense of gathering and participation. In this arrangement, some people would end up standing behind the celebrant and this, for many, even some who had been part of the process from the beginning, was a bridge too far. The idea of standing behind the presiding celebrant was not acceptable. In people's minds, the place of the priest/celebrant was dominant and people thought everyone should be able to look at the celebrant, front on.

It was difficult to encourage people to be positive about creative options when they had experienced only conventional liturgical space. They needed an opportunity to experience something different before having to commit to it. A way of dealing with this was to propose a moveable 'sanctuary', able to be modified as the community's liturgical understanding developed. Growth in active participation and inclusivity is an evolving scenario and remains fluid. People need opportunity to develop understanding.

The process up to this point had fostered wide consultation and it was seen as important that this should continue. We were wary of making a decision, coming down in favour of one point of view or another, and felt it wiser to

work towards a consensus position on those remaining obstacles.

It then became about finding wriggle room. How could we create a little flexibility? Were there new ideas, possibilities we hadn't yet identified? Ongoing conversation helped us to give a little here and adjust a little there. In doing this, trust grew as people saw their voice had an impact, that something was not being imposed from beyond, but that there was a genuine search for agreement.

In part, this journey was not just about designing and building a church, it was about learning how to be in community. How to hold various perspectives, sit with the tension of difference and move forward together.

Without warning, just as we were making steady progress, the Covid-19 pandemic made its advance. As it did so, plans, visions, hopes and dreams for the future began to fade. The pandemic settled like a dark cloud over everything, dismantling Sunday Masses, altering the human shape of the community and attacking the financial viability of almost everything, including building a church.

This is our current situation!

9

Accessibility, Intimacy, Flexibility and Immediacy: Welcoming the Contemporary Worshipper

Joseph P. Grayland

He aha te mea nui o te ao
What is the most important thing in the world?
He tangata, he tangata, he tangata
It is the people, it is the people, it is the people.[1]

Context shapes ideas and responses. The context of this paper is New Zealand, where I am the parish priest of three very distinct parishes. Each church building is rectangular, and each has been modified to accommodate the *novus ordo* liturgical rites.

The paper is divided into three parts.

Part One offers a commentary on the critical elements of the contemporary liturgical space. This commentary begins with *SC's* principle of *actuosa participatio,* followed by the relational role played by communication between liturgical space and ritual place. It concludes with a comment on the communication functions of intimacy, accessibility and flexibility for contemporary worshippers and liturgical buildings.

Part Two briefly outlines the reasons and process for modifying the liturgical space at Our Lady of Lourdes Church, Palmerston North, to achieve better communication through intimacy, accessibility, and flexibility.

Part Three concludes with a reflection on the demands on liturgical practice following Covid-19 liturgical lockdown and the Synodal Process's call for liturgical change. These offer the opportunity to consider a new type of

1 Maori proverb.

House for Liturgy based on the initiatory structure of the RCIA.

Part One:
Active Participation – The Organisational Idea

Liturgical buildings built before the Second Vatican Council were focused on the performance of rites and rituals. They separated laity and clergy using a topographical iconography of steps, lighting, vesture and altar rails. Since the Second Vatican Council, the focus of the liturgical building has been on people: how they gather, listen, move and participate in rites as a single ministerial group. The communication is no longer altar-to-pew but within the assembly. The focus has turned to the presence and participation of the entire assembly as liturgical ministers. This change, brought about through the post-Conciliar liturgical reform, is only possible where a single defining organisational idea is present.[2] That organisation idea is provided by *SC* and is called *actuosa participatio*.

Actuosa participatio defines the difference between the 1962 and 1969 Roman Missals. It grounds the *novus ordo*'s understanding of liturgical theology, practice and presence and shapes the conciliar understanding of the liturgical environment. *SC* frames the liturgical act as the place of salvation that requires the *actuosa participatio* of the liturgical assembly in the act of worship.[3] Full, active liturgical participation by the entire baptised community (ordained and laity) expresses the presence and activity of Christ in his Church's liturgical celebrations.[4] Liturgy is the primary source from which 'the work of our redemption takes place',[5] and the liturgical assembly is one of the four presences of Christ.[6] The assembly's participation in the rites relates to their ministerial function.[7]

In *Shaping Interior Space*, Roberto Rengel writes: 'good design begins with

2 Rengel (2007), 12.
3 *SC*, n. 14.
4 *SC*, n. 7.
5 *SC*, n. 2.
6 *SC*, n. 7.
7 *SC*'s understanding of *actuosa participatio* is mirrored in *LG*, ch. 2, on the People of God: 'The sacred character and organic structure of the priestly community (common and ministerial priesthoods) are brought into being through the sacraments and the virtues' (n. 9); and see: nn. 10–11, 14–15.

a simple and powerful organizational idea'.[8] The designer's task, he writes, is to balance the various demands the idea makes between its pure form and its particular application with a particular client. *Actuosa participatio* is the liturgical space's organisational idea because it articulates the interrelationships between space, place, movement and ritual. It is also the organisational principle of the contemporary worshipper – of the people themselves.

Because *actuosa participatio* addresses hierarchy, welcome and access through giving circulation, function, relationality, pathways, place, enclosure and the delineation of a purpose in respect of the people who gather, it creates a language to guide the design process and the building's function. Thus, it establishes a grammar of liturgical ecclesiology. This grammar articulates who the Church is and how they gather and function ministerially. It is not about the building's exterior but its interior design. As Marcel T. Rooney observed, once 'one has examined the basic thought of the Council with regard to ecclesiology and liturgical theology, one can then ... better grasp ... the stance which the Fathers took with regard to sacred architecture'.[9]

SC encapsulates the centrality of *actuosa participatio* thus: 'When churches are to be built, let great care be taken that they are suitable for the celebration of liturgical services and for the active participation of the faithful.'[10] This principle is stated earlier in SC concerning liturgical inculturation,[11] and it underpins the *GIRM* and the *Rite of Dedication of a Church and an Altar*.[12]

Where the liturgical building's organisational idea is *actuosa participatio*, its interior design will express the dynamic interaction between the liturgical assembly and the space through the communication media of movement, flexibility, intimacy and accessibility.

8 Rengel (2007), 12.
9 The architectural place has its own principles concerning architecture and furnishing articulated in *SC*, ch. 7, which Rooney says are established 'in the earlier chapters' and do not stand alone; see Rooney (1977), 13.
10 *SC*, n. 124.
11 *SC*, nn. 37–40 and also n. 128. Acculturation is orientated towards inculturation; and inculturation and local episcopal authority are essential to good contemporary liturgical development. See O'Loughlin (2021).
12 Both the *GIRM* and the *Rite of Dedication of a Church and an Altar* presume the principle of *actuosa participatio* in contemporary worship; on the latter's approach to catechisis, US Conference of Catholic Bishops (2018), nn. 1,1; 1,13; 1,17; 1,30; 2,2; and 2,84.

Liturgical space

According to Rengel, the design challenge is to master the concept of space. While most people define space as 'room', Rengel argues that the subtlety of space is expressed in proportions that 'suggest stability or induce movement.' Design should include a sequence of places within the space along pathways that lead people to understand how 'all the spaces work as a system.'[13]

Liturgical space is a system of ritual places that are both implied and literal. A ritual place within a liturgical space may be implied through specific furniture, like a font. It may use something that is permeable, like glass or partial walls.[14] Defining space through place means demarking one place from another and creating a hierarchy of places, pathways, edges and openings in a multi-dimensional structure. Semiotic analysis of a liturgical space reveals the internal relationships between the various ritual places and amplifies the weaknesses in the design, especially in the areas of movement, lighting, presence of the community and accessibility to the ritual place. Such an analysis will reveal how places and persons are differentiated from each other through unseen but clear lines of demarcation, such as the flooring, lighting and cladding material. The most obvious demarcations are those of stage/stalls and actor/audience, which should be avoided in a *novus ordo* church building.

Ritual places

Ritual places are created through function (the things done in the place) and containment (boundaries, shapes, dimensions, openings). They are communication places whose function and containment make the larger liturgical space habitable or accessible. They are discrete entities with a definable purpose and character. They have their size, proportion, limits and form, depending on which rite is performed at the place.

At the centre of each place is a piece of liturgical furniture whose ritual use determines its form and placement. A ritual place may be a destination within the space (baptistry), a circulation place (gathering area), a central place (nave) or a subsidiary place (devotional area).

Ritual places must accommodate the ritual and the liturgical assembly. When not in use, these places have a theological incompleteness. They are

13 Rengel (2007), 11.
14 Rengel (2007), 58.

places *awaiting* the liturgical presence of God and the assembly.

Architects like Emil Steffann and Rudolf Schwarz understood that ritual places are formed by the 'spatial dimension' of the liturgical ritual. Design that lacks an understanding of the 'spatial-architectural dimension' of rites fails because it does not comprehend the communicative spatial dimension of worship.[15]

Liturgical movement

Martimort's classic, *The Church at Prayer*, opened the subject of movement in liturgical prayer.[16] Previously, it was not considered necessary because it lacked a systematic language.[17] For the contemporary worshipper, movement belongs to the nature of sacramental ritualisation.[18] Movement links the ritual places within the liturgical space and the assembly to its ministry. Liturgical movement is *perichoretic* or trinitarian movement that reflects God's creative and redemptive movement. The movement belongs to the rites and is specified by them. It is a communicative movement because it communicates the ministerial assembly's role and provides the ritual recipient with an experience of *transitus* – of movement from a former way of living to a new one.

Liturgical Movement makes spatial demands on the interior space. It asks the designer to 'view space dynamically, or in terms of movement through it, as opposed to statically'.[19] Designers must consider the communication function of movement because, as Werner Hahne writes, 'it is God himself, who in worship through Christ moves and wants to move us'.[20]

Liturgical presence

Liturgical presence is the active, conscious presence of the gathered, apostolic, sacramental, ministering assembly and thus the most profound expression of *actuosa participatio*. Liturgical presence is the 'presence of ministry' as the Church participates in the life of God. It is communicative presence: more than 'just being there.' The assembly's presence-to-the-rite, not just

15 Lukken and Searle (1993), 13, 62–3.
16 Martimort (1992).
17 Sequeira (1990), 25.
18 See Krosnicki (1987).
19 Barrie, (1996), 47.
20 Hahne (1999), 340.

their proximate physical presence, expresses the intimacy of *perichoresis* and *actuosa participatio* as communication.

Liturgical presence is as attitudinal as it is spatial; it is the physical articulation of being physically close and involved. The building's 'job' is to facilitate this liturgical presence by creating a spatial environment attuned to the liturgical relationship between movement, presence and participation as forms of communication in a dialogical setting.

Liturgy as communication

The priority of the architectural setting of contemporary worship is communication. Liturgy is an act of communication. It is not primarily communication as in being able to see or hear something during a eucharistic celebration – though that is important – but communication as *participation in* the work and life of God and as *recipients of* redemption. The liturgical space must communicate to the assembly its participation in the work of salvation.

The liturgical building facilitates communication by providing for movement through the space that enables presence in various places. Communication includes entrance, exit, circumambulation and technology (audio, visual, Internet) as well as art, colour, seating, warmth, sound and visibility.

Increasingly for the contemporary worshipper, the space needs to communicate intimacy, accessibility and flexibility. It is most evident in the contemporary funeral, where the family requires these attributes in order for them to communicate their understanding of death and grief by visual tributes, contemporary, secular music and live streaming.

Part Two:
Communicating Intimacy, Accessibility, and Flexibility

Between Easter 2018 and September 2020, we modified the liturgical space at Our Lady of Lourdes Church to facilitate greater participation by the assembly in the liturgy. Our goal was to create a stronger sense of community through intimacy, immediacy, accessibility and flexibility.

The community is multi-ethnic, and members communicate in a variety of languages. They use a variety of liturgical styles and devotional practices

and have different expectations of intimacy and immediacy in worship.

The church building is rectangular, with entrance doors at the western end and a raised sanctuary dais at the eastern end.

The architecture of the 1950s shaped the building's interior design and liturgical character. Twelve years ago, the interior was refurbished. The raised sanctuary with three steps at the eastern end was retained, with the addition of a mobility ramp on the left side and a music area on the right. On the raised sanctuary were the altar table, ambo, presider's chair, and chairs for the servers.

For Holy Week 2018, the parish liturgy committee requested we place the seats along the length of the church in a choir format with the altar table at the eastern end and the ambo at the western, with the community facing each other across the building. The presider's chair was placed in the front row of seats.

With the parish council's agreement, this format was in place from Passion Sunday to Low Sunday. It was repeated for Easter 2019 and 2020 when it remained in place until after Pentecost Sunday, when we celebrated First Communion. We did this to enable accessibility, intimacy and immediacy for children and their families.

In 2020 following the first liturgical lockdown, we removed most chairs and formed small groups of chairs, or 'bubbles', meaning families and individuals could sit in groups according to their needs.

Following two parish meetings in October 2020, parishioners agreed to a compromise seating plan. Seating on the left and right of the altar table and ambo provides access for the elderly and immediacy for families and children. The central aisle gives direction and orientation to the space and handholds for elders.

The current seating pattern gives immediacy to the liturgical place and places the scriptures and Eucharist amongst the assembly. It has enabled greater access for all and brought the liturgy within the community of believers.

The format communicates intimacy, immediacy, flexibility, and accessibility. Both able and disabled parishioners can minister because there are no steps to negotiate. It allows the space to work well as a place of welcome. It works very well for funerals of any size and family, school, and child-centred

eucharistic celebrations. Because the space is not delineated through changes in height, special lighting or distinctive floor coverings, the whole space operates as a single cohesive space, and the whole liturgical space becomes the sanctuary.

New televisions were installed so that song lyrics, PowerPoint funeral tributes and video clips can enhance communication and communicate intimacy and accessibility, thus making the space more participatory.

This format is neither challenging to achieve nor new, as the photos of St Christophorus Church in Westerland/Sylt and St-Marien-Kirche in Schillig show.

Part 3

The Covid-19 view and synodal challenge

The Covid-19 experience showed that we need liturgy as a physical gathering. It also showed that the liturgy is a communicative act. Throughout the pandemic, communication through digital media grew, but the sustained absence of physical community worship has reshaped habitual patterns of worship and disrupted established liturgical and pastoral presumptions.

Covid-19 forced us to look at how we communicate liturgically. Virtual worship gave people access to funerals, weddings and Sunday Mass, but it has also created a passive onlooker congregation.

Internet connectivity opened liturgy to more people and made it accessible and democratic. Many saw this as a positive change because it included individuals usually excluded from physical liturgical gatherings. This was the antidote for an organisation mired in an exclusivist mindset, but it is not without its problems.

The synodal process has illustrated that people want change, especially in their liturgical experience. In New Zealand, this process has identified the need for change, especially in how we 'do' liturgy. The synod message is that liturgy must focus on its communicative dynamic and become more inclusive, accessible, communitarian and less hierarchical.

Hierarchy is a word that symbolises oppression and exclusion by setting barriers to full participation in ministry. Liturgical spaces that support a hierarchical liturgical view are less desirable because their interior design delin-

The layout prior to 2018.

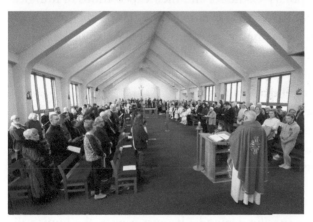

The layout on Pentecost Sunday 2019.

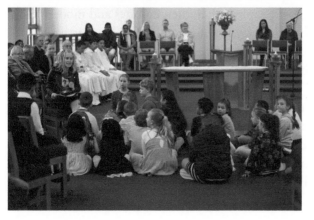

An adaptable space for a Sunday liturgy today

eates the space into separate clerical and lay places. Welcome, as a quality of liturgy, is the antidote to hierarchy because it communicates through various media that the church is a house of the liturgy where people actively participate. Welcome, because it gives everyone access to the liturgical space, is a new principle of contemporary liturgical ecclesiology and thus a fundamental principle of liturgical interior design. Welcome challenges the clericalist design perspective that designs from the 'priest out'.

Accessibility, intimacy, flexibility and immediacy are aspects of welcome. By moving the 'sanctuary' into the assembly at Our Lady of Lourdes, we created an 'inclusion zone' for families, children and the elderly.

The idea of welcome is indicative of a substantial movement in the theological values of contemporary Catholics and their expectations of liturgical practice. Welcome signifies more than creating a welcoming environment at a eucharistic celebration by having a greeter at the door. Welcome is the code word for including cultural perspectives, indigenous languages, ancient indigenous art and prayer forms, the rainbow community and those divorced and remarried, and giving them all a place.

The Covid-19 experience and the synodal critique offer the opportunity for a new type of liturgical building with new interior functions. It is the opportunity to create not just a *domus ecclesiae* or a *domus Dei*, but a *domus liturgicus* or 'a house for liturgy.'

Domus liturgicus

A *domus liturgicus* makes specific demands. It must express the human dimension of the liturgy (how people gather, their cultures and modern communications) and the liturgy's salvific function. It needs to articulate the interwovenness of the communities of the Trinity, the universal Church and the local community. To achieve this, the house for liturgy needs a theological and anthropological structure.

This structure is provided by the RCIA. Following the RCIA, the contemporary liturgical space must be permeable, not rigid, malleable and intimate, a place of 'disclosure' and 'mobility' to address different faith needs. Buildings that are less 'sociofugal' and more 'sociopetal' are needed.[21] These buildings have 'a more circular, semi-circular, or antiphonal layout where people

21 Vosko (2019), 132–7.

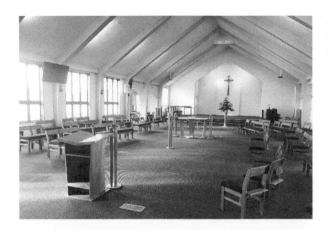

Seating after Covid-19 in 2020 with limit of fifty people.

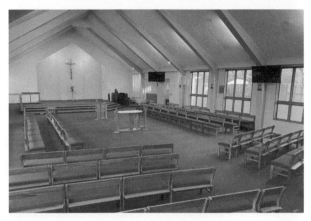

The current layout since October 2020.

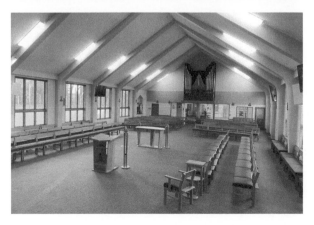

The current layout with presider's chair to the right of the ambo.

St Christophorus, Sylt,
Westerland, Germany.

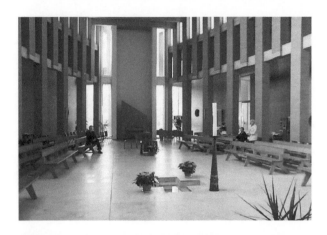

St Marien-zu-Schillig,
Wangerland, Germany.

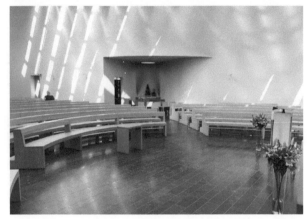

can interact and see one another'.[22]

The RCIA's catechumenal structure is a model for the *domus liturgicus* because it does not presume exclusive use of the building only by the baptised as most churches do, where the font is the doorkeeper to the space and the ambo is embedded in the eucharistic room. Instead, the RCIA's structure and theology allow the liturgical space, with its ritual spaces, to act individually or in sequence, depending on who needs them. Based on the RCIA, the *domus liturgicus* respects the distinction between catechumens, enquirers and initiates. It understands that liturgical symbolisation differs at different

22 Vosko (2019), 133.

stages of faith and provides places for this within a single cohesive interior space. This model of a place, using the flow of the structure of the RCIA, based on *SC's* demand for active participation, is not a mono-voiced building with everything jammed into it, as we normally do, but a place of liturgical encounter. It is like a home/house: a place that is moved through from room to room and its concept of designed space is larger than just room. Most churches are built like residential studio flats: everything in the same space.

One space, many places

Following the RCIA, a model of a *domus liturgicus* is offered below, a location of interconnected places that communicate through place, movement, accessibility, and flexibility.

With the increasing use of scripture-centred and lay-led worship, fewer celebrations of the Eucharist, funeral services for non-participating Catholics, and more aware of cultural expectations, here is a model for a contemporary liturgical space, a *domus liturgicus*, with four ritual places.

The design uses *actuosa participatio* as its organisational idea and the theology and anthropology of the RCIA to frame its communication. In this figure the multi-roomed liturgical space is based on the initiatory structure of the RCIA and *SC*, n. 56. The lines between the spaces do not necessarily represent walls; however, the space between the Place of Initiation and the Place of Evangelisation and Mission would represent a division, such that the former cannot be directly entered from the latter, but only via the Place of the Word or of Eucharist.

The Place of evangelisation (1) and mission (5)

Evangelisation and mission share the same place. As a place of welcome, it is the place for evangelisation and hospitality. Here, the introductory rites are celebrated, the deceased is received, and the wedding couple is greeted. From here, the assembly moves to the place of the scriptures.

It is also the place of sending and dismissal into the world where the liturgical rites are concluded. From here, the community returns to be the leaven in the world, to engage with life from a Gospel perspective.

This place must communicate the double dynamic of shelter and welcome for the enquirer and mission and sending for the baptised. Because it has a

social dynamic and is a meeting point, its materiality is important. It should be well lit with natural light and large enough for the assembly to gather at the beginning and end of the liturgy. It should be the only entry and exit to the liturgical space. The pathway from here to the place of the scriptures should be straightforward, as should the pathway from the place of the eucharist to the door of mission.

The place of the scriptures (2)

The place for the scriptures is designed for proclamation and listening and is accessible to the initiated and the catechumen alike. The speaker defines the room's functionality.[23]

The key to the space is an enclosure that nurtures listening and enables it. Enclosure creates active participation through seating placement, audio-visual and amplification (if necessary) and flexibility. The room also should respond to the listeners' cultural listening style (sitting for Europeans or reclining on the floor for Pasifika).

From here, the assembly moves to the place of the eucharistic memorial via the place of initiation.

The place of initiation (3)

The place of baptism locates the font and the aumbry. The place is used actively for baptism and chrismation and passively as the sacramental link between the scriptures and the eucharistic gathering.

Christian initiation follows catechesis. The sacraments of baptism and chrismation are sacraments of entry into the Church, so the place of water and chrism is a place of *transitus* or a pathway space. To access the place of initiation, one must move off the main pathway between the places of scripture and Eucharist.

It illustrates that the faith journey is not from the font at the front door to the altar table at the other end of the church (as in most places). Instead, we move from evangelisation via scriptural catechesis to the font; from there, to eucharistic participation and ministry.

The place of initiation is orientated to the place of scripture – from which it receives – and towards the place of the eucharistic gathering to which it

23 GIRM, n. 272.

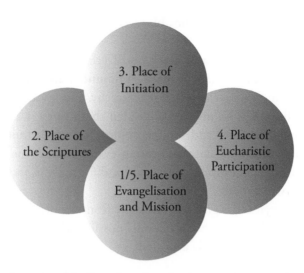

moves. The font should allow baptism by immersion or submersion in a space large enough for the community to gather.

The place of the Eucharist (4)

This place houses the eucharistic *circumstantes*, who, standing *around the table*, participate fully and actively in the Eucharistic Prayer. From this shared table, the assembly receives the Eucharist.

This place has only the altar table in a central position that facilitates immediacy, intimacy, and accessibility. There is no seating here.

All the modes of communication in this place are active. Here communication happens *around the table* and not '*across the table*'[24] or 'out from the altar', as is so often the case. Thus, its form and function create an assembly of participants, not a collection of passive spectators.

Conclusion

The shape of the liturgical environment determines to a large extent how people worship. It either limits or enables participation. The topography of the floor plan determines where people sit, how they move around the space – if at all – how they listen and how they enter and leave the building.

Where the interior design's organisational idea is *actuosa participatio*, spa-

24 Grayland (2004).

tially aware places are intimate, flexible, accessible and communitarian places of communication.

The impact of Covid-19 and the synodal critique have emphasised the need for liturgical spaces that are more communitarian and liturgical practices that communicate welcome, not hierarchy. Liturgy that is accessible, intimate and flexible is an unmistakable sign that liturgy is an act of communication between God and God's people. The opportunity for a new liturgical space capable of communicating evangelisation and sacramental meditation through accessibility, flexibility and intimacy is necessary for the contemporary worshipper.

The *domus liturgicus* design demands more from the designer, the presider and the assembly. A *domus liturgicus* is only possible where the organisational idea *actuosa participatio* is truly accepted.

10

A Dance Manifest

Laura Hellsten

In the beginning,
it was completely Silent.
And in the beginning, there was the Word.

The Word started to resonate …

Davar, Davar, Davar …
It vibrated into the Silence …

God said the words, and it became as God had said:
darkness and light, space and time.
Life and creatures.

And God said, Human.
So we came to be with everything else that exists.

And it became evening and night, 6 June 2022, in Karlstad, in Sweden
and everywhere else.

Let us now listen to the church bells that remind us of the sound vibrat-
ing into the silence:
Logos, Logos, Logos …

And we stood there, some seated on the church benches or chairs, others
standing with their feet on the ground, and others still at home, in front
of their screens. And we could sense how the sound of the bells vibrated in
our ears, in our bones and through our bodies … filling up the whole space,

resonating with all of matter.

This is how the Mass on the second day of Pentecost started in what also was the celebration of thirty years of dancing in the Church of Sweden.[1] Participants had gathered from the different congregations of the diocese, across the country, even from Denmark, Norway and Finland. Some people in the room had never danced in a church in their whole life. There were also people there who had brought the tradition of 'Sacred Dances' to the Church of Sweden many years ago. Some people in the space chose to participate actively through their bodily movements in the choreography that was to unfold. Others participated by playing the instruments for the newly composed music that created the danced Mass. Others again participated by sensing the movements in their bodies and receiving the vibrations in their cells even though they may have remained sitting in silence and stillness throughout the Mass. This is the miraculous ability our created beings have of being reciprocal partners in the story of creation through the task of being called to be priests and kings/queens in the Great Liturgy of Life.[2]

Introduction

For many, dancing in churches may still be a foreign element of Christian liturgical life. Often when I tell people about my research on dance in the Christian traditions of the Latin West, the responses I get are strong. Mostly, people get very excited about something they would love to be part of but never heard was possible. In contrast, others stiffen up in their muscles and seem very uncomfortable, sometimes even upset, about bringing 'radical and new' elements into a tradition where such things do not belong. As comporting ourselves and bodily relations are a very intimate and vulnerable part of human existence, I would never recommend a programme that states that everyone must start dancing in the ordinary liturgy. Simultaneously, I usually answer both of these reactions to my research area with the facts about Christianity having various dance traditions in its historical archives.[3]

1 The Mass can be watched in its entirety from here: Karlstad Stift, 'Den Stora Berättelsen – Uppbjudna Till Dansernas Dans!' https://www.youtube.com/watch?v=bIAr6vYc8hk&ab_chan-nel=GlimtTV.
2 Stevens (2000); Smith (2013).
3 For the most extensive historical overview see: (Dickason 2021); and for a more theological discussion see Hellsten (2021a).

We know now of dance being part of the practices of the early Church.[4] We know of the resistance towards specific ways of dancing and the apparent acceptance of others. We further know about the wide variety of dancing practices that were part of the liturgies and para-liturgies of the medieval period.[5] With this knowledge in mind, I want to reflect theologically on the possibilities of dance today in creating liturgies that are simultaneously faithful to different traditions and open to how the Holy Spirit might move communities to find new expressions of worship. The task of this chapter is thus to create a theological framework for practitioners of dance and leaders of liturgy that is open to the gifts and insights about the liturgical space that dancing in churches may offer. I build the arguments partly on the experiences I have gained from researching dancers in the Church of Sweden.

Dance and theology – a short overview

Dancing in churches in the Latin West is nothing new. Even though it seems like people in the Western world particularly have forgotten about the dance practices that were more common earlier, certain traditions have continued throughout centuries.[6] Others, again, have established themselves during periods of revival, and, in more charismatic communities, specific forms of dance or movement expression are interpreted as the arrival of the Holy Spirit. Many prohibitions against dancing can be linked to the Protestant movements of the early modern period. Simultaneously, for example, Jesuit communities engaged with writing ballet and dramas where dancing was an integral part of the performance. Thus, the history of dance in the Christianities of the West is more complex than merely stating that Christianity has always been hostile towards dancing or had an ambivalent relationship with bodies. Not even the statement that Cartesian dualism is to blame for the disappearance of dancing in the modern period is a complete answer to this dilemma.[7] It is, of course, arguable that the dramas and ballet of the Jesuit community or later performances of modern dance in churches are phenom-

4 See Bowe (1999); Beard-Shouse (2010); Hellsten (2016) and (2021b); Yingling (2013); Dilley (2013); Schlapbach (2022); and Klinghardt (2014).
5 Knäble (2022).
6 Gougaud (1914) singles out three stories that are picked up by Rahner (1967); but see the critical examination in Hellsten (2021a), 142–8.
7 See Walz (2022) for the range of these arguments; for arguments on different relationships to the body in a Christian tradition, see Coakley (2002).

ena that are, more strictly speaking, outside the realm of liturgical practices.[8]

To help us understand what dancing in churches may imply, I want to provide this broad road map to show how differently the communities of dancers may interact with the spaces they are given.

First of all, it can be argued that dancing never strictly disappeared in many regions that churches from the West colonised. In Central and Latin American traditions of Christianity, we may find dancing as part not only of the Carnival period but also of saints' day celebrations and other liturgically significant feasts of the year.[9] Often these take form outside the church buildings – in processions and open spaces where there is room to move around. These practices have also been described as resistance to colonialism.[10] However, what is highly problematic is to portray dancing only as an act against oppression. Dancing carries many more meanings than that.[11] Simultaneously, unfortunately frequently, negative rhetoric around dancing was and still is part of a colonial, hegemonic practice, where both missionaries and scholars of theology and religion in the West perceive dancing as a more 'primitive' behaviour.[12]

In contrast, reading the Word and more disembodied prayer practices are portrayed as the norm of more 'enlightened' or 'civilised' forms of religion. This is the epistemology and ontology particularly of a modern and secular age which has challenges with understanding and accepting dance within the traditions of the Christianities of the West. I have argued that this is why certain forms of dancing, particularly in Europe and elsewhere, that used to be part of liturgical enactments, are now classified as folkloric elements, cultural customs or entertainment and amusement. Sometimes they may be seen as acts of piety or exotic devotional traits. Nevertheless, they are not recognised as part of the 'proper' worship or liturgy. Thus, I would argue that portraying dance as liturgical and religious in many cases functions as a decolonising praxis because sustaining dance traditions that have been condemned earlier may be signs of resilience against oppression. Once we

8 My understanding of liturgy is not strictly defined to the practices centring on the Eucharistic celebrations. I rather elaborate on the kind of socio-political imagination of worship described by Smith (2016).
9 Romero (1993); Nájera-Ramírez et al. (2009); Harris (2003) and (2010).
10 Gotman (2018).
11 Sithole (2022).
12 LaMothe (2013); Kelly (2019).

The author, Laura Hellsten, caught in a prayerful movement.

re-examine the history of dance traditions within Christianity, these older forms of conceptualisation need to change.

As an example of the needed reconceptualisation, I argue that there is no place in Christian liturgical service for elements of entertainment. To portray dancing as entertainment runs the risk of belittling its importance and buying into capitalist frameworks of religion.[13] The ideal would thus be that when touring devotional dance companies and individual artists perform in churches, they would be given proper commissions for their works so that once they enter the space of worship, their gifts can be recognised as part of the congregational service. Their 'performance' may, or may not, be part of a regular Mass. However, if the artists perceive their work as devotional, their enactments within the church should not be treated as entertaining performances. This cuts to the core of how I perceive liturgy: it is an act of love – reaching out to our beloved and being transformed in that desire for

13 Lloyd (2011), 115–6.

the other. And, simultaneously, this is not an individual act, but something we do as part of a tradition and in a community.[14]

Another aspect of the rethinking needed is to realise that even though commercial entertainment and the competition of professional dance scenes are not part of liturgical worship services, playfulness and joy can very well be so.[15] Particularly in the medieval period, engaging in Sacred Folly or Holy Play was something that shaped many of the liturgical elements and formed an integral part of how freer forms of dancing could be part of the worship service. Furthermore, the excellence that arises from the joy of co-creating in gratitude to God is not something that needs to be shunned.

In the case of the danced Mass 'Den Stora Berättelsen', the Diocese of Karlstad went so far that they commissioned professional musicians to compose the music in collaboration with the choreographer. After this, the music and movements have then been recorded, and musical notes were created for public use. This is so that the whole liturgical service is free of charge and can be re-created in every congregation willing to bring the dances into their churches. There are even charts written for smaller or larger set-ups of musicians. With such an invested practice, even the modern copyright laws and other challenges for newer music in churches are taken care of.[16] One could understand these acts, not as a creation of something new, in the supersessionist logic of describing a capacity to transcend tradition. Instead, the danced Masses created in Karlstad can be understood as a liturgical critique of history from within history.

What has been noted is that these dance companies in churches do not seek the rigorous standards of the professional dance fields and welcome all sizes and shapes of bodies. In certain churches, there are dance groups that, just like church choirs, work on a volunteer basis, with the leader receiving a salary for their ongoing work and preparations. This is also the kind of group in which 'Den Stora Berättelsen' was created. In other congregations, I have encountered a mixture of the above and a more traditional form of prayer

14 Lloyd (2011), 119.
15 Goto (2016).
16 'Den Stora Berättelsen' is the second complete dance Mass that has been created for congregations that want to have dancing as part of their liturgical life. In the first Mass, 'Din Ljusa Skugga', there was also poetry set to music so that the church choir could be part of the celebration. However, that Mass required quite skilled church musicians and singers, so the service was often conducted with the help of a recorded CD, which is not ideal.

group and/or spiritual formation community. Some leaders explained that anybody is welcome and the practices are very much centred around healing wounded body images and dysfunctional relationships with ourselves. In this format, the dancing in a worship service may or may not be the primary goal of the practitioners. Creating and practising a perfect choreography is not the central part of the group's goal when meeting. Fumbling and finding one's way back to the care of the community is a much more prominent aspect of the dance. The aesthetic values of this context are not perfectionism and attaining a sense of 'sanctity', but are focused on being gracefully transformed.[17] In parallel with preparations for participation in the Mass, the weekly or bi-weekly meetings are centred on a deepening relationship with God and self.

Here also, the space of the church plays a big difference. When pews have been built into medieval churches or newer buildings have fixed seating arrangements, there can be challenges with having space for dancing. Also, built-in stairs and steps may create safety issues. Sometimes this creates the sense of feeling unwelcome in the house of God. Many dance groups thus prefer to meet in other congregational buildings for their practices. In the Mass danced in Karlstad, I was pleasantly surprised by the interior of the early nineteenth-century building in a classicist style. Those kinds of pale and pompous buildings seldom speak very deeply to me. However, the space was perfect for dancing a Mass with almost a hundred participants. The altar in the middle of the cross-shaped building created a rare occasion for dancing around the sacraments without using a small portable table, which is often the custom. When one wants to dance in a church, the buildings shape the praxis and the aesthetics, and choreographies need to be altered to fit the space.

Dancing has been a concern of the liturgical movements since as early as Dom Louis Gougaud (1877–1941), and is also linked to the rising interest in more esoteric forms of religious expression. It has re-surfaced within the consciousness of Western practitioners of Christianity as a form of lived religion.[18] As I see it, liturgical dance movements can be grouped into at least three different kinds; some overlap with others.

17 Hellsten (2021).
18 Knibbe and Kupari (2020).

In the US, much of the dancing in white churches seems to have started from the inspiration of the practitioners of staged dancing. By this, I mean dancing in predominantly Protestant settings where Margaret Fisk Taylor (1908–2004) was one of the pioneers.[19] Often these individuals were inspired by the work of early modern dance practitioners like Isadora Duncan (1877–1925), Mary Wigman (1886–1973), Ruth St Denis (1879–1968), Ted Shawn (1891–1972) and Martha Graham (1894–1991).[20] From there also grew the Sacred Dance Guild.

In Catholic settings, on the other hand, it seems to have been the Second Vatican Council particularly that stimulated experimentation and work involving dancing. The liturgical revival that sprang up in that setting brought with it practitioners of dance who had experimented and written quite extensively on dance and liturgical movements from a practical point of view. These practices are often strongly connected to the church buildings and dancing within the liturgy. Focus may lie on creating gestures for praying, blessings and specific liturgical sections like the *Te Deum* or the *Gloria*.[21] Such practices are surprisingly close to what can be found in some medieval liturgical records.

In the European context, there is the 'Sacred Dance' movement. This tradition grew out of the pioneering work of Bernard Wosien (1908–1986). It spread from the Findhorn community and the work of Wosien and his daughter Maria-Gabriele to churches in Germany, Finland and Sweden. The Sacred Dance movements are often slow, meditative movements in a circle that, in a Nordic context, have been created to classical music, Taizé songs or popular music with spiritual or religious undertones in the texts. The Sacred Dance communities also uphold the idea of preserving/reviving 'folkloric' dancing traditions from Greece, the Balkans, Armenia, the Roma people and other Eastern European communities. It is often imagined that dancing at religious events was kept as a 'natural' element of those cultures longer than in the West. Thus inspiration is sought from these communities.[22] This idea is sometimes extended to Jewish or Middle Eastern songs, dances and practices. The uplifting of a connection between Jesus and the Jewish roots

19 Her book, *The Art of the Rhythmic Choir*, first published in 1950, can now be found as Taylor (2009).
20 Schnütgen (2022).
21 Gagne (1984).
22 For a critique, see Hellsten (2022).

Participation in the new mass 'Den Stora Berättelsen', where Sacred Dance leaders Cecilia Hardestam and Hans Kvarnström, together with their dance community, have created a choreography that takes people through all the elements of a traditional liturgy. In Karlstad, Sweden, August 2022.

of dancing within Christianity is sometimes a potent and problematic connection made to legitimise dance in a Christian context.

Yet another strand in modern interest in dance comes from feminist women's spiritual groups, partly led by anti-patriarchal movements of religious expression and partly inspired by the early modern dance practitioners. Some of the practitioners of dance have a robust feminist agenda. When this takes the form of feminist theologies of solidarity and black womanist traditions of dance and theology, they bring essential elements to the liturgical dance practices. The practitioners speak about creating rituals against war and abuse or raising awareness around questions of environmental stewardship of God's creation. By bringing up the sensory and emotional aspects of suffering, affliction and pain, dance rituals may bring healing and a vital element of authentic embodied prayer to the worship services.[23]

Theologies of dance

When it comes to theological writing on dance, Riyako Cecilia Hikota has recently noted that, particularly in modern theological texts, surprisingly many authors have turned to the use of dance as a metaphor for presenting different theological ideas.[24] This is often built around the use of the Greek term '*perichoresis*', in both a Trinitarian and Christological sense. Hikota argues that building a theology of dance on a Trinitarian concept risks promoting pantheism or panentheism and obscures the original meaning of '*perichoresis*'. She is also looking for a dialogue within theology where the

23 Méndez Montoya (2022).
24 Hikota (2022a) and (2022b).

embodied nature of dance is adopted more concretely instead of referring to dance mainly as a metaphor. Hikota states that St Gregory of Nazianzus (330–390) used the verb *'perichoreo'* for the first time in a theological context; and the concept was then developed by St Maximus the Confessor (580–662). In both, the term was used in a Christological sense, which according to Hikota, is the best application of the idea regarding dancing. The primary implication is that as Christians, we do well in imagining Christ as our lover, partner and leader of a dance.

However, in using this image, Hikota seems to ignore the critical questions of desire and *eros* that lie implicit both in the traditions of Christianity that portray Christ as a lover and in the lived experiences of pouring ourselves out in dance as prayer. To be in relationship with God through our embodied experiences of dance and prayer is very much in line with the more mystical traditions of Christianity.[25] Fredrik Heiding further states that in communal liturgical services, there is often very little room for expressing these aspects of our prayer life more fully.[26] An exception would be the open cathedral with many side-altars where people can withdraw into a more private space while still participating in the ongoing service. Having designated spaces for dance could be one way to invite people to engage in this form of worship and prayer in services that are not strictly centred around dance.

My last remark about the possible avenues of theology that promote dance concerns what Hikota calls the Trinitarian use of *perichoresis*. She states that when reading St John of Damascus (676–749), who extended the Christological usage of the word to the Trinitarian use, one needs to understand that it is not a dance *within* the Trinity that is explained. In the patristic literature, images are portrayed of either a celestial dance involving creatures in heaven or, then, an idea of the Trinity *as* dance. And, many metaphorical usages of an idea of dance seem to be at odds with the embodied experiences of dancing.

On the one hand, we have a social Trinitarianism, where the 'mutual' indwelling within the Trinity is understood as a pattern stretching itself out into the whole cosmos. Everything is perceived as a mutual relationship between equal partners, where the distinctions between God and creatures are

25 There are numerous examples in the medieval literature; see: (Dickason 2021), 141–74; and Hellsten (2021a), 227–30.
26 Heiding (2020), 46.

erased. However, as Sarah Coakley noted, there are severe problems with applying the idea of the prototypical relationship within the Trinity as an easily accessible model for ecclesial, political and personal relations. An uncritical notion that what a church community needs to strive for is the harmonious relationships of all people, based on a utopian idea that this is what we are called to when we participate in the dance of the Trinity is problematic.[27] One of the pitfalls of this kind of idolatry is a worship practice that aims to uphold a 'feel-good theology', and is willing to erase the differences between people and Christian cultures across the world for the sake of a 'mutual unity'. However, Coakley's main point with these arguments is not to defend any theological orthodoxy (which is what I sense is the quest of Hikota), rather, as her focus is on desire as the root of prayer and our human condition as embodied persons, she states:

> For it is vitally important not to confuse this quest for the right 'alignment' of sexual desire and divine desire with the false attempt directly to imitate the life of the Trinity – an idolatrous project that we have consistently resisted. Because we are embodied, created beings, we may indeed (through the graced aid of the Spirit) 'imitate' Christ, the God/man; but we cannot without Christ's mediation directly imitate the Trinity itself.[28]

It is not because the idea of imagining the Trinity as a harmonious dance or the concept of dance within the Trinity is idolatrous. Instead, what is at stake is the question of what we as humans are called to do.

At the other end of this same dilemma, we may find the neo-platonic forms of theology that want to proclaim a vision where creation started from nothing, expanded into something and will once again return to a quiet stillness and the end of all striving and suffering. In Coakley's account, this image, which is strongly linked to structure and order, both in the heavenly and worldly spheres, is the Christian community envisioned by St Augustine.[29] In some theological accounts of dance, the striving for participating in the ongoing harmonious dance of the creatures in the cosmos is perceived as the point of liturgy.

What I want to propose is different. One should not pursue a chimera

27 Coakley (2013), xiv, 27–8, 270–2, 301–3.
28 Coakley (2013), 309.
29 Coakley (2013), 268–95.

Worship movements engage women, men, young and old in the church of Karlstad in Sweden.

of freedom and life force, with no real acknowledgement of the pain and suffering that human experiences also contain. It becomes a meek God who has lost the ability for justice. Our dance would lose its indwelling potential for healing and transformation when we are called into dancing by God. Instead, I opt for two other possibilities. The first one is built on Coakley's depictions of the Trinitarian ideas of St Gregory of Nyssa. She explains that for him, the practice of prayer and contemplation ultimately leads to a loss of control and an over-flooding of our senses. She also explains that his vision of eschaton and potentially ongoing worship in heaven is ecstatic. The longing we sense in our bodies will not end. Instead, our desires will be transformed, and with the outpouring of the Holy Spirit in our bodies, we will be able to contain more and more of this flood of life force.[30] In this kind of liturgical vision, there is, as I see it, room both for more ecstatic movements of dance and stillness in the body and rapture of the mind. However, the progression is from the Spirit within us praying, not from our own efforts to enter into ecstasy. We may grow with Christ as our partner, which is a *wild* ride into unpredictability and noetic darkness.[31]

Finally, I also see another more subtle space for dancing. Hikota argues that there is no evidence for a Trinitarian discourse on *perichoresis* continuing into the Latin west in medieval period. She accurately describes that:

When the Greek word was later translated into Latin, two different words were used to distinguish between its static and dynamic senses: namely, '*cir-*

30 Coakley (2013), 281–8, 294–5.
31 Coakley (2013), 311–22.

The Dreihasenfenster ('window of the three hares') in the courtyard of Paderborn Cathedral.

A triskele in one of the windows of the parish church of St Katharina in Schluderns, Südtirol, Italy.

A triskele in one of the windows of the parish church of Saint-Marcellin, Isère.

cumsessio', from '*circuminsedere*', which means 'to sit around,' and '*circumsessio*', from '*circuminsedere*'e, which means 'to move around.'[32]

Thus, the use of the term '*circum-in-sedere*' – to sit in a circle – was St Thomas of Aquinas's (1225–1274) preferred rendition. While at the same time, Bonaventure (1221–1274) chose the term '*circum-in-cedere*' – a depic-

32 Hikota (2022a), 52.

tion of moving around.[33] Both Heiding and Coakley note these distinctions in relation to artwork, Coakley in the circular frolicking of the hares and Heiding in the architectural triskele.[34] In these images there is room for the ongoing movement and the ability to stay in relationship and communion while in stillness. One does not exclude the other – there is space for both/ and. More importantly, for the case of dancing, Heiding also moves into the more mysterious aspect of Aquinas's writing. Thomas is not an author who leaves his theological thinking to dualities. We do not need to focus on the movement *or* the stillness, the heavenly *or* the worldly. Instead, by sensing into the space in between, the experience of being drawn into the divine dance can be something we perceive in our bodies.[35] In this description of relating to the divine dance, I find a much more subtle practice, one that is equally important for our formation as worshipping beings in God's creation.

33 Heiding (2020), 173.
34 Coakley (2013), 252–3; Heiding (2021), 27.
35 Heiding (2021), 25–9.

11

Return to Ronchamp: Re-imagining Liturgical Space

Anne Dixon

The first visit

In spring 1975 I visited Le Corbusier's pilgrim chapel at Notre Dame du Haut, Ronchamp, for the first time, with a group of student architects, eager to view what was already an architectural icon. We were participants in an educational visit hosted by L'École des Beaux Arts, Besançon. At the time of the visit it had been built for only twenty years, so it was a year older than I was. It was a beautiful morning and we were enjoying ourselves.

'Make as many sketches as possible to fully understand the spaces,' our tutors instructed optimistically as we climbed off the bus onto the fresh green hilltop. We stared at the familiar and distinctive profile above us. The leading edge wall pointing heavenwards, the strangely bulbous roof, the apparently random dark squares punctuating the white concrete walls. It was extraordinary.

A French-speaking guide appeared and rapidly explained the story and the concept. Three clear memories remain. The first were his movements – as he spoke he moved fluidly across the external sanctuary, occupying each place and demonstrating the ergonomic design. He hands went out, his hands went up, his knees bent and straightened almost as if he were engaging in a dance with the architecture.

He was Le Corbusier's modular man in motion.

The second memory recalls the chapel's interior. The dark holes in the white walls were now bright jewels overheard, and the doorway behind us, showing a glimpse of a sunlit landscape beyond, gave access to a world of shadows and mysterious alcoves. And then he sang … a single voice, which

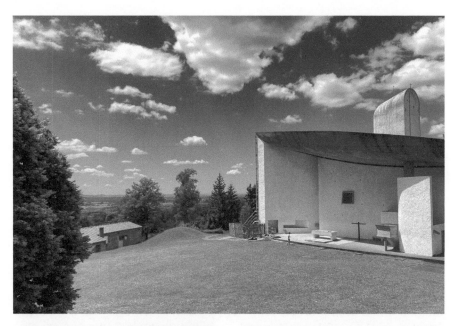

Top: Chapelle de Notre Dame de Haut, Ronchamp.
Above: Le Corbusier's design responds to the human person.

swelled to fill the space.

The sound faded but the third memory, of the story that he attempted to tell us, remained. We thanked him and headed outside to enjoy the sunshine and each other's company. A tick in the completed column of our 'architectural icons visited' spreadsheet and we were on our way. I have no sketch record except those three memories – **place within space; light and darkness; and, finally, telling the story.**

Unlike Mies van der Rohe, a practising Catholic, Le Corbusier did not claim to have a religious faith, but he did claim his work had a spiritual element, even suggesting (in an interview at La Tourette in 1961) that he had invented the term 'ineffable space' to describe this phenomenon:

> When a work reaches a maximum of intensity, when it has the best proportions and has been made with the best quality of execution, when it has reached perfection, a phenomenon takes place that we may call 'ineffable space'.

Whilst Mies was influenced by the work of Rudolf Schwarz and, through him, the innovations of the Catholic theologian Romano Guardini, Le Corbusier worked in collaboration with the Dominican Marie-Alain Couturier, who edited the French journal *L'Art Sacré*, which featured Ronchamp as its lead article and on the cover of its September/October 1955 issue. Le Corbusier was supremely confident of the effect of the spaces he was creating.

In 2007 a multi-disciplinary, inter-faith symposium between Yale School of Architecture, Yale Divinity School and Yale Institute of Sacred Music borrowed the term, naming the event *Constructing the Ineffable – Contemporary Sacred Architecture*. It raised the questions, What is sacred to us today? And how may it be embodied in architectural form?

In these essays, might we also consider similar questions? What is liturgy to us today? And how might our architecture help or hinder its celebration?

This essay offers three projects from my own portfolio, each invoking at least one Ronchamp 'memory' for consideration.

Place within space

'Is the task of Architecture not to wrest place from space in order to provide not just the body, but the whole human being with shelter?' Karsten Harries[1]

1 Harries (2010), 53.

A new understanding can be supplied by a change in vantage point. I was visiting an Anglican Benedictine congregation of religious sisters in Kent and was invited to participate in their liturgy as a silent observer. Non-community guests were located in a small side chapel, right-angled to the sanctuary, where I found myself gazing across the ancient empty sanctuary from an unfamiliar angle. I noticed the beauty of the stone, the places where it was worn on step and edge and the play of the light on the uncluttered surfaces. It was beautiful and I was lost in its expanse.

I recalled how the cathedral builders used height and space to create a sense of the awesomeness of God and the insignificance of the human observer and I wondered if this was still a contemporary response.

'We cannot continue on from where the last cathedrals left off. Instead we must enter into the simple things at the source of the Christian life.' Rudolf Schwarz[2]

The experimental liturgical space within Burg Rothenfels, inspired by Romano Guardini and realised by Richard Schwarz, is simple and spacious. It includes a wall of full-height windows looking on to the surrounding landscape, each one held within its own alcove. Furnishings are simple cubes of timber, easily mobile. The space can be formed and re-formed, enclosed and released, from intimate to infinite as the celebration demands.

This is reminiscent of the work of Susan Susanka, a North American architect who presents an alternative residential design offer to over-sized speculative housing developers. Susanka identified that these aspirational homes had mistaken quantity of space for quality of space. Her designs, by contrast, create spaces within spaces so that human scale is restored and the activities of living together as family can be accommodated graciously.

> … one of the best examples … is the window seat. The floor is raised, the ceiling is lowered and the walls are brought in to define a place for one or two people, from which they can observe the world. Sitting in a window seat feels like an embrace … [3]

To reference our liturgical spaces to those of the domestic dwelling is not to trivialise them. On the contrary, as the theologian Miroslav Volf asserts, it is to return to one of our most authentic sources:

> I am not entirely persuaded that the sacred needs architecture.

2 Schwarz (1958), 35–6 (cited in Torgerson [2007]), 71).
3 Susanka (2001), 18.

Architect's sketch of proposed prayer room.

> [Christianity's] triumphant first centuries, when it was arguably as vibrant as ever, saw it completely devoid of anything like sacred architecture. Then, the ordinary homes of Christians, in which they pursued the ordinary activities of daily life served also as places of worship, thus the emergence of the term 'House Church.'[4]

South Downs home prayer room

My first example is drawn from a liturgical space in a domestic setting. An Anglican priest with a contemplative prayer ministry approached our architectural practice to design a place for solitary and communal prayer within her home site. She had identified the only space available – the roof of an existing flat-roofed double garage. Our brief was a collection of words: *connection, privacy, view, light, space, natural, sustainable, warm, cool, cosy, prayer, quiet, solitude, contemplation, trees, foliage, together, apart.* Whilst the words sound oppositional, the client had a clear vision which helped us seek and find an acceptable form. The walls were raised to create a low eaves to the first floor. Into this low wall a series of smaller openings, horizontal and vertical, was formed, allowing tall and wide views of the immediate surroundings

4 Volf (2010), 61.

Above:
Aerial view of proposed prayer room.

Right: Interior view through roof windows to silver birches beyond.

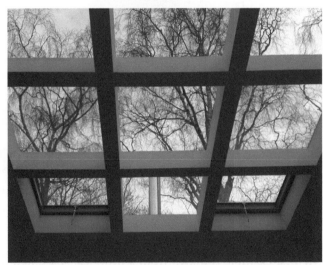

without compromising the privacy of the space within. The floor and low seating shelf provided ample opportunity for framed views in an intimate space. Each aspect of the space continued upwards with a sloping surface that met at a fifth plane, angled towards the east and framing nine large roof windows. The roof space created was distinctive, but not cavernous. The resultant cruciform of fenestration against the silver birch foliage beyond provided all the decoration and symbolism required. A wood-burning stove ensured warmth from a source independent from the adjacent house. The space was simple but beautiful, encouraging solitary or community prayer. Externally the building was clad in cedar shingles, thus blending into its

wooded location.

The space works for the purpose for which it was designed because of the clear vision of our client. It was a deeply personal project, which yielded even more than we expected. Could this then be considered a liturgical space?

Sarah Susanka provides us with her own unexpected response on completing a similar project:

> The day I stepped into that space for the first time and sat down on my cushion to meditate, a most amazing thing happened. I felt as though the person sitting there, supposedly me – had been sitting there for eternity and would continue to sit there forever. There was a timeless, placeless connection to my true self – the more aware and thus higher aspect of myself – and all the occasions I could recall of my being completely engaged in the moment were there too.[5]

Sometimes, as architects, all we have to do is show up, and the genius in the walls does the rest!

Light and darkness

In February 2009 Elizabeth Gilbert delivered an energetic TED talk entitled 'Your elusive creative genius'. As the author of the popular novel, *Eat, Pray, Love*, she explained that after her first novel's success she was often asked how she intended to follow up on that work and if she was ever afraid that the creative impulse had left her. This was her response:

> In ancient Greece and ancient Rome people did not happen to believe that creativity came from human beings. People believed that creativity was [a] divine attendant spirit that came to human beings from some distant unknowable source for some distant and unknowable reasons ... the Romans ... called that ... creative spirit a 'genius' ... They believed that a genius was ... [a] magical divine entity who was believed to literally live in the walls of an artist's studio.[6]

Reassured by this knowledge, Gilbert's work methodology has been to 'turn up', and if the genius doesn't, well, she's played her part. Sometimes architectural solutions are similar. If they are not always the outcome of a startling conceptual breakthrough, they may simply be the application of

5 Susanka (2008), 24.
6 Gilbert (2009).

155

Above:
Early sketch of prayer
room.

Right: Photo of
completed prayer
room.

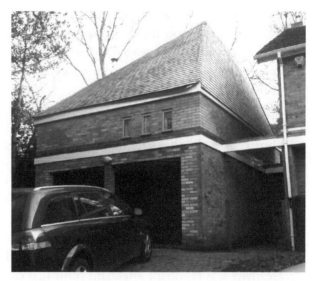

informed wisdom to a recognised building type within a constrained budget. This next example of liturgical space, the only example of a church interior in this small selection, falls into this category.

Octagonal parish church, Essex

I have to admit that daylight, the light on things, is so moving to me that I feel it almost as a spiritual quality. When the sun comes up in the morning ... and casts its light on things, it doesn't feel as if it quite belongs to this world. I don't understand light. It gives me the feeling there's something beyond me, something beyond all under-

standing ... For an architect that [natural] light is a thousand times better than artificial light.[7]

Following the Second Vatican Council, architects experimented with circular or octagonal church plans. There are famous examples and also smaller versions, purchased 'off plan' by the rapidly expanding dioceses of the time. Sixty years later and the cutting edge of the liturgical reforms has blunted in some locations. We were invited, by a newly appointed parish priest, to consider one such church building to try to determine why the space 'felt' wrong and what remedial action might be taken. The available budget was constrained. No major structural work could be undertaken. The building was to remain in use as much as possible.

The building was constructed from eight glue-laminated cranked beams joined at the apex to form an octagonal tent-like roof. Almost three-quarters of the building's external envelope was roof, the other quarter being a three-metre high wall punctured at regular intervals with utilitarian timber-framed windows. The glazing was single pane obscure glass. Minimal light entered through these low openings and artificial light was always necessary, whatever the season. The 'drama' of the space was the apex of the roof which occurred midway down the central aisle. The roof then continued to descend over to the farthest eaves line where it formed the upper line of a cramped sanctuary space. An undersized crucifix denoted the rear wall of the sanctuary. The furnishings were arranged in multiple rows of benches, parallel to the entrance doors and either side of a central aisle. It was as if the interior belonged to another building. The overall effect was dingy and oppressive with little or no connection to its location.

The first issue to address was that of the low light levels. The extensive roof surface needed to be allowed to let the light in. A clerestory line of glazing or a lantern light were prohibitively expensive. We decided to install sixteen roof windows. A temporary internal scissor lift meant we avoided the need for external scaffolding and minimised disruption to the existing structure. The transformation was instant. The nave flooded with natural light, making artificial light superfluous in daylight hours. As the day progressed the light source moved around the church, highlighting different areas and creating a connection with time and space. Seasonal differences were also noted.

7 Zumthor (2006), 61.

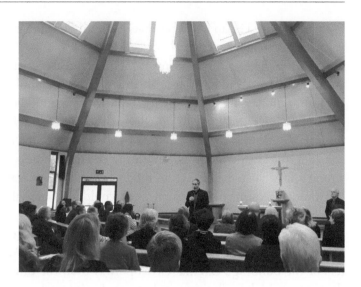

New light in
church interior.

Heaven's light had brought life to this dull space and the liturgies took on a new connection to their calendar. In addition the furniture was arranged to maintain the sanctuary in its existing position, but the seating was rearranged in a faceted plan to acknowledge, rather than conflict with, the shape of the space. The windows and doors were replaced with high performance double-glazed fittings with etched glass and smaller sections, increasing the clear glazed area, improving the thermal performance and enhancing the aesthetics.

It is a long way from jewelled glass in Ronchamp to roof windows in Essex and there are many anecdotes in between that often remain untold. When we learn its story, a place takes on new meaning.

Telling the story

Above all else, sacred place is 'storied space'. Particular locales come to be recognized as sacred because of the stories that are told about them.[8]

As Lane's words remind us, before any ideas, concepts or solutions are put forward, the land itself has its own story to tell. His work is primarily con-

8 Lane (1988), 15.

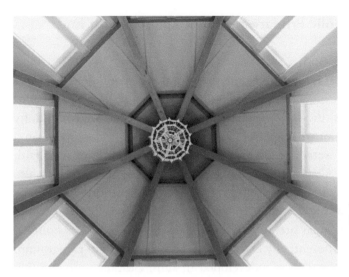

The octagonal roof becomes a lantern.

cerned with American spirituality. A more British approach is supplied by Philip Sheldrake:

> Celtic Christians had – and even today have – a strong sense of living on 'edges' or 'boundary places' between the material world and the other world. The natural landscape was both a concrete reality where people lived and, at the same time, a doorway into another, spiritual world.[9]

Beginning with the natural landscape, in architectural terms, all places may be considered to carry at least three layers of story:

• The first layer relates to the land itself – and its 'sense of place'.

• The second layer is the story told by the client – the issue looking for a built solution.

• The final layer is the story the architect tells through the architecture.

A final example may help to illustrate this.

9 Sheldrake (1995), 7.

159

New Catholic Primary School in London's East End

The first layer – the land

London's Isle of Dogs is low-lying land, perfect for canals and dockyards, the growth of which encouraged an immigrant population of Irish Catholics to settle in the area. In the early nineteenth century the Catholic community was denied a place of worship, but was allowed a small schoolhouse on a residential road on waterlogged land. This became the centre of their faith community, where Catholic worship took place clandestinely. It was also rumoured that the school playground served as a makeshift burial ground.

Eventually a new site was granted for a church building but the school remained on the original site, rebuilt and enlarged. The street was bombed during the Blitz and eventually became part of a larger school playground. The surrounding streets were redeveloped in slum clearance programmes and a new generation of immigrant families arrived, primarily from Bangladesh. The predominant faith community of the area was now Muslim and the Catholic site became a small island. The children of this area, of all faiths and none, suffered some of the highest levels of child poverty in Britain.

The second layer – the client's story

A few streets away, about twenty minutes' walk, a second, smaller Catholic school was struggling to survive. Staff recruitment and retention was almost impossible and the most constant presence for the children were the teaching assistants: local women with a fierce loyalty to 'their' school. Educational attainment targets for the children were missed. Both the diocese and the local authority agreed that the schools should pool their resources in a single school. Both were keen to stress that this was not an amalgamation, but a new school altogether; and a new building with its own story was required.

The contrast between the resources available to these children and the conspicuous wealth represented by the looming banking towers of the Canary Wharf was stark, making all involved determined to offer the children the opportunity for transformation. A good education could transform their lives if they would embrace it. Could a building raise their aspirations?

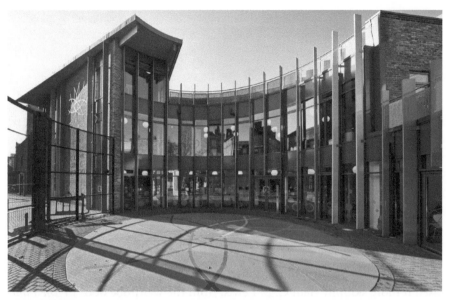

School entrance on an arc.

The third layer – the architecture's story

Is the use of a school example pushing the idea of liturgical space too far? For many of the children attending the school the links with their faith community were at their strongest in this context, as the only liturgical space they would be likely to experience was the place of the assembly within the learning community.[10]

We used storytelling to connect with the children's hopes for the future. We discovered that their participation was enthusiastic but their aspirations were poignantly modest. The aim was to convince them that education was a portal into a bigger, better, more exciting world of opportunities.

The idea of a magic door that opens on to wonderful new worlds is a

10 The 'School Assembly' is a daily event in schools in Britain, mandated by the 1944 Education Act. It involves the whole school – all the age cohorts – usually in the school hall. It was intended to be a short period of common worship; and in Catholic schools it tends to be linked to the catechetical programme and also to include 'morning prayers'. It was traditionally described as being intended 'to provide the opportunity for young people to consider spiritual and moral issues, to develop community spirit and reinforce positive attitudes'; but in a more multi-cultural situation this has altered such that many view the assembly as 'when the school community, or a part of it, meets together to share aspects of life that are of worth'.

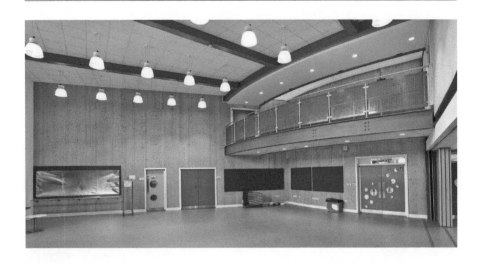

much-loved theme in children's literature and arguably few authors have used it more skilfully than C. S. Lewis, from the wardrobe door in *The Lion, the Witch and the Wardrobe* to the stable door of *The Last Battle*. The stories build to a final realisation:

'I see,' she said at last, thoughtfully. 'I see now. This garden is like the stable. It is far bigger inside than it was outside.'

'Of course, daughter of Eve,' said the Faun, 'the farther up and the farther in you go, the bigger everything gets. The inside is larger than the outside.'

Lucy looked hard at the garden and saw that it was not really a garden but a whole world, with its own rivers and woods and sea and mountains. But they were not strange: she knew them all.

'I see,' she said. 'This is still Narnia, and more real and more beautiful than the Narnia down below, just as it was more real and more beautiful than the Narnia outside the stable door! See ... world within world, Narnia within Narnia.'[11]

This is the building we designed. An arc-like plan, entered at the centre of the circle, the rooms increased in size from door to window wall. As the children progressed through the school they rose higher in the building and their rooms were larger. Each room gave access to external teaching areas,

11 Lewis (1956), 168–9.

Opposite: School hall with curved bridge.

Left: Circular vision panel to school door.

encouraging engagement with the natural environment. Each child could trace their progression by their physical location. The building told them this. Each classroom was unique, just like them.

When they came together for liturgy, assembly or shared food they entered the central space through a double door into a space confined overheard by a curved red steel bridge – the connection between Key Stage One and Key Stage Two.[12] To cross that bridge was a rite of passage in itself! Beyond the bridge on the entrance floor the space expanded wider and higher, beyond two storeys, supported by outwardly radiating red steel I-section beams. It was as if the space continued to expand further and further, beyond the curved glazed end wall and out into the wider world of adventure and achievement.

A bespoke 'tree of life' crucifix, hand-carved in lime wood, was hung on the timber wall of the hall. A bespoke folding altar, ambo and vestments were designed and used initially at the opening Mass, celebrated by the cardinal, with the readers positioned overhead on the red steel bridge. The congregation faced away from the window walls and the raking walls, focusing all attention on the liturgy.

The building, which aimed to be an exemplar of the possible, was de-

12 These are currently the most significant divisions with the National Curriculum in use in England and Wales. Key Stage One (= Years 1 and 2) is for children aged five to seven years; Key Stage Two (= Years 3 to 6) is for children aged seven to eleven years.

signed to be ecologically pioneering, employing a hybrid structure of steel and cross-laminated timber construction, highly insulated with ecologically designed energy management systems. A preferential option for sustainability was exercised in the design wherever possible, and when Cardinal Nichols held a press conference to launch the papal encyclical concerned with integral ecology, *Laudato Si'*, he did so from the roof terrace of this building, with the towers of Canary Wharf forming the backdrop.[13] This was a building, rooted in the story of the community it served, telling a new story to all those who had ears to hear.

The Return to Ronchamp

Forty-seven years after my first visit, I returned, with my husband – who had also been there on the 1975 visit. We were journeying home from our daughter's wedding in Denmark and realised we were close by. 'Shall we go back and make the sketch we never made?' we asked, knowing that this was a kind of homecoming too.

It was a beautiful morning, just like before, but there have been changes. There is a visitor centre and a convent, both designed by Renzo Piano. As we walked up the steep path, time collapsed and we would not have been surprised to see members of our student group sitting on the grass. We felt the imprint of their presence.

We sat and sketched. One of the religious sisters exchanged a few words with us. I sketched the external sanctuary and remembered the architectural dance of our long-gone guide. Then we stepped inside.

The liturgical space was empty, soaring over our heads, but here were the chapels, scaled down to meet humanity, and the recesses that were just high enough to walk into. I walked into one to remind my body memory – place within space. There was scaffolding on the south wall externally so the jewelled lights were subdued but the contrast through the open doors and the hidden roof lights at the top of each chapel tower provided the drama of light and darkness I remembered.

And then, I sang. I sang the Canticle of the Sun, beginning with 'The heavens are telling the Glory of God … ', because it is joyous, and we had sung

13 Pope Francis published his encyclical *Laudato Si'* on 24 May 2015. It is to be found at: https:// www.vatican.va/content/francesco/en/encyclicals/documents/papa-francesco_20150524_enciclica-laudato-si.html.

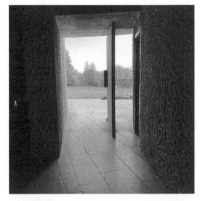

Light from the landscape floods into the dark chapel interior.

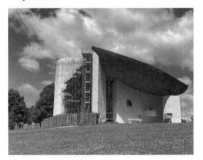

Human scale spaces in the chapel at Ronchamp.

Ronchamp today.

A sketch by the author.

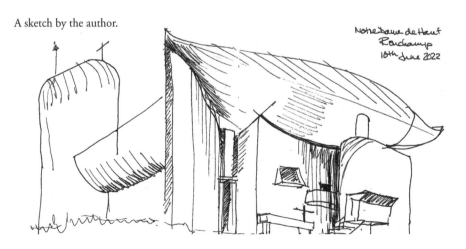

it at our daughter's wedding a few days earlier. Just as before, the sound filled the space and it sounded as though other voices joined mine. I had brought them with me: the long-ago guide, the younger student friends, the bride and the groom. I had come full circle.

My first visit, as a young girl, was as an architectural tourist. Now I am the older woman, my daughter is the young girl and I am not a tourist, but a pilgrim, and this time I have ears to hear the full story.

12

'A place made up of persons, faces, warm with life and the beating of hearts'

Margaret Daly-Denton

The story of the Liturgy Room designed by Richard Hurley for the Irish Institute of Pastoral Liturgy begins in Mount St Anne's, Portarlington, County Laois, where the Presentation Sisters generously hosted the Institute during its infancy years (1974–78). Its founder/director, Fr Seán Swayne, was appointed as National Secretary for Liturgy in 1973, on his return from liturgical studies in Paris. His brief was to work for the implementation of *SC* throughout Ireland. He founded the Institute out of a burning conviction that liturgical formation is the key to liturgical renewal. The sisters not only provided the premises for this new venture, but they appointed several sisters to serve in catering and housekeeping roles. A chapel had been added on to the original Morrison mansion in the 1960s. Its layout showed scant awareness of the oncoming liturgical renewal that would transform church design. With its three-tiered ranks of choir stalls to accommodate sixty sisters, its raised sanctuary at right angles to their natural sight line, and its undistinguished commercial stained glass filling the side walls, it could not but work against post-Second Vatican Council liturgy. Seán commissioned Richard to treat it to a liturgical reordering.

The principal challenge, I imagine, of Seán's brief to the architect was that, because of the Institute's sojourner status, there was no possibility of altering the chapel's fabric or permanent fittings. There were, however, other challenges. The core assembly that would people the liturgical space consisted mainly of the students doing a residential one-year course in pastoral liturgy. In the first year (1974–75), for example, there were ten priests, four religious

sisters and one lay student. Including the staff and the visiting lecturers, there would typically be about twenty people at the daily Eucharist. All in residence at the Institute also celebrated Morning and Evening Prayer in the chapel each day. On Sundays the congregation would expand when the Institute welcomed groups from parishes all over Ireland. On their arrival (literally in busloads!) in the early afternoon they were offered refreshments. Seán gave them a talk about liturgy, then the Institute's students led them in group reflection on the day's Lectionary readings. A rehearsal of the music followed. After the 5.00 p.m. Eucharist, all enjoyed a time of fellowship over a mug of soup and some bread (the best sustenance for their journey home that could be devised with the limited facilities available). Sung Evening Prayer followed at 7.00 p.m., for most people a first experience of the Liturgy of the Hours.

Richard designed an elegant square altar, unmistakably a table, to stand in the space between the choir stalls. It was surrounded by an oval arrangement of about twenty stools, upholstered in a bright Kelly-green fabric. At one end of the oval was the presider's chair, distinguished from the stools only by its slightly more ample design. Completing the oval at the other end was the ambo. The timber for all these elements was ash. Richard commissioned Sister Rosaleen McCabe to make altar cloths and ambo falls in the liturgical colours. She made these of traditional Irish handwoven tweed with embroidery in wool, appliqué and beads. The strong colours of the textiles and the vestments (also designed by Rosaleen) drew the eye away from the distracting aspects of the environment towards the liturgical action. Richard also commissioned a processional cross from Seán Adamson. In his brief to the sculptor, he asked that it portray the crucified and glorified Jesus lifted up from the earth, drawing all to himself (John 12:32). The resulting bronze figure, with hands freed from the cross and reaching out, elicited a memorable response from a child on a school visit to the Institute: 'He is welcoming us.' This reordering was an early essay in what Richard would later come to call the antiphonal arrangement of liturgical space. Initially forced upon him by the given features of the Mount St Anne's chapel, this approach was to become immensely fruitful in his later work.

At the weekday Eucharist the stools accommodated the concelebrants (concelebration being de rigueur at the time,) while the much smaller num-

ber of lay persons sat in the choir stalls. This arrangement, imposed by the givens of the space, tended to create a stadium-like effect. Besides, a liturgical assembly with so many more clergy than laity was somewhat top-heavy. Seán, conscious of this, suggested that before the eucharistic celebration began each priest might come in informally and sit down, rather than having what he described as a phalanx of concelebrants in procession bearing down on a little group of half a dozen women. It is an indication of where liturgical renewal was at in 1974 that one priest objected, 'At that rate I might as well be a lay person.' Presumably, by the end of his year's study he knew better.

On Sundays, with the diocesan priests returning to their parishes at the weekend, there were fewer concelebrants. The spare stools were needed to accommodate the visiting parish groups and this significantly mitigated the clerical-lay divide. Even the rigidity of the choir stalls was surprisingly softened as the people filled them to capacity. Often additional seating had to be brought in. On those occasions the overflowing chapel with the table at its centre was undoubtedly an experience of the liturgy as what Richard would call 'the people's environment'.[1] My first experience of the Eucharist celebrated at an altar-table placed in the centre of the assembly coincided with my early learning, as one of the first class of students at the Institute, about the awe-inspiring rites of Christian initiation. I found myself recalling St Ambrose, addressing the newly baptised and making much of their joy when, for the first time, they drew near the altar[2] and saw what they had not been permitted to see before,[3] 'the sacraments on the altar',[4] clearly the eucharistic bread and wine. For the first time, I realised that to come close to the church's table, to be able to see at close quarters how well it has been designed, how beautifully it has been made and how worthily it is dressed is one of the major privileges that the faithful enjoy.

By the time the Institute had developed to the point that it needed its own premises, Richard had become a frequent and much appreciated presence there, as a lecturer on the year course, as a speaker at numerous gatherings of architects and artists, as a member (and chairman for ten years) of the Advisory Committee to the Bishops on Church Art and Architecture, and, above

1 Hurley (1997), 32.
2 *De Sacramentis* 3, 11.
3 3, 14; and 4, 5.
4 4, 8.

all, as a liturgically knowledgeable dialogue partner in a mutually mentoring friendship with Seán.[5] His conceptualisation of the Institute's new worship space would, therefore, be the outcome of his profound rapport with its aim and spirit, as described by Seán in the five words – refreshment, banquet, praise, word, outreach.[6]

Seán's vision for the Institute was inspired by the Benedictine ideal of a hospitality that welcomes people to fellowship and food as well as to worship. Choosing as a motto Augustine's saying, 'Restless is the heart until it rests in God', he was overjoyed when, for example, a priest going through a difficult time asked if he could come and stay for a while. A key figure in the fulfilment of this vision was Sister Rose Wright, the Institute's cook, who loved people to come into her kitchen at any time and sit down for a cup of tea or coffee and a chat. It was often remarked that the best theological discussion took place, frequently well into the night, around that welcoming kitchen table.

In 1978 Richard was tasked with designing the refurbishment of the former Junior House of St Patrick's College, Carlow, which Bishop Patrick Lennon of Kildare and Leighlin Diocese had made available to become the Institute's new location. This involved the design of a reception area, lecture room, library, offices, common room, kitchen and dining facilities, a bookshop, accommodation for the team and, of course, the liturgical space. The Diocese of Kildare and Leighlin financed the refurbishment of the building's fabric. The Peter Collins pipe organ had already been purchased with a grant from the Irish Episcopal Conference. All the furnishings and equipment of the new Institute were the gift of the People of God, who responded with alacrity to a fund-raising appeal. To look back on such generosity brings wistful memories of the enthusiasm at that time for the liberating freshness of conciliar thinking, a time when liturgical renewal was truly recognised as the work of the Spirit.

A beautifully proportioned former study hall on the ground floor, dating from 1818, with elegant Georgian-style fanlight windows, was the obvious place for the Institute's new chapel. However, Richard was adamant that it would not be a chapel, but a Liturgy Room. The setting for the celebration

5 Jones (2011), 14.
6 Swayne (1979), 12–3.

of the liturgy was to be a special room in the Liturgy Institute's home. When people entered the Institute, they would find themselves in a spacious mall, a gathering space with an open-plan coffee dock where they would be offered refreshments. To the left of the mall was the Liturgy Room with its welcoming eucharistic table; to the right, the open commensality of the kitchen and dining area. In another generous gesture, the Presentation Sisters had seconded Sister Rose to the Institute. So Richard ensured that her new kitchen would feature a large central table over which she could hospitably preside.

Explaining the thinking behind the Liturgy Room, Seán wrote,

> The concept ... is that of a banquet hall. It is the room of the *sacrum convivium* arranged to reflect the Missal's description of the Mass as 'the gathering together of the people of God under the presidency of a priest, presiding in the name of Christ, to celebrate the memorial of the Lord, or eucharistic sacrifice' (*GIRM*, 7). The great table-altar, standing on an oval rug, dominates the space, and seems to beckon the assembly to gather around. By taking his place at the head of the table during the Eucharistic Prayer the priest avoids a polarised or confronting situation, and is seen as part of the assembly, while yet presiding over it.[7]

I treasure my memories of the gradual coming together of the Liturgy Room: the painting of the ceiling and walls in white, the laying of white tiles on the floor, (eliciting from one priest who peeked into the room at that early stage the comment, 'An operating theatre!'), the arrival of a creamy white hand-woven oval carpet, and then the new altar, similar in style to the Mount St Anne's one, but long rather than square, the placing of the ambo and presider's chair from Mount St Anne's in their new location at each end of a much larger oval arrangement of stools, two large *ficus* trees in white planters, new altar cloths in the liturgical colours created by Rosaleen, the mounting on a side wall of a Madonna and Child in terracotta by Benedict Tutty OSB, the stronger impact of the processional cross when placed in its new setting against a less distracting background, the contemplative Blessed Sacrament Chapel with its tabernacle in silver and rock crystal by Peter Donovan, set against a small window so that it could be a source of light. When one entered the Liturgy Room at quiet times, one tended to be struck by its

7 Swayne (1986).

'At one time joyful and bright, cool and empty': the chapel in St Mary's Abbey, Glencairn. A model case where a re-ordering was ordered according to the principle of form following function.

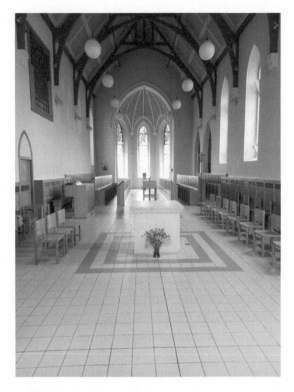

whiteness: 'at one time joyful and bright, cool and empty'.[8]

It was a place of dignity and repose, but also an expectant room awaiting the arrival of the assembly whose clothes, including the priests' vestments, would bring colour and life into it. During the liturgy, it truly became 'a place made up of persons, faces, warm with life and the beating of hearts, serving the assembled community in a simple form'.[9] R. Kevin Seasoltz OSB included the following description of the Liturgy Room in his book, *A Sense of the Sacred.*

> In some ways the ambiance was reminiscent of Cistercian churches, which traditionally have placed emphasis on interiority and simplicity; at Carlow the emphasis was not only on awe and mystery but also on the whole assembly as the celebrant of the liturgy. A totally

8 From the critique of another of Richard's projects, St Mary's Abbey, Glencairn, in Hastings (1994).
9 Richard Hurley (1974), 15.

different environment was created in the Blessed Sacrament chapel, an intimate area off the space for the eucharist, conveying a sense of peace and withdrawal, a place for personal prayer and quiet reflection.[10]

The Liturgy Room embodied to perfection that 'noble simplicity' called for in the Liturgy Constitution of the Second Vatican Council. Richard's vision for it was informed by his familiarity with the work of the early twentieth-century German and Swiss architects who were inspired by the Liturgical Movement, particularly those who came under the influence of Romano Guardini. These architects took church building in a new direction, resisting monumentality and the imitation of historic styles in the belief that they were somehow more sacral than contemporary idioms. Richard particularly admired the work of Rudolf Schwarz. He also formed a fruitful friendship with Ottokar Uhl. However, he regarded Emil Steffann, who was inspired by St Francis of Assisi, as 'the greatest of them all'.

> The special Christian qualities that Steffan possessed were his spirit coupled with his sparkling authenticity. Above all, he succeeded in equating poverty and transcendence in a way that neither time nor place can touch, precisely because he understood so well that 'less is more' and that Christian witness embodies both this idea and also the idea that the paschal gathering is a microcosm of the entire Church of God.[11]

'Less' was most definitely 'more' in Carlow. And in Richard's insistence that the Institute's worship space was not a chapel but a Liturgy Room, the echo of Rudolf Schwarz's *Liturgieraum* was loud and clear. As his essay for the journal *Worship* (reprinted in this volume) shows, Richard resonated deeply with Schwarz's view of the church architect's task:

> … to build churches out of that reality which we experience and verify every day, to take this, our own reality, so seriously and to recognize it to be so holy that it may be able to enter in before God … and beyond all this to guard ourselves against repeating the old words when for us no living content is connected with them.[12]

An interesting fact about Schwarz is that when he drew up his plans for

10 Seasoltz (2005), 268.
11 Hurley (1974), 15.
12 Schwarz (1958), 11; and Hurley (1996).

173

churches he always sketched in the people. As he explained, 'they are one of the building materials or far better, it is out of their ordering that the structure takes form'.[13] He believed that each person brings into the liturgical environment 'the full warmth of [their] heart and yields it without reserve'.[14] For Schwarz, the liturgical environment was 'not merely a walled shelter, but everything together: building and people, body and soul, the human beings and Christ, a whole spiritual universe – a universe indeed, which must ever be brought into reality anew'.[15] All of this could have been written about the Carlow Liturgy Room.

We who lived through the coming into being of the Liturgy Room had grown up worshipping in theatre-like churches, resolutely divided into sanctuary (the holy end!) and nave. Now Richard was giving us a profound lesson in ecclesiology: the whole liturgical space was holy. Or, to use his own words, 'There was no "sanctuary" ... only an expression of ritual space and the integration of everyone who participates in it.'[16] In our previous liturgical experience, we had seen only the backs of our fellow worshippers' heads. Now we could see their faces. Some people felt a little too exposed and I recall Richard saying that several stools should be placed near the entry doors, so that those who did not feel comfortable sitting in the oval formation could remain on the fringe of the assembly if they wished. In Mount St Anne's the laity had occupied the 'bleachers', leaving the 'playing pitch' to the concelebrants. This was not at Richard's bidding, but out of an instinctive deference, as if it would be rather brash to sit down beside a concelebrant! In Carlow, however, all were on the same floor level. All were seated on the stools. A layperson could find herself sitting right beside the presiding celebrant's chair.

When preparing to write this piece, I asked a few people who had experienced Sundays at the Liturgy Institute in the 1970s and 80s for their memories and impressions of the Liturgy Room. I expected that they would say something about being close to the altar or feeling really involved in the liturgy, but without exception the first thing they mentioned was hospitality. That is why it has been impossible to write about the Liturgy Room without mentioning cups of coffee, mugs of soup and that welcoming kitchen table!

13 Schwarz (1958), 36.
14 Schwarz (1958), 42.
15 Schwarz (1958), 212.
16 Hurley (2001), 95.

On reflection, this is hardly surprising.

> As common prayer and ecclesial experience, liturgy flourishes in a climate of hospitality: a situation in which people are comfortable with one another, either knowing or being introduced to one another; a space in which people are seated together, with mobility, in view of one another as well as the focal points of the rite, involved as participants and *not* as spectators.[17]

Significantly, when Seasoltz explains in his description of the Liturgy Room that 'the institute was the brainchild of Monsignor Seán Swayne, a very gifted and tireless worker for liturgical reform and renewal', he notes that Seán was 'distinguished by his genuine spirit of Christian hospitality'.[18] Seán was always conscious of the fragility of the Liturgy Institute, set up, as he used to say, 'with the bishops' blessing and not much else'. As it turned out, it flourished for a time and then wilted. With uncanny prescience, Seán used to quote a French proverb: *Les danses que nous avons dansées qui peut nous les enlever.* The Church danced in Richard's Liturgy Room and no one can take that away.

17 US Conference of Catholic Bishops (1978), 11.
18 Seasoltz (2005), 268.

13

The Church of the Community of the Resurrection

George Guiver CR

Push open a door and go into the unfolding space beyond and you are taken over. When I am in a church I feel it with my pores, breathe its air, its sounds, its smells. In the promptings my senses pick up there is the most unfathomable sensation, a sense of being-somewhere, in an environment and at its mercy. I sense this place all around me. Photographs of churches are informative, but often come over as any old church, compared with the experience of being in it. People who know the church of our community and watch our services regularly on line have commented that, in coming here eventually to a service, the difference in being here takes their breath away. People love photographing striking scenery nowadays, with such unexciting results as to demonstrate that trying to capture views is usually a waste of time. In the current debate over streaming of worship I have not noticed this particular truth much to the fore. Every building has its genius, some of them blessed with more genius than others. Organisations like the Redundant Churches Trust do an invaluable job in keeping unused churches open to the public, but it can be very apparent to visitors that the spirit has gone out of them. If a church interior is music playing round the clock, then we must be very judicious in living with it, and in tinkering with it. Conversely, many a building's 'music' is muffled by bad design and arrangement, and then we must discern how the place's genius may be let out of prison. To alter the interior of a church is always risky.

With the worship-space of a monastic community the challenges are particularly taxing. The church of the Community of the Resurrection is pret-

ty big – a fine and unusual work by the early twentieth-century architect Walter Tapper.[1] There was, however, little in it of artistic merit, and when the electrics and heating collapsed, at a time when increasing numbers were coming to the church for different purposes, it seemed a moment to seize the opportunity. The monastic choir was in a well two steps down, banishing more infirm brothers, while the much-used eastern Chapel of the Resurrection presented a total of seven steps up. The most brilliant achievement of our architects was to persuade us to clear everything out and level the entire floor. From there everything was designed anew. The choir stalls went, all the altars went, the pews, the mediocre art works, all the steps and levels, all of it went, as we were encouraged to treat the empty building as a blank cheque. Some of them were loved, a lot of them heirlooms of brethren's whole life in community going back over half a century. (Where items are of value for aesthetic or other reasons you have to take that seriously, and one small chapel in a corner, that of the Holy Cross, we left as it was with its three steps, not to do a disservice to the architecture.) We were lucky in having architects who encouraged us to be bold, and were lucky too in being a religious community, a little bit trained in not hanging on to things.

A big challenge was that, however good the architects are, they cannot be monks, and cannot know from the inside what can foster the place's genius, however much we tried to explain ourselves. Our architects, after a variety of rejected designs, produced a solution by introducing us to a programme called Sketchup: without any great expertise you can use this to build a computer model of the building that you can walk around on screen.[2] They let us produce our ideas. The 'genius' in fact was not simply a truth about the building, but about it as an extension of us, our bodies and our life. What is done with buildings can often be helped by having a key word, and ours was 'monastic'. In chapter meetings we walked around our model on screen, trying ideas as we went – an altar could be pulled out of the ground in a jiffy, furniture could be created and moved around. We tried different things, discussed and installed features, including light fittings and choir stalls, all designed with Sketchup, and then handed them over to the architects to make a professional job of them.

1 For an illustrated history of the church and its reordering, see: Stott (2017); obtainable from The Bookshop, Mirfield, WF14 0BN [£6 + pp.].
2 Sketchup 8 is easier to use than later versions.

A moment in the process of design – a still from Sketchup.

What were our parameters? I have mentioned the overriding monastic parameter, characterised by practical considerations arising from how the community goes about things in the church, and by a concern for a building that would, as it were, 'bring people to their knees'. Central, too, was a desire to bring out the genius of Walter Tapper's architecture. There were other users to consider as well: the students of our theological college and their participation in much of our worship; being a good exemplar to them of what is important in the character, design and furnishing in a church. There were growing numbers of visitors and groups coming to stay, and often praying together in various ways in the church. There were other educational partners on our site, and also the wider church coming for meetings, parish visits and the like. The monastic church ought to meet them where they are, but also open new vistas, and offer visions of what their own church could be like.

It was quite a journey. The community chapter argued over every inch, it is fair to say – the corporate effort was a sweat, but, surprisingly, it paid off, not least in a common sense of ownership. We created a pilgrimage route around the church telling the story of salvation, each stopping-point with a work of art as a focus, six of which were new commissions funded by donors. We weren't experienced at all in this, but wanted to avoid the mediocrity that characterises so much in British churches, and give an example people might be encouraged to follow. One particular bone of contention was introducing a font. Some brothers said monasteries don't have fonts. Others however

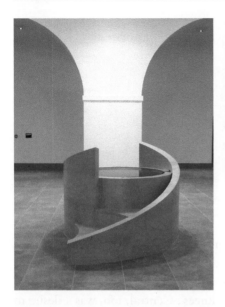

Above: The Resurrection Chapel.

Left: The new font: the Church is rediscovering baptism as a fundamental focus of the Christian life.

pointed to school classes coming here who could be taught about baptism, to the fact that we do occasional baptisms anyway, in a measly bowl on a table. It was also said the Church is rediscovering baptism as a fundamental focus of the Christian life, something no less true for monasticism. We struggled endlessly over size and design, but in the end took one of the architects' ideas, completely transformed it with Sketchup, and then voted on it. The outcome was that we agreed to have a 'cantharus', which was a fountain at the entrance of ancient churches at which people washed themselves before worship (the relic of the cantharus of old St Peter's in Rome is the pineapple in St Peter's Square). The water would be in a large dish in the top. For baptisms the dish would be removed, revealing a deep bowl that can be filled with a ton of water, so becoming a total-immersion font. In Eastertide the Sunday Eucharist begins at this font. Some babies have been baptised in it by sprinkling, and one adult so far by total immersion. When a brother makes his final vows the rite begins at the font – for the life of religious brothers and sisters is simply a living-out of their baptism.

In addition to the font, we knew that we needed choir stalls that were a bold expression of what we were about, a high altar that was a strong focus, and a lectern as a visual focus for the Word. The eastern chapel, the Resur-

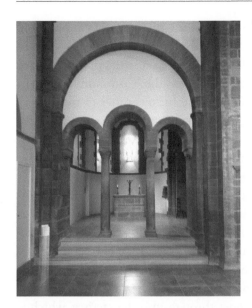

The Chapel of the Holy Cross.

rection Chapel, similar to the Lady Chapel behind the high altar of many cathedrals, is a focus for our prayer and the place of our weekday Eucharist. That too needed to be a space with a freestanding altar as a strong focus, and laid out for the community with its guests to gather round. We wanted to continue having the hanging pyx with the Reserved Sacrament, and we wanted the chapel to be a place that 'brings people to their knees'.

Secondly, our over-mentalised Christianity needs to rediscover the prime importance of bodily practices in prayer and the imaginative use of the physical space. In the eastern Orthodox traditions there is an unselfconscious confidence to public worship: the whole building is used and people move about it as freedly as if it were their own home. We need to learn from this, in our static culture of sitting and looking in one direction (this staying-put is largely motivated by fear, as people in church don't feel free to be themselves or step out of line). Why do people put fonts at the front, when a font at the back gives an opportunity for everyone actually to move? Why do everything in one spot? It encourages over-spiritualised and over-personal religion. In using various parts of the building and coaxing people out of their seats we are in fact speaking to what people yearn for, though through awkwardness they avoid it like the plague. We struggle to 'get through to'

our over-mentalised God, while the trail to God is often waiting to be blazed by our bodies. In our daily Eucharist in the Resurrection Chapel at Mirfield a bench runs round the wall and the lectern is set at the opposite end of the chapel to the altar (what the Germans called the 'Communio' model). The synaxis is at the lectern; at the Peace the ministers move to the altar at the other end and everyone turns in the other direction. On great feasts we begin Evensong with a procession, usually from the Resurrection Chapel. We have less success here, so far, in encouraging everyone to mill around hugger-mugger – British people look for a grid to fit into for safety!

We are doing better with such use of other parts of the building, for instance with the 'Stations of Salvation'. This has proved very popular for groups and individuals. You start with the Incarnation, marked by an icon of John the Baptist, the statue of Our Lady with Jesus, and also a design of the Nativity on the glass doors of the sacristy. It so happens that this is the location of the tomb of Charles Gore, a great promoter of the importance of the Incarnation. Then the group goes through into the sacristy, which is also St James's Chapel, with artworks about St James, appropriate for beginning a pilgrimage round the church, but also focusing the mind on Christ's ministry. Then to the adjacent Chapel of the Holy Cross for the crucifixion, and on to the Resurrection Chapel, where Nicholas Mynheer's Resurrection carvings guide you round the back where you see that the whole altar is a sepulchre with the stone rolled away. (The sepulchre entrance can also enable a brother in a wheelchair to celebrate there, his knees going inside – one foot in the grave, as one brother quipped.)

The next Chapel around is the Reconciliation Chapel, with glass engravings about Mary Magdalene by Mark Cazalet, and inside an intimate carpeted space for people to pray, amid the ethereal, exalting effect of the illuminated engraved screens. It is a place for counselling and confessions – in other words for the healing and reconciliation that flow from the resurrection. Continuing around, we come to the station of the Ascension, with a large icon-triptych painted by Sister Johanna Reitlinger in the 1930s. Christ is enthroned in glory, his feet on the wings of the wind, flanked by Sts Basil and Seraphim of Sarov, and again, happily, the adjacent tomb is of Walter Frere, one of whose accomplishments was his pioneering work with the Russian Orthodox, as well as his awareness of the developing Liturgical Movement,

and its rediscovered centrality of the Paschal Mystery. The adjacent glass entrance doors show the Ascension of Elijah. Thence a journey through the tunnel of the south aisle to the cantharus/font and Pentecost. The swirling design of the font evokes something of the corkscrew-shaped images of Babel in medieval paintings. The Spirit breathes over the waters in a gentle jet of air. Finally, we return the length of the church to gather round the High Altar, dedicated to the Holy Trinity, and made of stone packed with fossils 350 million years old, including sharks' teeth. It is elemental, evocative of the unimaginable ages of the Universe, and of the timelessness and wonder of God the Holy Trinity.

Despite its many aberrations throughout history, monastic worship traditionally should be simple, and the place of prayer simple, bringing stillness. We commissioned the works of art because of our pastoral engagement, but when you stand at the back of the church and look towards the altar you can't see any of them. People comment on the eloquence of the church's simplicity. For the church building of the future we need to take art more seriously, not only by commissioning works of art, but also by seeing the whole design and layout of the building as a work of art, awakening our artistic sensibilities and expectations, and expressing truthfully the character of the worshipping community. The Italians have an outstanding gift for design and arranging things in a space, but it doesn't get into their churches, whose furnishings are generally poorly designed with little thought for the overall composition of the interior space. In Britain we have been on a journey of becoming much more artistic and this is increasingly evident even in people's homes. As in Italy, however, you cannot expect to find British church interiors arranged with much artistic sense: flower arrangements plonked in an ad hoc way on an old stool designed for something else; things propped up or stuck any old how without regard to how they sing in their setting; mediocre design of furnishings and vestments; unevenly-hung frontals, battered fittings and clutter. It might be thought endearing, but what truths does it pinpoint? One country where things are often different is Germany: there you can find care taken in the design, layout and cleanliness of churches. People in the congregation seem to have more of a sense for the presentation and quality of every item – this isn't elitist, it's part of everyone's culture, and of the attitude to the church building. How the worship-space looks is im-

portant because it opens doors that otherwise are shut or merely ajar, doors of perception and a sense of what we are about. It removes impediments to the Gospel. Such care must come up from below – there is not much to be gained from experts insisting on arrangements the congregation haven't owned. Formation is needed in training of eyes and expectations, not to make people churchy-arty, but as a contribution to our society, holding up standards of care about how our humanity is expressed, and, for Christians, how our faith is rejoiced in. Today we often try too hard to make worship enthusiastic – this is partly because the worship-space has not been enabled to do its important work for us. In a good church interior whose genius affects people, you don't need to try so hard in worship. It says something about our approach to worship today that a service can more easily be praised for being exciting than for being serious. There is a circular dynamic here: a community that finds the love of God in a building will be people who are already loving what goes on in it, and will be feeling fruits in themselves, and sense themselves to be growing in that love, which somehow manages to imprint itself back on how the building looks and feels. The building cannot simply stand there like a painting in a gallery – it must be in an ever-developing relationship with a living community, and its genius is as much of the people as of the stones.

There is great interest in secular use of the church building today: you can find art exhibitions, markets, sit-down meals – in one exceptionally large parish church wonderfully cleared of all its pews I encountered a youth band playing to passers-by in one corner, a coffee bar in another, and various kinds of stalls and activities around the building that engaged the visitors. It's certainly right to attract people into church buildings in this way: it is a step towards the gospel feeling more accessible than it seemed, and a necessary element in contemporary mission. But – we are not always so good on the fine-tuning. The divine voice in the building can be lost by it becoming a mere venue, and such secular use is, in fact, a give-away test of the spiritual life of the church community – how far it can feel at ease if its building is used as a mere venue. How motivated are we to seek to give people a sense that this is a place of prayer? How far are we prepared to go without undermining the spiritual life of the community? In our monastic church at Mirfield we sometimes have concerts and recitals, and the local secondary

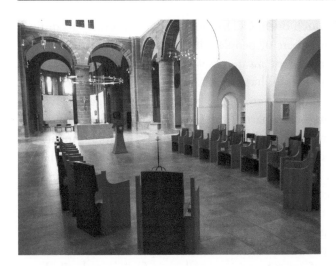

The church as it is today.

school uses the church every year for its Christmas concert, with hundreds of rather surprised families coming into this unusual space. However, when someone suggested we hold a dinner in it as part of our fundraising campaign, we instinctively knew it was impossible – the clash, and the following reverberations, would be too great. If no difference is marked between God and daily life, then we will cease to be able to see God in daily life. Ours is a monastic church, and the sensibilities will be different in a parish church, but the same principles apply, resting on how strong our life of prayer is, and our sense of the living culture (for want of a better word) of the prayer of the Body of Christ and its places of encounter with God.

Apart from the stone fixtures of font and two altars, we were sure everything else in the building needed to be moveable. We had to discover what worked best once we were back in, and we have found ourselves trying different arrangements. Needs also change over time, and it is also good to make the building as flexible as possible for special uses such as concerts and exhibitions. In some areas there had to be a trade-off: for instance the altars have no steps, simply rising out of the expanse of the floor. This enables infirm brothers to function at the altar when before they could not. On occasions when the church is full, many people cannot see anything. We decided, however, that in a monastic church the community's common life has to have priority, and such large services are only occasional. Accessibility

includes leaving the church open. CCTV helps protect it, but its recordings also reveal to us the numbers of people who come in unseen to look and to pray – far more than we are aware of. We take the risk, and every now and again something unhelpful happens, but we need to go to the greatest lengths to ensure our churches are open, because I would go so far as to say that church buildings are a part of the Gospel. Christ's good news is by explicit intention for real human beings, and there is a profound instinct in human beings for special places. Horace said you may drive human nature out with a pitchfork, but it will always come back by the back door. The instinct will always be there, not only to help us to pray, but also because of our desire physically to mark what is important for us. A building can work on our behalf, keeping a hold on things we repeatedly allow to slip through our fingers: it has the power to remind, to wake us up as we walk in from the street, to build, to transform. One visitor, perhaps referring to the Prologue of the Rule of St Benedict, v. 49, said of our monastic church that it was 'a place for the heart to grow large in'.

14

Shaping Space:
Some Examples from the US

John F. Baldovin SJ

In 2000 the US Conference of Catholic Bishops issued a statement, *Built of Living Stones: Art, Architecture and Worship* (*BLS*).[1] It was meant to replace a 1978 document of the US Bishops' Committee on the Liturgy, *Environment and Art in Catholic Worship*.[2] The latter document had been criticised for being too progressive and 'modernist'. One of the sticking points was the relegation of the place for reservation of the Eucharist to more or less of an afterthought. Despite the fact that *BLS* is a very balanced document, the liturgical architecture wars continue, with a number of new and relatively new churches built in what I will refer to as a classic style, i.e. a nave with a longitudinal central aisle, side aisles leading up to a sanctuary space (called a *presbyterium* in the official Roman documents), with or without an altar rail, and a tabernacle on a pedestal centred behind a free-standing altar. A good example is the Chapel of the Holy Cross at Jesuit High School in Tampa, dedicated in 2018. This chapel is a deliberate (perhaps one could say provocative) throwback to a pre-Second Vatican Council style of church building, with a free-standing altar so located visually that one would think it was an altar set against the 'east' wall except when ministers are behind it.

To be sure, an argument could be made that all of the basic principles of *BLS* were followed in the design of this chapel, but it seems to me that the Tampa Chapel does not suit the spirit of that document.

I count four basic principles in the US Bishops' document:

1 US Conference of Catholic Bishops (2000).
2 US Conference of Catholic Bishops (1978).

187

- The building must serve needs of the liturgy, primarily the celebration of the Eucharist: n. 28.
- It must be a building of 'noble beauty': n. 29.
- It must image the gathered assembly and foster active participation: nn. 30–31.
- It should respect the various roles exercised in the liturgical celebration: n. 32.

In addition, it is important to note that when it comes to describing the church building itself, *BLS* begins with the space for the gathered assembly rather than the 'sanctuary', and makes it clear that in the liturgy there is 'no audience'.[3] Here I think is a very important test for a space that suits the reformed Catholic liturgy: does the space give the impression that the assembled constitute an audience? If that is the case, then it seems to me that it will be difficult to celebrate the liturgy as the Church conceives it. I admit that there are a number of commentators on liturgical environment who would disagree with me vigorously.[4]

In what follows I aim to discuss five different worship spaces or situations that I have encountered over my almost fifty years of ordained ministry. Each space is unique but all are meant to serve the four basic principles enumerated above in the spirit of the post-Conciliar liturgical reform.

1. St Joseph's Cathedral Basilica, San Jose, California

Located in the heart of downtown San Jose, the original church on this site was built in 1803 and served as parish church of the Archdiocese of San Francisco. Until around 1992 it was staffed by the Jesuits. After the establishment of the Diocese of San Jose, Bishop Pierre Dumaine designated the church as a cathedral and began the process of major renovation of the space. Since I was teaching liturgy at the Jesuit School of Theology in Berkeley at the time I was kindly invited to participate in the planning. The church building is constructed in the form of a Greek Cross (i.e. with four equal arms) with a central dome. Prior to the renovation the arrangement of the church was the typical classical style, suited to the pre-Conciliar

3 Note that the word 'sanctuary' denotes different things to different Christian denominations. For most Protestant and Anglican churches sanctuary denotes the entirety of the worship space. What Catholics call the sanctuary they often call the chancel.
4 For example: Stroik (2012); McNamara (2009); or Schloeder (1998).

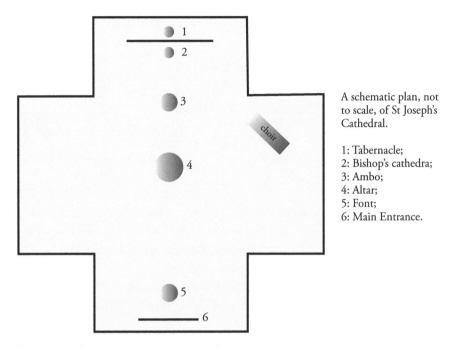

A schematic plan, not to scale, of St Joseph's Cathedral.

1: Tabernacle;
2: Bishop's cathedra;
3: Ambo;
4: Altar;
5: Font;
6: Main Entrance.

liturgy, with an altar at the east wall and the congregation in pews with a longitudinal axis. I note that St Joseph's traditionally served as a shrine for Mexican-American Catholics and had a significant space dedicated to Our Lady of Guadalupe. The cathedral was dedicated in 1991 and named a basilica by Pope John Paul II in 1997.

After some discussion we decided to make use of the unusual shape of the building and centre the altar on a platform directly beneath the dome. Given the space, the altar itself is circular and stands on a circular platform. The seating for the assembly was arranged in circular fashion with part of one arm of the cross reserved for the use of liturgical musicians and the choir. A baptismal font[5] was placed inside the main entrance of the church at the head of the aisle on a longitudinal axis with the altar, ambo and bishop's chair (*cathedra*). A low wall was constructed where the old high altar had been located and the tabernacle was placed behind it, forming its own chapel. The bishop's chair was placed immediately in front of the wall and the ambo on a longitudinal access between the altar and the chair. Differ-

5 Unfortunately, on account of engineering concerns it is not an immersion font.

Ground-plan of St
Ignatius Chapel.

1: Processional Way;
2: Entrance and narthex;
3: Baptismal font;
4: Assembly;
5: Altar platform;
6: Blessed Sacrament
Chapel.

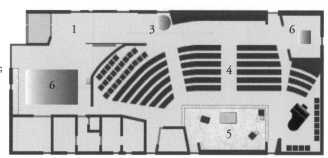

ent height levels make each of these foci easily visible. The various shrines
in the church, particularly that dedicated to Our Lady of Guadalupe, were
refurbished, and variable lighting was employed to make them more prom-
inent when the liturgy is not being celebrated.

An admittedly radical departure from the old arrangement of the build-
ing enabled the gathered assembly to participate actively in the liturgy, with
all of the major roles clearly respected.

2. St Ignatius Chapel, Seattle University

Like many Jesuit colleges and universities, Seattle University, founded in
1891, lacked a separately constructed chapel until the 1990s, when this
situation was remedied and a major construction project was approved.
Well-known New York architect Stephen Holl was commissioned to design
the church.

What is not obvious from the ground plan of the chapel is Holl's inven-
tive use of what he called 'bottles' of light, which cast different colours on
the walls at different times of the day. Approached along a reflecting pool,
the entrance leads directly to a processional path with a baptismal font
along the way, terminating in a chapel for reserving the Blessed Sacrament.
A wide entrance to the main worship space is located immediately to the
right of the font. The sacrament chapel is itself rather unique in that the
walls are covered with beeswax (giving off a rather traditional smell), the
tabernacle is placed on a low level so that someone kneeling or sitting has
quite intimate access to it, and the tabernacle lamp hangs from a Madrona
tree, which is indigenous to the area. The space for the celebration of the

Eucharist is arranged with seating that makes it clear that the people form a gathered assembly around the altar. The raised altar platform has distinct and visible places for the altar, the ambo and presider's chair.

Aside from original icons related to the life of St Ignatius of Loyola in the narthex there is very little iconography in the chapel. (A sculpture of the Virgin Mary entitled *Gratia Plena* [Full of Grace] was later placed to the right of the altar platform.) The chapel has been heavily criticised by those of a more traditional bent, both for its lack of iconography and for emphasising the gathered nature of the assembly. In my opinion Holl's use of light and colour suffices for iconography and the space for the assembly clearly reflects the Church's desire to promote active participation. The visual placement of the Blessed Sacrament Chapel is a most inventive way of making Eucharistic reservation prominent without it distracting from the main space for celebration.

3. St Leo's Church, Piedmont Avenue, Oakland, California

The parish church of St Leo the Great, located on a busy street in the Piedmont neighbourhood of Oakland, was dedicated in 1926. The church, which has a rather traditional longitudinal axis, has seen several renovations. The first, during the 1980s, was a minor renovation dealing mainly with fixing structural problems and repainting the interior. A more ambitious renovation making the altar more central was undertaken at the beginning of this century.

My reason for including St Leo's in this survey does not have so much to do with this (lovely and classic) church building as it does with the change of worship space during the first renovation in the 1980s. I helped there on Sundays for about six years and always found the congregation to be participative and appreciative. It was a well-run parish with good ministerial support. As good as the usual experience of worship was, I found that participation vastly improved during the shift to the elementary school auditorium while the church was being renovated. The change in acoustics, as well as bringing people closer together, helped to make the singing more lively, and the fact that people were 'displaced' from their normal seats in the pews enabled them to relate to one another much more actively. Though the renovation was well done it seemed to many people that some-

thing of the quality of our worship was lost when we moved back into the church. The moral of this lesson is, of course, that the disposition of the liturgical space makes a great deal of difference when it comes to liturgical celebration. The St Leo's auditorium was most certainly not a beautiful space, but the fact that the members of the assembly were enabled to inter-act more robustly made all the difference in the world.

I recall a somewhat similar experience at St Paul's Church in Harvard Square, Cambridge, Massachusetts. St Paul's is well known for its choir school and for very reverent, even elegant liturgical celebrations. The church is very classical but arranged, insofar as possible, to comply with the post-Conciliar liturgical reform. During the summers, to save on air conditioning, the 5.00 p.m. Saturday anticipated Sunday liturgy was held in the choir school auditorium. I noticed much the same change in participation. Lesson: God's grace can certainly transcend our sometimes lacklustre liturgical spaces, even though our Catholic instinct has been to house the church as beautifully as possible in whatever social and cultural circumstances we find ourselves. Aidan Kavanagh noted this well in his manual for celebration.[6] At the same time, we can learn a great deal about participation from spaces that encourage more interaction in the assembly.

4. Holy Name Chapel, Faber Jesuit Community, Brighton (Boston), Massachusetts

In 2010 the Peter Faber Jesuit Community, the Jesuit theologate for the Boston College School of Theology and Ministry, moved from Cambridge MA into newly built housing across from the Boston College Brighton Campus. The community consists of six houses, five of which are residenc-es for around seventy students and staff. The sixth building is a centre with offices, dining room, library and a chapel. The space constraint for 'small projects' in in the city of Boston is 50,000 sq. ft. Unfortunately, those con-straints affected the size of the main chapel, Holy Name.

The chapel has clear glass windows, enabling it to reflect the four seasons characteristic of the Northeast of the United States. This in itself was the subject of some negative comments from students of a more traditional

6 Kavanagh (1990): 'Christian instinct has been to house this assembly as elegantly as possible, avoiding tents, bedrooms, and school basements'

mindset, who judged that coloured glass would make the space seem more sacred. A rather large crucifix dominates the 'east' wall of the chapel. The only iconographic pieces in the chapel are a replica of Our Lady of Mont-serrat, a gift of Cardinal Séan O'Malley, and a statue of St Peter Faber. The rectangular altar and ambo match. There is no raised altar platform. Seating consists of chairs rather than benches or pews. Some of the seats are equipped with kneelers but the community stands throughout the Eucha-ristic Prayer. The original plan was to have a carpeted floor, but wiser heads prevailed and the floor is made of wood.

Unfortunately, the seating plan of this exceedingly tight chapel (one colleague calls it a two-car garage) was originally unimaginative; the chairs were arranged in 'classic fashion' like lines across a printed page.[7] In time many in the community found that arrangement unsatisfactory especially since few could see the altar and thus the liturgical action while standing. One proposal that was tried as an experiment changed the seating into a kind of elongated U-shape with altar, ambo and presider's chair remaining at the east end. Finally, after a few years, a choir style arrangement was adopted – with the ambo near the chapel door, the presider (and deacon or server) seated at the front of the right row of chairs, and the altar at the east end. Although there were some members of the community who felt that we had abandoned 'facing the Lord' (the sacrament is reserved in a taberna-cle set into the east wall) the majority of the community signaled that they favoured the new arrangement.

In my opinion the choir-style arrangement has suited the community well. The chapel is small enough that one does not have to crane one's neck to see either the ambo or the altar. The acoustics are much improved and the singing more robust. Although there is no vocal dissent, I am sure that some members of the community would prefer to return to the former classic arrangement of 'facing the Lord'. Many, of course, understand the post-Conciliar value of recognising the many-faceted presence of Christ, which includes the assembly itself.[8] As Bert Daelemans, Richard Kieck-hefer, Kevin Seasoltz, Richard Vosko and many others have observed: the

7 This was an observation made by Aidan Kavanagh (op. cit., 105–7) with regard to (mainly Prot-estant) church buildings in the wake of the invention of the printing press.

8 *SC*, n. 7; *GIRM*, n. 27.

liturgical space shapes our theology and our theology shapes the liturgical space.[9]

5. St Paschal Baylon, Oakland, California

My final example is another parish that I had the privilege to serve as a visiting priest for about ten years in the 1990s. St Paschal Baylon Parish is in East Oakland, California.[10] A history of the parish is hard to come by and so I am going to postulate approximate dates. Founded in the 1950s or 1960s, St Paschal is located in a multiracial neighbourhood. When I served there the congregation was about a third African-American. The church property stood on a hill overlooking Interstate 580. There was a large bell tower topped with a cross that was easily visible from the freeway. A relatively unique feature was a permanent fire pit located in front of the church, used for the lighting of the Paschal Fire at the beginning of the Easter Vigil.

The initial plan was to build a church after building a school. As with many parishes the temporary arrangement was to house the worship space in the school auditorium until a separate worship space could be financed. That never happened and the auditorium was in time arranged in such a fashion as to serve the parish's liturgical needs.

At least as of the late 1990s the seating for the assembly was basically U-shaped, with the presider's chair in the middle of one arm of the U. (Consult the sketch of the church lay-out.)

A bi-level font accommodating both full immersion and infants is located near the main entrance to the worship space. The altar is on a raised platform, thus enabling the choir, which is located in front of the 'east' wall, not to overwhelm the eucharistic action. A later pastor changed the location of the choir and placed the eucharistic tabernacle on the back wall directly behind the altar. I am unsure of the process that led to this decision, but it does seem to me that our worship spaces are often prey to the pastoral and theological predilections of the parish priest.

St Paschal's was a very lively congregation with vigorous participation. The assembly stood throughout the Eucharistic Prayer and raised their

9 See Daelemans (2015); Kieckhefer (2004); Seasoltz (2005); Vosko (2006).
10 Several years ago St Paschal's was combined with another Oakland Parish, St Lawrence O'Toole, to form Divine Mercy Parish.

Schematic ground-plan
of St Paschal Baylon.

1: Main entrance;
2: Font;
3: Ambo;
4: Altar;
5: Presider's chair;
6: Choir;
7: Tabernacle.

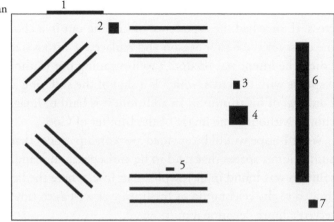

arms in the orans position along with the priest. All bowed together at the words of institution and at the end of the prayer. The music was of high quality and the singing robust. The parish benefited a great deal from being multiracial. Much of this had to do with talented leadership by the parish priest and his pastoral associates. However, even though one could tell that the church building was a transformed auditorium the space worked extremely well for the celebration of the post-Conciliar liturgy. I would say that this combination of factors – people and space – made for one of the consistently best experiences I have had as a worshipper and an ordained minister.

Conclusion

In this brief survey I have described five different worship spaces with which I have been associated as an ordained minister over the years. One lack in my survey is any extended reflection on art/iconography in these spaces. In each space the most important elements in the church building, the altar and the ambo, stand out. Admittedly the place of the baptismal font, of eucharistic reservation and of the presider's chair are both necessary and important. I have avoided discussing iconography (with the exception of the San Jose Cathedral) since it is so culturally determined. I would say, however, that some iconography and artwork is not only useful but also

necessary in a Catholic church. No church should be without a significant cross. (I once had the experience of helping out in a church that removed the cross for the Easter Season and replaced it with a statue of the Risen Lord. The intent was no doubt well-meaning but Catholic liturgy cannot dispense with the cross, which is a sign of the suffering and death of the Lord *and* of his triumph.) In addition, it is hard to imagine a Catholic church without some image of the Mother of God.

What I hope would be avoided are worship spaces that look simply like auditoriums, spaces that tend to be antiseptic and bland. A very good solution was found in St Joseph's, San Jose, where the lighting could be calibrated to the celebration of the liturgy as well as to times when the space served a more devotional purpose.

This survey is obviously limited to my experience, but I hope I can draw several conclusions. First, it is possible to arrange worship spaces that make participation in the post-Conciliar reformed liturgy of the Catholic Church more robust and even enjoyable. Second, none of these churches (with the exception St Leo's, Oakland, and St Paul's, Cambridge, whose temporary liturgies I described) were arranged in the classic 'bowling alley' longitudinal fashion. In my experience, the 'classic' type of arrangement does not foster the kind of full, conscious and active participation called for by the Council and implemented by the subsequent reform. On the contrary, what I am calling 'classic' churches inevitably encourage an audience mentality that we saw was eschewed by the US Bishops' Statement.

In my opinion more than the quality of liturgy is at stake here. As Pope Francis has made clear in his apostolic letter on the liturgy, *Desiderio Desideravi*, what is at stake is the ecclesiological vision of the Catholic Church as articulated by all of the documents of the Second Vatican Council.[11] In that vein it seems to me that the most successful of the spaces that I described is St Paschal's, with its prominent and unavoidable immersion font at the main entrance to the space. To some extent the baptismal font in St Joseph's Cathedral, San Jose, performs the same function, though less strikingly. The ecclesiological vision of the Second Vatican Council is both profoundly baptismal and profoundly eucharistic. It seems to me that in practice an ecclesiology that focuses not on distinctions of authority in the

11 Francis (2022).

Church (which are no doubt both necessary and useful), but on the fundamental equality of the baptised in exercising their share in Christ's priesthood, is better served by architectural spaces that truly encourage liturgical participation.

It is my hope that we can take our baptismal identity as a church seriously and that this theological conviction will have a profound effect on how we build new churches and renovate churches that are already in use.

15

Monastic Space: The Church of St Mary's Abbey, Glencairn

Eleanor Campion OCSO

When the Cistercian (OCSO) nuns at Holy Cross Abbey, Stapehill, Dorset, decided in the 1920s to make a foundation in Ireland, a property in west Waterford, already known as Glencairn Abbey, was purchased for them by the monks of Mount Melleray. It consisted of a large house with a farm, one of the many owned by Anglo-Irish families all along the Blackwater Valley. It is said that this land was part of the seventh-century monastic settlement of St Carthage at Lismore, just three miles away. Before the nuns arrived in 1932, the house was adapted in various ways to function as a monastery, and a church was built on. Naturally, this church was designed and ordered in accordance with the ecclesiology and liturgical understanding of the time.

Years passed, the community grew. The nuns assembled many times every day in the church to sing the praise of God in the Divine Office, to celebrate the Mass and to intercede for the needs of the world. In this church they dedicated themselves definitively to God when they pronounced their solemn vows. To this church the body of a sister was brought after her death, and for a day and a night the community took turns in keeping vigil beside her until her burial in the community cemetery.

Original layout
In that church four distinct areas could be easily identified, their boundaries being marked by grilles or other furnishings. The sanctuary at the east end of the church was the location of the altar and the tabernacle. It was principally the domain of the priest(s), and was separated from both the nuns' area and

the guests' area by a grille.

The nuns' choir area occupied most of the nave of the church. Here, in the choir stalls, the nuns sang all the Hours of the Divine Office by day and by night (the Hour of Vigils being a 'night Office', to be celebrated during the hours of darkness). It was also from these stalls that they attended Mass while the priest officiated at the altar on the other side of the grille.

At the westernmost end of the nave was another distinct space called the retro-choir. This was the area from where the lay sisters, whose life was oriented more towards manual work, joined in the celebration of a limited number of the liturgical Hours.

Finally, guests were accommodated in a very small chapel in the south transept, at right-angles to the altar. They were cut off from the altar by a grille, and cut off even further from the singing of the Office in the nave – the nuns could be heard but not seen.

Initial changes to the church after the Second Vatican Council included the removal of the large grilles (a rail remained in place between the guest area and the sanctuary), and the moving forward of the altar to allow for the celebration of the Eucharist *versus populum*. But more radical changes were needed.

Re-ordering the church

Towards the end of the 1980s, architect Richard Hurley was engaged to draw up plans for a complete re-ordering project. Discussions were lengthy and sometimes painful, as we all had to stretch our understanding, learn and agree to things that we did not even know we needed. For older sisters, who had spent decades worshipping in the existing church, there was significant anxiety and a sense of loss of something beloved. But eventually the project came to pass. We moved out of the old church on 2 November 1989, and for seven months celebrated the liturgy in the Chapter room (no guests could join us) while the construction team did its work. We moved back into the renovated church at the end of July 1990.

No change was made in the size of the building. The exterior walls remain the same. A significant redistribution of the use of space inside the building, however, means that the renewed church has quite a different 'feel', reflecting and promoting a different understanding of the *ecclesiola* that is the mo-

nastic community, of its relationship to the wider People of God, and of the celebration of the liturgy.

The first notable change is the relocation of the area for the celebration of the Eucharist. The altar now stands about two-thirds of the way down the nave. Carved in granite from the Wicklow mountains by Tom Glendon, its shape and location permit the assembly to gather *around* the altar, rather than simply in front of it, better expressing that the Eucharistic sacrifice is offered by the whole community. Chairs, rather than stalls or pews, are provided for both the nuns and the guests; because they are not fixed in place but can be easily moved there is more freedom to respond and reshape the physical assembly according to the occasion and the number of people present. The large president's chair, used by the priest when he is not at the altar or the ambo, is designed to indicate that the priest celebrant of the Mass is both a member of the family gathered around the altar and one who plays a special role within that family as the head of the liturgical assembly.

A new door was opened in the back (west) wall of the church, and this is now the entrance for visitors. The retro-choir space had been very little used in the decades immediately prior to the renovation, as one of the consequences of the Second Vatican Council was the unification of lay sisters and choir nuns, and the integration of the lay sisters into the full liturgical life of the community. The former retro-choir is now the area for guests, from where they join in the celebration of the monastic liturgy. Guests are particularly close, physically, to the nuns during the Eucharist and visibly form one body with them.

New choir stalls were installed further up the church (to the east). Together with the other furniture in wood, they were designed and built by Eric Pearse. We chose to retain the traditional type of stalls for choir-to-choir singing of the Psalms at the seven liturgical Hours of the day. The stalls, and the desks on which our large psalters stand, are firm and fixed in place. Each nun's place has a storage space for hymnals and other books, with a lid that closes and helps to maintain a tidy look.

The Word of God is proclaimed from the ambo in the celebration of both the Mass and the Office. It is fitting, then, that one ambo, located in a shared space between the Mass and choir areas, is used for both occasions. It is a two-sided piece of furniture, so the reader can face either the choir stalls or

The choir stalls and
our large psalters.

The tabernacle by
Benedict Tutty, the
glass by Phyllis Burke,
and the natural world
beyond.

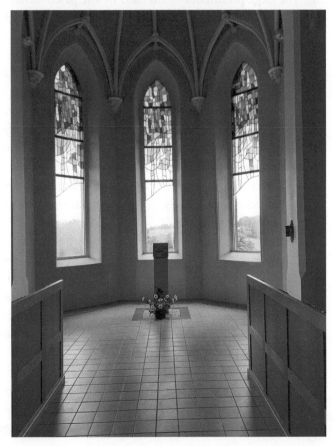

the Mass area.

The tabernacle is located in the apse. We debated whether the tabernacle should be moved to a side chapel (the former guest area, for example) or to some other location, but it was decided to keep it here. The Blessed Sacrament is reserved so that the food of the Eucharist can be brought to those unable to participate in the liturgy, especially the sick and dying, but it is also an important focal point for private prayer and many would be uncomfortable if it were not located in the main body of the church. Furthermore, the apse area is so designed that the eye is naturally drawn to this part of the church by features such as the previously existing mouldings. It would be strange to draw the eye to an empty area. The new tabernacle in beaten bronze was designed and crafted by Brother Benedict Tutty OSB of Glenstal, and stands on a pillar of the same granite as the altar. This establishes a subtle visible reminder of the intrinsic, inseparable link between the reserved Sacrament and the liturgical action of the Mass.

The crucifix that usually stands near the abbess's stall was also designed by Brother Benedict in the same material. One side shows Jesus crucified; the other depicts the raised serpent of Numbers 21:6–9, which is clearly interpreted in the Fourth Gospel as a type of Christ's salvific raising on the cross: 'As Moses lifted up the serpent in the desert, so must the Son of Man be lifted up, so that all who believe in him may have eternal life' (John 3:14–15). Because the crucifix is movable, it is on occasion (Palm Sunday and the days of Holy Week, or the feast of the Exaltation of the Cross on 14 September) moved to a more prominent place in the centre of the choir for veneration or to inspire reflection and prayer.

The stained-glass windows in the apse are a very striking feature of the Abbey church on which many visitors comment. There were three windows in the old church, containing dark blue glass in an abstract design. These windows were elongated by about one-third, and the new colourful abstract design by stained-glass artist Phyllis Burke incorporates some clear glass towards the lower part of the windows. The result is a feature that admits great light as well as providing great beauty in the church, while the view of the countryside outside connects us not only with the beauty of nature but with the world and all its people while we pray. The fall of the ground outside means that people or activity immediately outside the church are not visible

inside, and thus not a significant distraction.

The unity and inter-relationship of the different areas of the church is signalled by using one kind of flooring throughout: white tiles. Together with the extra light admitted by the clear glass in the apse windows, and the lighter wood (white oak) of the stalls, desks and chairs, the white tiles add to a sense of 'lightness' in the church, compared to the 'heavier' feel of the earlier church. Within this unified space, however, rectangles of blue tiles around the altar, the ambo, and the tabernacle indicate places or spaces that are particularly important, where something particularly significant or holy happens. As one looks up the church from the guest area, these three designated spaces are aligned on the central axis, and form a pleasing, harmonious line for the eye to follow.

The former guest area in the side-chapel was foreseen in the renewed plan as a reconciliation room for the celebration of the Sacrament of Penance, and it was used as such for a while. However, the nuns were never really enthusiastic about it, and prefer to celebrate the sacrament in another place in the monastery. So this place (divided from the choir by glass panelling and heavy curtains) is now used for individual prayer (the tabernacle can be seen from here) or, occasionally, for shared *lectio divina* by a small group.

Other elements

The icon at the top of the choir area near the apse was written by Sr Paula Kiersey OCSO, a member of the community who was a particularly gifted iconographer. It depicts the Virgin Mary under her primary and greatest title: Mother of God. Intimately bound to her Son, her cheek gently touches his in a gesture of tender care. She extends that same care to us, the sisters and brothers of her Son, on our earthly journey. At the end of Compline, the last prayer of every day, a spotlight is turned on the icon and, with the rest of the church in darkness, the community sings the *Salve Regina*, so beloved of Cistercians everywhere.

Twelve bronze crosses on the walls indicate that this church has been dedicated, blessed and set aside for the worship of God. On 27 August each year, the anniversary of the dedication of the church, candles are lit at these crosses, and we keep a feast, celebrating this beautiful church, but above all celebrating the fact that we, the community, are the people of God, *the* Church, the place where God lives.

The centre of the liturgical year: celebrating the Easter Vigil.

Visitors to the church are often struck by its simplicity. This is a characteristic of all Cistercian churches, which are usually devoid of or very limited in, for example, statues or other devotional furnishings, such as stations of the cross. It is not only because monastic life is designed to strip away unnecessary things and to focus on the essential, which may be said to be reflected in the simplicity of the church furnishings; it is primarily because priority is given in the monastic life to celebrating the Divine Office, the Prayer of the Church, in all its fullness, and the monastery church is oriented to that end. It is not a parish church and so, for example, there is no baptismal font here. Baptism is normally celebrated in the parish where the new member lives, and they are incorporated into the Body of Christ in a particular parish community. A monastic church does not need a baptismal font.

The church today

If someone is going to spend many hours a day in the church, as Cistercians do, it is highly desirable that it be a beautiful place, a good place to be in. This is certainly the case for the church at Glencairn. It is not perfect; if we were building from the ground up and with an unlimited budget, we might do differently. This church has its limitations: elaborate processions, for example, do not work very well here, and on occasions when the congregation is unusually large – solemn professions, funerals, Christmas Midnight Mass

– it can feel a bit too full for comfort. As an everyday monastic church, it is excellent.

It is now more than thirty years since the re-ordering took place and a significant number in the community, because they joined after 1990, never experienced the 'old' church. But whether we have a memory of the old church to compare it to or not, we love it in its present realisation for many and varied reasons. Among these there are, of course, the liturgical highlights through the year: the joyful celebration of Sunday Mass with neighbours and guests, the solemn liturgies of Holy Week and the Easter Vigil, the favourite seasons and feasts. There is the beauty of watching in prayer together in the very early morning after the singing of Vigils, when the first signs of light in the sky can be seen through the east windows, and a little later the rising of the sun brings the whole valley to new life. There is the delight of singing 'hymns and chants and spiritual songs to God' (Ephesians 5:19) in a liturgical space where the acoustic is top class – visiting choirs regularly comment on how splendid it is. There is the striking presence of an old sister deep in prayer in a corner of the church in the middle of a quiet afternoon, or the discreet figure of a passer-by who slips into the guest area and stays for a while, bringing who knows what problem or distress, or indeed joy, to leave with the Lord in this holy place and go away again with comfort or refreshment. There are so many, many reasons to love our abbey church.

The nuns still assemble here every day to sing the praise of God in the Divine Office. Vigils is still celebrated at night, during the hours of darkness (beginning at 4.00 a.m.); Lauds at daybreak; Terce, Sext and None at mid-morning, midday and mid-afternoon respectively; Vespers at evening; Compline, with the *Salve,* before going to bed. We still gather daily to celebrate the Mass, to keep the memorial of the saving death and resurrection of Jesus, and to intercede for the needs of the world. In this church new members continue to dedicate themselves definitively to God when they pronounce their solemn vows, lying prostrate on the white tiles while the Litany of the Saints is sung, before signing the schedule of vows on the granite altar and being dressed in a white cowl, the liturgical garment that they will wear in future in this place. To this church the body of a sister is brought after her death, and for a day and a night the nuns take turns in keeping vigil beside her, two at a time, praying the Psalms, until her burial.

As we sing at the response to the intercessions of Lauds and Vespers on the feast of the dedication of the church, every 27 August, echoing the exclamation of Jacob (Genesis 28:17) when he had an intense experience of the presence of the Divinity as he made his way from Beersheba to Haran: 'This is the house of God and the gate of heaven!'

16

The Eucharist Room at Carlow Liturgy Centre: The Search for Meaning

Richard Hurley[1]

There is a human longing to regain a lost unity, a return to a simplicity of vision, to nature and to the natural gesture of language. The unity of which we speak must contain two vital elements among others – creativity and an openness to a living dialogue.

I am concerned in this article with the small liturgical environment – the small liturgical space – the Eucharist Room – the place of the intimate celebration in the National Institute of Pastoral Liturgy in Carlow, Ireland. My main concern in designing the institute was a search for a valid architectural expression of the life and activity of the institute. The main problem, the fundamental question, was to establish the 'sense' of the place, a sense of the family gathered in worship.

One bright hope in the Church at the present time is the discovery of a quantified minority of smaller communities of Christians who are discovering a new identity through renewal – one which is free to question the dominant culture. In terms of the worshipping environment, what does this vision guide us towards? The emergence of a specifically 'Christian lifestyle' and its influences on the place of celebration reminds us of the intense suppleness which is necessary at a time when the liturgical assembly, the group gathering, the family sharing becomes 'wholly celebrant' in a place where only a slight accentuation of the domestic environment suffices to bring about important modifications. Our experience shows us that we can speak

1 This paper is reprinted from *Worship*, Vol. 42, (1), January 1996. Used by permission of Liturgical Press.The original photographs that accompanied the article could not be located. The photographs now included, along with the notes to sources, are proper to this edition. – *Editor*

of a common spirit, of common values for a group of a certain size.

From the very tentative and somewhat rigid beginnings in the Eucharist Room which I designed at St Saviour's Boys' Home, Dominic Street, Dublin, in 1967, I have tried to develop a human non-monumental scale, seeking a balance between complexity and strictness, striving to give the gathered family an opportunity to express itself in an active form of celebration. This meant a constant search for a liturgical arrangement which would be clear and flexible. The spaces which evolved over the years reflect the complexity of a living plurality expressing such characteristics as the liturgic, meditative, festive, social and practical aspects of the assembly. It has led to a stage where the celebration area is very free, fully integrated with that of the assembly, indeterminate, and something of a non-object. Nothing about it is determined or fixed irreversibly, sometimes not even the altar podium, which can be undone and re-built at another assembly point at any time. This direction developed for many years and finally came to fruition in the National Institute of Pastoral Liturgy in Carlow, where the brief had been developed in collaboration with Fr Séan Swayne, the director of the institute.

Let us begin at the beginning with what I consider to be perhaps the most decisive development leading to modern church architecture and which influenced my thoughts in approaching the design of the centre at Carlow.

Rothenfels, 1927
In 1927, the Schloss Rothenfels – the Castle which served as head quarters of the Catholic Youth Movement in Germany – was remodelled under the direction of its chaplain, the famous liturgist Romano Guardini, and the architect Rudolf Schwarz, who was later to become an important church architect internationally. The complex contained a regular chapel, but the most interesting feature was the hall, which was occasionally used for the celebration of the Eucharist. The hall was a large rectangular space with pure white walls, deep windows and stone pavement. There was no decoration.

The only furniture was one hundred black cuboid stools. The disposition of these stools could be easily changed according to the different

Part of the room designed by Schwarz as it is today (2021). The stone pavement has been covered, but the stools can be seen along the wall.

One of the cuboid stools today (2021).

functions of the room and the nature of the assembly. On a day of liturgical celebration, a provisional altar was set up in the hall and the faithful surrounded it on three sides. On the fourth side, facing them from behind the altar, the celebrant closed the circle. Other layouts were of course possible, as shown by Schwarz in his studies for the room. Its influence on the liturgical movement in Germany and Switzerland and subsequently in Europe and the entire world has been enormous, even if we have had to wait almost thirty to forty years to find a really consistent application of its principles to church design in general.

The liturgical arrangement at Rothenfels was probably the best possible solution at that time for an act of participation of the faithful. This corporate dimension of the Christian assembly was later to assume great significance. Developments in liturgical philosophy and practice indicate

that the liturgy was celebrated and understood as a totally corporate affair to be expressed with the best possible simplicity and flexibility. This included celebration facing the people, a free grouping of the faithful, and an overall interpretation of the place of worship where the interior symbol – the living community itself – took precedence over the exterior, the world of persons took precedence over that of objects, and hospitality was considered more important than monumentality.

Schwarz himself wrote,

> For the celebration of the Lord's Supper, a moderately large, well-proportioned room is needed, in its center a table, and on the table a bowl of bread and a cup of wine. The table may be decorated with candles and surrounded by seats for the congregation.
>
> That is all. Table, space and walls make up the simplest church.
>
> The table is the sustaining earth which rises up for the solemn celebration.
>
> [...]
>
> As such, it is also a prototype of the people surrounding the table and the walls surrounding the people, and thus it is, as it were, an innermost church.
>
> The candle is innermost light streaming out of the center.
>
> The space is sacred abundance.
>
> Walls and roof are the final outermost covering.
>
> The little congregation stands or sits about the table.[2]

When I first heard these words, as a young architect, I must confess I was greatly shocked, because I had always thought of a church building as being something embracing a significant construction. Although many of Schwarz's church buildings convey a feeling of 'fortress image', there can be little doubt that towards the end of a very long and fruitful life, he firmly believed that a church building should not be an image of a powerful representation, nor primarily a product of technical or artistic perfection. It should instead, perhaps, convey an ideal of something beyond its immediate representation. An image, perhaps, of the inner hidden meaning – the sense of becoming of the building. In this way,

2 Schwarz (1958), 35.

a greater richness and liberty could be achieved by thinking about the inner meaning, its life and its purpose.

Light as a Christian symbol

Light and the symbolism of light together form one of the determining elements in all periods of art. From the very beginning, the symbol of the basic meaning of Christian space was light, and the character of Christian space was determined by the interaction of light and material substance. Being the spiritual element, light transforms natural matter. It illuminates the things of the everyday world and gives them new meaning. We call the architectural aspect of this 'dematerialising'. In our own time, we see light as a symbol of hope in an otherwise dark universe and we still look upon light as the great determining factor in advocating the ultimate sense of place.

'Rag Pickers' Chapel, 1957

Rainer Senn, the architect for 'Rag Pickers' Chapel of St Andrea at Nice, made an important contribution when he said in 1963,

> In the design of churches I have tried to arrange the seats about a 'centre' and to emphasize this centre by spatial means and by the use of specially directed light. My aim has been that each individual should be aware on the one hand of one's 'togetherness with others and on the other hand of 'one's relationship to a common centre.'[3]

This simple building goes right to the heart of the matter and confronts us in a most profound and disturbing way. Not only does it strip away everything which obscures the meaning of liturgical worship; it is, as Peter Hammond observed, an outward embodiment of a community which has nothing and which yet possesses all things, a true image of the temple built of living stones. It is indeed an interior challenge of awesome proportions.

Through light, we can enter the threshold of poetic space and approach the dimension of lived-in silence. Through light, we can uncover the

3 The source of this quotation has not been identified. However, on Senn's chapel, see Baker (2018).

sub-conscious dimension of the human spirit and awaken and illuminate regions of our sub-consciousness. Speaking metaphorically, Emil Steffann reflected that too much light was not good for the soul. The soul does not indeed fear the light, but is startled by its full glare. It must, he said, be able to re-create itself from within, the objects which it looks upon, bringing themselves from being distinct into light. Is it not through light that we discover the 'outside' and the 'inside' of things, their 'reverse' and their 'right side'? From this, we understand there are two sides, one dark and one light. In this, I was prepared to be more open in my approach to church building. This enabled me to embrace the precarious and uncertain, and not to be afraid of experiencing the result as a poem in praise of the ephemeral.

Vienna, 1963–65

When I was in Vienna and Salzburg in 1965, attending the Biennale of Christian Art, I met the well-known Austrian Architect, Ottokar Uhl, who already had undertaken several interesting church projects, particularly his Students' Chapel designed in 1963. He and I became good friends and among his work he took me to see the University Chapel in Mozartgasse, Vienna, which had just been completed. This work advanced even further his philosophy of renunciation and economy of means. In a room measuring 7 meters 4 meters, Uhl placed a long oak table running two thirds of its length. He also provided a podium for the presider, sixteen wooden stools and a small credence table in white marble for the bread and wine. Nothing more. Walls and ceilings were painted white, and the flooring was in natural oak like the rest of the furnishings.

It was clear to me that he wanted to reduce everything to essentials, in order, as he said, to get back to where we came from. To understand what he was about, it is necessary to attend a celebration in the room. Only then comes the realization that it is the community itself, the living presence of eyes and voices, which animates and constructs the space. In the Student Chapel in Melk in Austria, he completely separated the two poles of the liturgy – word and Eucharist. The assembly remained seated for the word and moved to the altar for the Eucharist.

As a festive room, the Eucharist Room is concerned with gestures to be car-

ried out, with speaking, listening and seeing, eating and drinking, in short, with human senses. We enter the world of *Ritual*. Ritual requires a powerful evocation of space. This space will possess a character of its own and evoke a specific ethos. Blessing and abuse of earthly things, and the splendour and temptability of the human senses play their part.

St Patrick's Seminary Chapel, 1970

When, in 1970, I was commissioned to carry out a major seminary chapel renewal at St Patrick's Seminary, Carlow, post-war church architecture had reached an important stage in development. I adopted a radical plan – a single level two-room space, a room for Eucharistic celebration and a room for personal prayer and devotion, linked together by the location of the tabernacle – a significant development at that time. The whole space became a ritual space, involving the entire assembly, linked together by the white tiled floor. The furnishings, designed in wood, allowed a flexible approach to the problem of location at a time when the liturgy was developing.

Where an interior either disturbs or does not permit the celebration of a feast bound up with the senses, it does not accord with the concern of a celebrating assembly. Writing in his book, *Modern Architecture and Christian Celebration,* Frederick Debuyst has this to say, 'The coming to life of most Vatican II churches can be summed up in one phrase, serving of the assembled community in the simplest possible form.' Beyond the limited perspective of pure liturgical functionalism, this means humility, limpidity, and above all, a great opening to a living dialogue. But dialogue excludes any kind of rigid confrontation between the presider and the family, and thus also rigidity in the form of material and location of the liturgical objects. This place of 'celebration,' this place of the 'Paschal gathering' of which we speak, indicated to me a nonrepresentational space, certainly a non-monumental place, a place which displayed human scale and human characteristics of calmness and the simplicity of joyfulness, the light of things to come, a place leaning more towards domestic scale, which rejected pretence towards formalized relationships, a space and interface which would bring about a full human intimacy of celebration and spontaneity.

Space serving ritual

What I allude to here, perhaps, is that the sacred is not found in any particular form or shape, but in human values. In the past, church architecture has tended to express a master image rather than a servant image. In the Christian dispensation, particularly relating to church architecture, this idea became unacceptable. The interiority which I refer to helps to activate the function of the celebration and support the assembly in the development of the celebration. It allows the presider to be more fully human and promote a liberating influence in a more relaxed, and in this sense, a more human way of behaviour. I aimed at a more friendly atmosphere in the hope that it would help to overcome the stiffness so often associated with solemnity. I referred earlier to a planning approach which would be open-minded in an attempt to find formal relationships that would be meaningful and advantageous.

In this way, I was trying to get away from rigidity, or the concept of a finite perfect arrangement which the intellect could grasp totally, and instead I wanted to develop an area of organic planning, which would bring us closer to mystery. In this sense, I was trying to achieve openness and accessibility for everybody, yet at the same time, to create a feeling of security coupled with concentration. At that time, this was another area of challenge facing architects working in the field of church architecture – the problem of openness and accessibility coupled with security and concentration. Space should follow the form of the ritual. On a functional level, it is primarily concerned with people and seeks to provide a place where the experience of the group – of the family – could be primary and where the quality of fellowship could be reinforced by the shape, the form and the feeling, and the outwardness of the worship space.

The room as a place of meditation

I would like also to refer to Aloys Goergen, who talks about the church as 'a place of meditation.' The architect has the task of forming the empty interior in such a way as to keep the epiphanic symbolism of emptiness, but at the same time, to relate the same interior to the meditator, whether he or she be alone or in a group. Here, the rules of meditation

have to be applied. According to the theory of meditative prayer, the effect of material, colour and proportion is of decisive importance for the outcome of the meditative prayer – the interior has to realise stillness so that the individual and the praying community may find tranquillity and generosity of spirit. For meditative prayer the right light in the place of meditation is required. A wrong light hinders the meditative prayer or even makes it impossible. There is also an appropriate prayer height of the room which relaxes, concentrates and elevates.

Carlow Liturgy Centre, 1980

For me, the basic problem at Carlow was that of making the Eucharist Room a place of corporate interface, transcending its function and relating it to time and place. We were again faced with the problem of symbolising a spiritual meaning, developing the function into an appropriate outward form, which could reveal its own identity. Thus experienced, the Eucharist Room could become a symbol and a visual focus in the community and a unifying factor within the institute itself.

When the National Institute for Pastoral Liturgy moved from Portarlington to Carlow in 1980, the then director, Seán Swayne, commissioned me to design the centre, which included a Eucharist Room. It was to be located in what was known then as the junior wing of St Patrick's Seminary. The brief was extensive: the building had to be gutted and put back together again, creating something new out of something old. The heart of the project would be the Eucharist Room. This nerve centre comprises four spaces – the gathering area, the Eucharistic Room, the Blessed Sacrament Chapel and the Vesting Room. The gathering area is of great importance in the scheme of things. It provides a place of welcome, a place to assemble both before and after the liturgy and also a place to enjoy the hospitality of the institute.

The Eucharist Room is entered directly off the gathering area, which is a long narrow 'mall,' partially two storeys high and containing an open string staircase.

The Eucharist Room measures approximately 7.5 meters 17 meters and is 5 meters high, with the long axis running east-west and having tall elegant windows on the south and west walls. Spacious and light filled, it is

The Eucharist Room
as seen in April 2015.

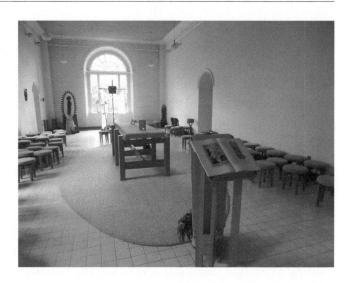

the great room of the house, and it can honestly be said that one of the reasons why the Institute decided to make its home in Carlow was the wonderful potential of this space.

The layout of the room is orientated towards an informal gathering surrounding a central area focused on a movable altar. Counter balancing this informal assembly is a disguised central axis running east to west, culminating in a magnificent eighteenth-century semi-circular window, which catches the evening sun. The mystery of human fellowship is heightened by the idea of the family gathering around the table. Within the family group is the principal celebrant, seated at their head. The ambo is placed at the other side of the altar, on axis facing up the room. Ritual space, demanding maximum movement, is created. The surrounding stools provide an informal seating arrangement. The all white room has often been commented upon. Everything is in a shade of white – walls, floor, ceiling, light fittings and carpet. There is, however, subtle colour in the sap green of the fig tree in the corner of the room, the oak of the furnishings and stools, the terracotta of Brother Benedict Tutty's Madonna and Child. What to some observers is an uncompromising space, is softened by the intimacy of the assembly. The space comes alive during the celebration through the eyes, the voices, and the ever present

interface of human presence.

The white spirit of the room provides fertile soil for the growth of spiritual freedom. The limitations of the materials also contain the inner intention, namely, to radiate the spirit of freedom, a power which transcends the material. On a human level, each member of the gathering takes his or her place within the whole body, having both rights and responsibilities equal with others. There was to be no 'sanctuary' in Carlow, only a powerful expression of ritual space totally integrated with everyone who participates in it. Within the assembled community – within the room – the quality of fellowship is heightened by the shape, the form, the feeling of outwardness, paradoxically at rest within the enfolding walls of the structural shell.

The idea of corporate unity – the assembly united through the Eucharist – is expressed in Carlow by the concept of enveloping the assembly completely surrounding the altar area on four sides. This is the concept of the 'open ring' – where the altar is both apex and threshold. In a certain sense, the presider, when he celebrates the Eucharist at the altar, closes the ring, but the space beyond develops in dynamic and symbolic form. The plan develops in space by means of the enclosure as defined by light. Space then becomes a means of communication and assumes a metaphysical meaning. With definite purpose, the space converges on the altar, but develops away from rigidity and breaks out of its enclosure towards the realm of light, creating openness and accessibility balanced by a sense of belonging and concentration.

A totally different atmosphere is experienced in the Blessed Sacrament Chapel, a small space off the Eucharist Room. The idea here was to evoke a feeling of repose, quiet, calm and withdrawal, a place for meditation and personal prayer. However, the space is not static – the tabernacle is placed off centre, and this is reinforced by the dynamic curve of the slatted ceiling overhead. One tall, south-facing window controls the quality of light entering the space.

If we combine the symbols of function and light which we have been considering during this paper, perhaps the final form of space in terms of the Carlow experience might take two streams, one in which the light predominates and the other which is darkness, like a tree in the first dawn, whose branches reach up into the light seeking life and whose

roots reach down into the earth seeking stability. The religious group-consciousness is re-created through the communal celebration of the liturgy. I think this is an elementary human disposition. The family will gather about the table, so to speak. The environment for this family gathering will speak of buoyancy, lightness, and clarity as opposed to heaviness, darkness and ambiguity.

Symbolism of domesticity

It is well, at this stage, to realize that church buildings say as much about the people who cause them to be built as the functions they serve. Part of the architect's task is making visible in church buildings something of the inner mood of the institution; this is characterised in present-day dialogue as openness and willingness to be seen in service.

Consequently, our task is not only to provide the framework for the definable human action, but also to provide within the tension of the space a way of releasing, or at least of stimulating new ways of behaviour. I was in a sense trying to move away from rigidity, and if I did stumble now and then in my fumbling and groping efforts towards the intangible, I did not worry unduly because I hoped the seed would bear fruit. We needed in a sense to recover our lost spirit, authenticity, and start again equating a certain sense of poverty and transcendence in a way that neither time nor place could touch, perhaps the idea that less be greater than more and that the paschal gathering is a microcosm of a much wider gathering, that gathering of human fellowship wherever it may be. Out of these thoughts come two ideas which gave us an image, that of familyhood and domesticity.

We noted above our effort to provide an environment for the family gathering, which would speak of buoyancy, lightness and clarity as opposed to heaviness, darkness and ambiguity. Yes, the delicate will prevail against the oppressive. Perhaps, we can imagine two spaces making up a Eucharist Room. One, the shining manifestation – 'field of action' – for the celebration, and the other, the dark, hidden 'shrine' for the passage of the interior communion. The 'outside' and the 'inside' of things. Such a space would consist of two rooms, one large with the table in the centre and the other small, containing the tabernacle – the Holy of the Holies. The ground plan

would have two poles. I can see of no other way of reconciling these eternal opposites. Change and permanence combined. Therefore, it seemed to me legitimate to build a 'table' and 'shrine.'

Plan of the future

It is possible that in the future our places of worship may come into being solely out of the act of worship itself. Already, we are witnessing the great emptying of our churches and places of worship and we are seeing the little congregation of two or three gathering together as was foretold. In the event of such a happening, at the beginning there will be no space, and at the end none will be left over. The space would come into being and would sink away simultaneously with the celebration. The dematerialization process would be complete. However, to conclude let me return to our own problems of our own time, in our own places of worship. Let us continue in our search for meaning – this search for that which has meaning, and the will to discover it are surely the most important task for us today. I commented earlier on the 'outside' and the 'inside' of things, their 'reverse' and their 'right' side. Here I would like to quote a philosopher, Jean Grenier, because he puts it very beautifully: 'If the world is such that there is no reverse side, if there is only a right side which is subject to longer or shorter exploration, then the human situation is truly despairing.' We must at least attempt the explanation of everything in us and around us. Consequently, I believe objects are formed out of meaning and function at once. And here we are confronted with the mystery of both permanence and change being present at once, and it is in this sense that I suggested that two paths merge, the path of 'temenos' or simply the area surrounding the sacred, and the path of 'metamorphosis,' the path of change complete. And because of this, I am led to think perhaps that church architecture is more vessel than edifice and that this vessel becomes a work of architecture which shelters both happening and permanence.

When I am asked what it is that the Carlow Eucharist Room manifests for us, on the threshold of the third millennium, I must confess that I find it easier to respond now than fifteen years ago. The passing years have clarified any ambiguity which may have lingered in my mind. It is a place for gathering,

to enkindle the spirit, a place of challenge, celebration and renewal. It is a place for ritual. Its character is softened by the intimacies of the celebration. It manifests its own function; it reveals its own identity. It precedes 'Internet.' In recognizing the paradox that our only chance of genuine renewal lies in going back in spirit to the simplicity of the beginning, it shows us something of the direction we have to follow.

I referred earlier to a longing to regain a lost unity. I feel now that this unity for which we constantly search can only be brought a little nearer if we are prepared to let go of our concept of the old idea of unity. Perhaps the great poet Goethe was exercising his particular gift when he wrote:

> There is no past which we would long to resurrect, there is an eternal newness only, reconstituting itself out of the extended elements of the past, and true yearning should always be towards productive ends making some new, some better thing.

17

Liturgy and Australian Churches

Tom Elich

Participation

A church is most commonly thought to be a performance space for the liturgy. This is true but can be a little misleading. In a concert hall, a symphony may be profoundly moving and even bring us to tears. We listen; we participate; but we are not playing the music. We go to a powerful theatre piece and are transported to another world, but we remain in our seats as spectators. At a sports stadium, people may get very excited; they sing and shout and sweat, but they are not playing football.

On the other hand, in the church, the whole gathered assembly *is* celebrating the liturgy. Who celebrates the liturgy? asks the *Catechism of the Catholic Church*. 'Liturgy is an "action"' of the whole Christ (*Christus totus*) ... It is the whole community, the Body of Christ united with its Head, that celebrates.'[1] The baptised are not just joining themselves to something that the priest is doing. They participate by doing the liturgy themselves, together, with the priest presiding. Liturgy is a corporate action that admits of no spectators, even engaged spectators. This is a great challenge for an architect because we do not have any models for this kind of space. Performance spaces for the arts or sport do not help us conceive a genuine liturgical space.

This assertion is grounded in the affirmation of the Second Vatican Council that:

> full conscious and active participation [is] called for by the very nature of the liturgy. Such participation of the Christian people as 'a chosen race, a royal priesthood, a holy nation, God's own people' (1 Pt 2:9) is their right and duty by reason of their baptism. In the reform and promotion of the liturgy, this full and active participation

1 *Catechism of the Catholic Church* (1994), nn. 1136 and 1140.

by all the people is the aim to be considered before all else.[2]

What does liturgical participation mean? Some authors internalise it and make it purely an activity of mind and heart. Others focus on ritual activity, that is, singing and responding, standing, sitting and kneeling, moving in procession or exchanging the sign of peace. In fact we have to find a way of holding internal and external together as two sides of a single coin. I maintain that this occurs when we realise that all the baptised are actually doing the liturgy. More than any external action or internal devotion, full conscious and active participation occurs when the baptised know that they are part of what the Body of Christ is doing in its corporate act of worship. They have the mindset of being present as 'doers'.

Now, this realisation is new. Churches constructed earlier in the twentieth century often give the opposite impression. There is a sanctuary for the priest where 'the action' takes place. Perhaps separated by a rail or rood screen, the apse may be beautifully decorated as a sacred space, with marble floors, murals and stained glass. Seating for the people is arranged in rows like an auditorium, and, indeed, one used to speak of the people coming 'to hear Mass'. Such architecture proclaims that the liturgy is the priest's work. It is troubling to see so many contemporary churches, stunning architecturally, that enshrine this same, unreformed set of relationships.

Even sixty years ago at the time of the Vatican Council, we did not fully understand the ramifications of active participation. Our first architectural reform was to move the altar away from the wall to make space for the priest to 'face the people'. This turned out to be disappointing because it tended to make the priest into a 'performer' and stimulated an extensive scholarly debate about the merits of returning to an *ad orientem* arrangement. The thing is, we did not take it far enough and find an architectural expression of the *circumstantes*[3] who are the agents in the liturgical action.

Liturgical ordering of Australian churches

I believe that gathering the assembly around the ambo and altar is critical. The reader and preacher open the Scriptures in the midst of the assembly.

2 *SC*, n. 14. For a full documentation of this vocabulary in *SC*, see Elich (2013).
3 The Roman Canon (Eucharistic Prayer I) describes those present as *omnium circumstantium*. The verb '*circumsto*' means *to stand round* or *in a circle, to surround*. It implies a physical arrangement of those gathered for worship.

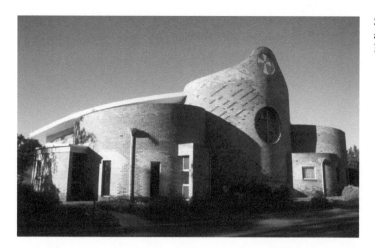

St Michael
and St John,
Horsham.

People surrounding the altar can begin to experience the sense of standing
with the priest to make the offering. A key aspect of structuring the liturgical
space 'in the round' is that members of the assembly are aware of one anoth-
er. This makes it clear that liturgical prayer is corporate prayer. Seeing other
people across the altar is not a distraction but rather a reminder that liturgy
is the Church at prayer.

Stephen Hackett has elaborated a typology of liturgical spaces, five of
which represent the kind of participatory layout that would help give shape
to the vision of the Vatican Council: a cruciform or cross-arrayed type, a cir-
cular or polygonal centrally arrayed type, the antiphonal arrangement in an
axially arrayed type, the three-sided seating arrangement of a U-arrayed type
and, finally, the fan-arrayed type.[4] Hackett acknowledges that these church
layouts can still be rather frontal; a sanctuary elevated several steps high can
still appear as a stage for performance. There is a participatory architecture
to be constructed, but these centralised plans are a good start.

I will illustrate five churches in Australia that demonstrate some of these
patterns of liturgical ordering. I will take them in historical order of con-
struction.

St Michael and St John, Horsham

In 1987, architect Gregory Burgess designed the church of St Michael and

4 Hackett (2011), 247–58. After assessing each of these arrangements, he takes an Australian
 example of each for particular examination, 276–341.

St John for the provincial city of Horsham, 300 kilometres north-west of Melbourne. It is a fan-shaped church in which the assembly is embraced by strong curved walls.[5]

What lifts this church above the many other fan-shaped churches of the period is the sacred geometry of the *vesica piscis*[6] which he uses. As Gregory Burgess' diagram shows, this symbolises the meeting of heaven and earth, made incarnate in Christ. It asserts that the liturgical assembly is the Body of Christ, and its worship is the offering of Christ on the cross, which reconciles the world to God. Note how the sanctuary is included within the *vesica piscis*, unifying the whole assembly in Christ.

To the east of the sanctuary is a chapel for the tabernacle and, near it, a space for the font; to the west is a curved space for the music ministry. The narthex and entry areas continue the rhythm of the embracing curved walls. As Hackett astutely points out:

> The sanctuary, adjacent alcove chapel and music ministry spaces, and reconciliation chapels project from the southern side of the vesica into the circle which represents heaven. The narthex, vesting sacristy

5 Images courtesy of the architect: gbarch.com.au/projects/
6 The *vesica piscis* is the lozenge shape created when two equal circles intersect, with the centre of each lying on the circumference of the other.

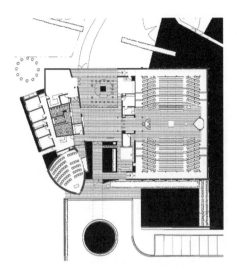

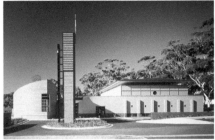

Our Lady of Fatima, Carringbah.

and other service rooms extend from the northern side of the vesica into the circle which represents earth.[7]

The antiphonal ordering of the liturgical space is commonly associated with monastic chapels arranged for the Liturgy of the Hours. Two Australian churches show how it works on a larger scale: one is the parish church at Carringbah, a southern suburb of Sydney (1999), and the other is the cathedral at Parramatta (2003).

Our Lady of Fatima, Carringbah

The Church of Our Lady of Fatima at Carringbah is the work of architects Allen Jack and Cottier.[8] Entering from the circular drive, a day chapel, parish office and meeting room are on the left. On the right at the entrance is a Eucharist chapel accessible after hours. A passage leads to the foyer and the church itself opens to the right. Passing through the narthex, one encounters in turn the font and then the altar and ambo. Stepped seating for the assembly is arranged to the left and right facing the centre.

Internally, the space is structured into seven bays by the timber frame-

7 Hackett (2011), 330.
8 Images courtesy of the architects: ajcarch.com.au

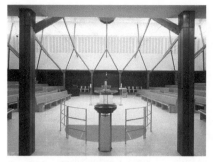
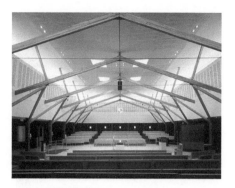

Our Lady of Fatima, Carringbah.

work, evoking the memory of traditional worship spaces. The transcendent dimension is preserved by the light that floods the space from above. The architects' description of the church notes:

> The church is an attempt to interpret the principles and objectives of the Second Vatican Council document on liturgy in a way that is relative to contemporary society. Its forms are derived from that liturgy and not from traditional church forms; they are also derived from its particular site, its particular surroundings and environment … That centre is a sanctuary, a safe haven, the gathering place for that community. And whilst these spaces must clearly serve the liturgical action, they should also support the sense of mystery and reverence which that action expresses. This demands a kind of transparency and simplicity, so that one can experience both the quality of the space and something beyond it.[9]

Parramatta Cathedral

A second major example of the choir formation in church design is the cathedral of the Diocese of Parramatta, dedicated in 2003. The 1936 neo-Gothic cathedral was destroyed by arson in 1996. Eight years later the new cathedral was dedicated; it was designed by renowned architect Aldo Giurgola in consultation with local committees for liturgy and for art.[10] The original cathedral was rebuilt to house an entry foyer, the baptismal space and the Eucharist chapel for the tabernacle, as well as reconciliation and devotional spaces. This allowed the new nave to accommodate the assembly for the cel-

9 Keith Cottier, 'Notes from the architect', dedication of the church in 1999.
10 Plan with thanks to Reverend Peter Williams. Photo courtesy of Hamilton Lund photography.

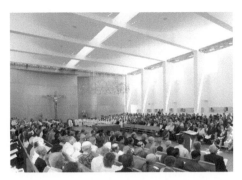

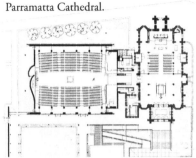

Parramatta Cathedral.

ebration of Eucharist. It accommodates 800 people, with possibilities to extend capacity by a further 400. Reverend Peter Williams, at the time director of the diocesan Liturgy Commission and executive officer of the National Liturgical Commission, wrote of the axially arrayed ordering:

> This configuration has been part of the tradition of church design for centuries. In this case it places the altar in the middle of the building, thus making it the central focus for the worshipping assembly … The sanctuary is wide and long and permits gracious ceremonial action. The movement of ministers is enhanced by the generous processional space. Here the assembly does find visible expression as an organic unit, joined to the bishop who presides from the cathedra at the head of the sanctuary, and with Christ symbolised by the altar at the centre of the space. The people can clearly focus on the proclamation of the word at the ambo and the liturgy of the Eucharist at the altar for they take place in the midst of the assembly. It removes any notion of static spectatorship. This is a place of liturgical action, of participation, and of engagement.[11]

St John the Baptist, Woy Woy

Next there is the centrally arrayed church of St John the Baptist at Woy Woy (2007), the work of architect Randall Lindstrom.[12] People approach the church from the gate by a covered pathway. At the entry, the accessible chapel for the tabernacle is on the right and the front doors lead to a circular processional way which passes several devotional chapels on the way to the

11 Williams (March 2004).
12 Images courtesy of Julie Moran and the parish of St John the Baptist, Woy Woy.

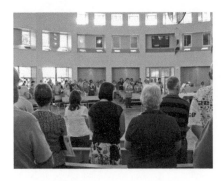

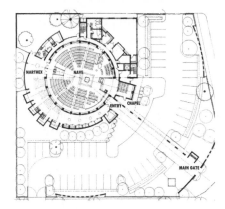

St John the Baptist, Woy Woy.

narthex. This in turn leads past the baptismal font into a circular nave which is centred on the altar. The architect noted that the entry path serves as a metaphor for the Christian journey through life, which reaches its summit and source in the Eucharist.

The pilgrim people of God are drawn together by the sacred geometry of the circle into a single worshipping assembly which unites all the baptised at the table of the Lord. Prominent within the circle and located at the entry point near the narthex is the baptismal font, a permanent reminder that active participation is the right and duty of all by virtue of their baptism.

Stephen Hackett comments:

> While other churches have many characteristics in common with St John the Baptist church, none has attained the relationship of liturgical *foci*, distribution of liturgical functions, and clarity of liturgical symbolism, that are evident here ... [It] is a profoundly liturgical

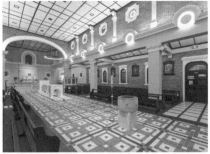
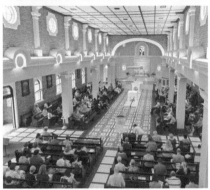

The church building in Bulimba.

structure. It reveals the potential of the [centrally arrayed] ordering to fulfil the conciliar injunction. Yet every church structure is more than its liturgical ordering, and the form and design of the church contributes significantly to its achievement.[13]

Sts Peter and Paul at Bulimba

Our final example is the 1926 church of Sts Peter and Paul at Bulimba, which was restored and reordered in 2015 by parish priest Tom Elich, in conjunction with a parish team of volunteer architects, finance and project managers.[14]

The traditional arrangement of a raised sanctuary located in the apse, fronted by a nave filled with rows of pews, was reshaped into a U-arrayed

13 Hackett (2011), 328–9.
14 Photography Daren Kerr, courtesy of Dion Seminara Architecture.

ordering. The sanctuary, which had been greatly enlarged with broad steps in the early 1970s, was reduced back to its original dimensions, restored and allowed to retreat back within the apse arch, to become a prayer space centred on the tabernacle. The nave was refocused by grouping the pews around a central celebratory area paved with a strong design of coloured tiles. The new ambo and altar, each carved from a single block of marble, are arranged on the central axis. The ancient Norman font is placed in the midst of the assembly, at the west end of the central space. Here it is accessible to those who enter the church from all three entrances. Lighting helps draw the attention of the assembly to the liturgical action at ambo, altar and font.

The new arrangement works well because the distribution of the assembly around the altar is balanced (there are six rows of pews on each side). The front pews draw the assembly from the lower, side aisles into the liturgical action of the higher nave. Surprisingly, the church's seating capacity was not reduced in this reordering, but it has given the nave a spacious feel and allows for movement and easy celebration of the sacraments.

Relationships

One of the criticisms levelled at churches designed 'in the round' is that the liturgy can become self-referential and purely communitarian, whereas a good liturgical space is a place where God acts in our midst and where the gathered people offer worship to God. In other words, an openness to the transcendent must be expressed. In a centralised space, a vertical axis can generally be integrated with the horizontal, perhaps represented architecturally by an apex or the height of a wall, a dome or ceiling lights. This is why the ordering of the plan is not enough; it must be matched by architectural forms and finishes that evoke the sense of the sacred, the mystery of otherness.

In any case, all centralised arrangements of the liturgical space are built around the altar. *The location of the altar in the place of worship should be truly central so that the attention of the whole congregation naturally focussed there.*[15] The altar is a symbol of Christ; indeed 'the altar is Christ'.[16] This means that we do not simply focus on one another and our own liturgical actions; we

15 *IO*, n. 91 and *GIRM*, n. 299.
16 *GIRM*, n. 303; and US Bishops' Conference (2018), n. IV.4.

focus on Christ. It is not necessary to encumber the altar with large candles and a crucifix to demonstrate this reality: the altar itself does that.

The second thing that these church arrangements challenge us to do is to rethink the web of relationships enshrined in a church building. How are altar, ambo, chair, font, music, tabernacle, entry, people's seating, related to one another?[17] Underlying this question is the more basic one of the relationship between front and back. As long as we conceive of an oblong space with the door at the west end and the altar at the east end, many of the desired relationships will appear contradictory.

Such a church, designed in terms of The Front and The Back, will never take us very far. We put the altar, ambo, chair, font, tabernacle at 'the front', people enter from 'the back', and in between seats are arranged in spectator rows. The liturgical books themselves help us to reimagine the liturgical space. The tabernacle needs a relationship with the altar because the sacrament kept there derives from what is done at the altar; but it also needs a relationship with the narthex or entry since it should be prominent and accessible when people arrive for private prayer. Likewise, the font must have a relationship with the entry because it is baptism that brings us into the eucharistic assembly; yet its location should make provision for the public communal celebration of the sacrament, even during the Sunday Mass. Well, comes the frustrated question at the beginning of the design process, where do you want it, at the front or at the back? I answer, both!

A careful examination of the church plans from Carringbah, Parramatta, Woy Woy and Bulimba will show how church plans can be reimagined. The controlling idea for all Catholic worship spaces must be centred on Christ who is the celebrant of the liturgy. This translates, not to the priest who acts *in persona Christi,* but to the whole assembly baptised into Christ, the priestly people, which we call the Body of Christ. The 'full, conscious and active participation', of which the Second Vatican Council speaks, presumes that all the baptised are joining Christ in the liturgical offering by which the Church enters into the great saving act of the cross.

17 This is the approach taken in the two official documents on the arrangement of churches produced by the Australian Catholic Bishops' Conference (2014 and 2018). Both these policy documents were prepared by the National Liturgical Architecture and Art Council, and approved by the Bishops' Conference.

234

18

The Simple Room in Carlow

Richard Giles

In April 2015, on a visit to Ireland, I was taken by a friend to see with my own eyes a place I had long heard spoken of with wonder, a space where once dreams had been dreamt, hopes made real, and glimpses of the Kingdom of Heaven shown to mere mortals.

It was just a simple room, in an ordinary town, part of a small college campus, but a place where extraordinary things once happened, a place spoken of with longing by those who cared about liturgy, across oceans and across communions.

The room was designed in 1978 by Richard Hurley, the renowned architect whose work fostering liturgical renewal can be found all over Ireland. It was a simple oblong, with large clear windows on two sides. The altar table stood in the middle of the space, the ambo at one end and the president's chair at the other, with an elliptical pattern of stools around them.

The room at Carlow was therefore deceptively simple and unassuming, but the simplicity was of its essence, exhibiting in every detail the 'noble simplicity' enjoined by the Second Vatican Council.[1] With decoration and symbolism kept to a minimum the room allowed the assembly itself to become the living icon of Christ. In so doing it threw down the gauntlet to the wider Church, quietly demanding that the theology of the eucharistic community as the Body of Christ should not remain mere theory but be expressed in every action, every posture, every move, every silence.

For this room, now a rather forlorn college chapel, was once the beating heart of the Carlow Liturgical Institute,[2] a place where the ineffable things of God were made real and accessible. Those who participated in the liturgy there were thereafter able to speak of 'what we have heard, what we have

1 *SC* 3,34.
2 The Irish Institute of Pastoral Liturgy, Carlow, to give it its full name.

The room at
Carlow in
2015.

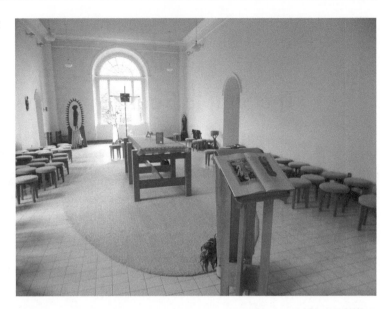

seen with our eyes, what we have looked at and touched with our hands'.[3]
Making Eucharist was no longer a textbook theory but a life-transforming
experience.

The room today has returned to its ordinary-ness, careworn, cluttered with
extraneous liturgical trimmings, and with superfluous seating jumbled to-
gether around the periphery. The basic liturgical furniture remains but has
the appearance of artifacts whose purpose is no longer clearly remembered,
inherited pieces of furniture no one quite knows what to do with.

In his poem 'The Chapel' the priest-poet R. S. Thomas describes a rather
forlorn place of worship, off the beaten track and uncared for, where once
'a preacher caught fire / and burned steadily before them / with a strange
light, so that they saw / the splendour … .'[4] In that room at Carlow, it wasn't
a preacher who caught fire, but the priestly community gathered in that
room around ambo and altar, who in that moment of surrender and offering
caught the flame, and saw the splendour that was around them and within
them.

3 1 John 1:1.
4 R. S. Thomas, 'The Chapel' – the complete text can be found at: https://allpoetry.com/the-
chapel.

What was witnessed was the terrible beauty of the people of God unleashed from their captivity to become all that God longs them to be – 'a chosen race, a royal priesthood, a holy nation, God's own people'.[5]

Every community in transition needs its Moses, and for Carlow it was Fr Séan Swayne who led, and interpreted, and cajoled and inspired those around him to continue the journey, and who made Carlow what it so famously became.

All that had been longed for and hinted at and glimpsed in the long journey of liturgical renewal from the nineteenth century to the present day, was given tangible expression in this room, as in other places of adventurous liturgical exploration across the world, little pinpricks of light in the dawn, where what had been formulated and authorised was actually lived, and lived to the full.

The gradual rediscovery of liturgy as an enabling and transforming power in people's lives, rather than a ritual to attend and observe, something we do together rather than watch others do, was a slow and gradual process. It was a long haul from the first shoots of the Liturgical Movement to the Second Vatican Council, as it was from the Parish Communion Movement to Common Worship,[6] but what was modelled in that room in Carlow, as in all centres of liturgical excellence, was an expression of the very best of all the hopes and aspirations that had gone before.

The Church may, after a prolonged and painful labour, give birth to fine documents, directives, texts and liturgical resources, but these can remain baffling formularies to be either reluctantly observed or avoided and ignored, unless flesh can be put upon them, unless they can be lived and breathed.

What happened in the final decades of the twentieth century to transform the experience of being a Christian at worship? It was a heady time when a passer-by might mistake members of the Eucharistic community for a load of drunks, as they had the first followers of the Way.[7] There was indeed a sense of intoxication, not from too much communion wine, but of the Spirit.

We were discovering as if for the first time the very essence of life in Christ,

5 1 Peter 2:9.
6 'Common Worship' is the collective name for the new liturgical texts produced, from 2000 onwards, by the Liturgical Commission of the Church of England. See Bradshaw (2001) and Bradshaw (2006).
7 Acts 2:23.

holding in our hands both the treasures of the first Christian centuries and the thrilling excitement of an advance into unknown territory. We were fearless, unquenchable and unstoppable. In the beautiful words of the great psalm of restoration, 'then we were like those who dream. Then was our mouth filled with laughter, and our tongue with songs of joy'.[8]

Immense strength came from the thoroughly ecumenical nature of what was being celebrated, in which neither word nor sacrament was the property of a religious institution but the birthright of the people of God. Strength came too from the interaction of old and new worlds; insights honed perhaps by the Little Sisters of Jesus before the Blessed Sacrament in a hut deep in the French countryside, or the brothers of a great Benedictine abbey in the Midi, were recognised and rejoiced in by a parish in Chicago or Huddersfield, or a cathedral in Portsmouth or Philadelphia. Wherever we were and whatever our previous label or allegiance, we knew ourselves for the first time as we stood around the ambo and altar of God as full participants at last, washed in the abundant baptismal waters in which we had been set apart for the work of God. The fonts at which we began our journey each week were lavish in their provision, baths rather than stoups, rivers rather than stagnant pools.

In England in this period there was a thirst for new ways of being Church and making Eucharist, and a readiness to accept the upheaval this would cause, not least to the built fabric of our churches. Liturgy North was an annual weekend gathering of clergy, architects and lay leaders eager to experience renewed worship and to see for themselves the many examples of re-ordered churches in the region, while the northern diocesan advisory committees charged with oversight of liturgical spaces joined forces to organise training sessions to encourage parishes to think more boldly and imaginatively. These events were but small-scale versions of the powerful and the inspirational Form & Reform conferences in the US, which marked an explosion of creative energy in liturgical renewal and which left attendees changed forever.

In the midst of all this excitement the room at Carlow gave shape, closer to home, to all that liturgical reformers and dreamers and legislators longed to see. Sadly it now serves also to remind us of what began to go wrong. Al-

8 Psalm 126:1–2.

though the work of renewing the liturgy in Ireland continues in attenuated form at Maynooth, nevertheless the present, rather forlorn state of the room at Carlow stands as a reminder of how fragile and vulnerable are our efforts to renew the Church's liturgy, and how rapidly decline can set in should the prevailing winds change direction.

The history of the Church reveals a limited capacity for adventurous living. Renewal and reform is all very well for a time but can too easily be drained of energy by ecclesiastical disapproval and human fickleness. Since Constantine the Church has maintained power and influence by promoting safety and certainty in a changing world. Significantly, the biblical image of the Ark has been subverted to serve as a symbol of retreat to safety rather than of voyage to new lands.

The Second Vatican Council revolutionised the Roman Catholic Church in many aspects of its life, and its influence spread far beyond the bounds of that communion, but as far as liturgical reform is concerned, it lasted barely forty years before the forces of conservatism reasserted their grip. Conservatism is common to many human societies, and reactionary movements within the Church chime all too well with those in the political life of many nations at present.

Whilst many of the outward signs of liturgical reform remain in place, and although new texts and resources enrich our worship, there has been an almost imperceptible but nevertheless real blunting of the cutting edge of the Church's progress. In the Roman Communion this can be seen in the subsequent revision of texts in a more conservative direction, in the hardening of the rules surrounding the reception of Holy Communion, and in the drifting away from the theological clarity achieved by the Vatican Council in, for example, the clear spatial and devotional distinction between the Sacrament revealed in the Eucharistic celebration and the Sacrament reserved in the tabernacle.

Nurturing change and new life is hard work, and it can be with a sigh of relief that congregations learn they need no longer over-exert themselves and can instead sink back into their old ways of listening and watching as devout spectators. Clergy, too, hard pressed on many fronts, may find the role of prophet and animateur just too exhausting, and settle instead for 'keeping the show on the road' as the ultimate imperative. Why make life difficult for

ourselves in church when the world has troubles enough of its own?

In the Anglican Communion a quite different set of circumstances has worked to produce a similar end result. Advances in liturgical renewal over the last hundred years have been significant, chiefly in the provision of new texts which have greatly enriched our worship and which, in the case of eucharistic rites, have narrowed the gap between Canterbury and Rome. This has been achieved by producing, rather than a new book, a series of alternatives to the *Book of Common Prayer* of 1662, culminating in *Common Worship*, which began to appear in 2000. Even though replacing the 1662 texts altogether was considered too contentious, the new rites have at least liberated us from a Reformation mindset. Anglicans in the US were bolder, producing in 1979 a completely new *Book of Common Prayer* to replace the old, with subsequent supplements promoting more inclusive language.

Unfortunately, worship spaces have not kept in step with the liturgies that they are now required to facilitate. We may talk the talk about gathering around and moving together as a body, but the (largely Victorian) layouts of our building interiors frustrate our attempts to walk the walk. Altars remain distant, or moved forward to be jammed in between (empty) choir stalls, while the assembly sits marooned in spectator seating.

The legislative framework governing changes to the fabric, and the undue weight given to the views of the heritage lobby, make change a daunting prospect. The most creative and radical schemes can arouse opposition from traditionalists within and conservationists without, often necessitating a consistory court both costly and traumatic. We are left with church interiors that resemble the historic re-creations found in folk museums enshrining the past and showing us how people once lived..

In the US the considerable effort expended on maintaining the interiors of Episcopal churches as (imagined) replicas of those of 'the old country' makes radical change even more problematic than in England.

In a parallel development our theological colleges have for the most part downplayed liturgy as a part of clergy training, approaching it as an academic subject to be understood historically, rather than a life-changing force shaping our communities of faith.

Although therefore on both sides of the Atlantic strenuous efforts have been made to equip the people of God with the means of celebrating wor-

ship in contemporary language (a primary aim of Thomas Cranmer in the sixteenth century) this does not mean that the liturgy has been renewed.

Rather, it would appear that renewal of liturgical texts has somehow worked against the renewal of the whole experience of worship. The Episcopal Church in the US, having led the charge towards a completely new provision of liturgical texts, has collapsed exhausted upon the beachhead. With the hinterland yet to be touched, interest in liturgical renewal has quietly petered out, with worship in the average parish continuing on its traditional path, doing the new texts in the old ways.

In England, we have new contemporary rites of considerable beauty, as fine as any in the English-speaking world, and yet there is little idea of how to use them imaginatively.

The principal act of Sunday worship may be done competently enough but all too often it remains the reading of a service, the honouring of a requirement, rather than a transformative encounter with God and the mystery of our being.

The low priority given to worship is often revealed by the inadequate preparation, the lack of training of those reading the Scriptures or leading prayers and, above all, in the boring sameness of what is offered to God week by week.

One of the supreme advantages of the eucharistic rite in *Common Worship* is that, such is the rich variety of alternatives for each section – penitential rite, Eucharistic Prayer, affirmation of faith – no two Sundays need ever be quite the same. But none of this is apparent to the average worshipper, who is served up an unvarying diet of the same material week after week by clergy stuck in a groove, serving up in perpetuity the same selection of alternatives.

Congregations are rarely taught posture or appropriate behaviour; they chatter incessantly before the service, sit instead of stand when invited to pray, and display a complete unawareness of who they are or why they are there. It would appear that God is not expected to show up.

All this takes place amidst a seating plan appropriate to a nineteenth-century congregation called to attend church in passive, submissive mode, for whom worship is the sole responsibility of the clergy. It is as if the maelstrom in theological, liturgical and socio-economic thought that has consumed us in the last hundred years never happened; as if the transformation of the

The Influence of Carlow – St Dunstan's, Liverpool.

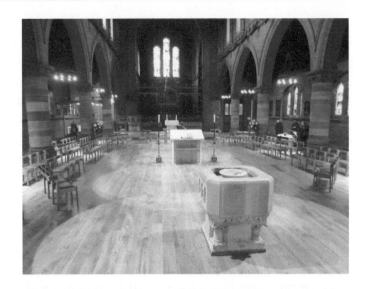

congregation into an assembly enjoying 'full, conscious, and active participation in liturgical celebrations'[9] never even began.

The resistance to change is nowhere more clearly seen than in music. The prevalence of hymn books to facilitate congregational singing in the majority of parish churches stifles new music and experimentation. Indeed, for Anglicans, the singing of Victorian hymnody is seen as a badge of honour that defines who we are. In the US the Episcopal Church went so far as to bind together the Hymnal with the new *Book of Common Prayer* in a single publication in 1986.

In a time of enormous creativity and vigour in the composition of contemporary hymnody from every tradition and from all over the world, a flexible approach to music is demanded, able to incorporate new material almost instantly, achieved either with song sheets printed for each Sunday or with overhead projection making any written material superfluous.

We are so set in our ways that in those situations where we are deprived of organ or choir the bizarre conclusion is drawn that we can no longer make music at all. Fortunately, musicians like John Bell of the Iona Community are there to show us how wrong-headed this notion is. Advocates of 'travelling light' when it comes to music-making are able to transform any random

9 *SC*, 2,14.

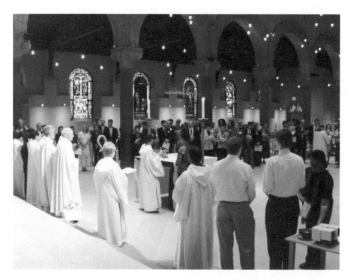

The influence of Carlow – a celebration of the Easter Vigil in Philadelphia Episcopal Cathedral.

group of worshippers into a choir in half an hour, singing in ways they never knew possible, and revelling in the power of music to liberate, energise and bind together the people of God.

Faced with these many difficulties and setbacks in the Church's task of giving honour to God and transforming the holy community in worship, how deeply we mourn the loss of that little room at Carlow! The room now assumes a greater significance than ever because it is lost to us.

The expression of Christian worship is moribund in so many places because we aim too low. Our hopes and expectations are too limited. Carlow was there to remind us of all that was possible, and attainable and oh so very simple.

We may be faithful members of a congregation, but that alone is not enough. We are called to be nothing less than a holy assembly, beloved of God, and enabled to participate fully in the shared priestly task.

When we enter our own place of assembly, and dip our finger in the baptismal waters, making upon ourselves the sign of the cross, when we eagerly crowd around the Scriptures to catch hold of the saving word, when we stand together around the table with hands upraised to offer together the great thanksgiving, when we taste of the holy food and when we are sent forth to change the world, then we at last discover who we truly are.

I like to think of the room at Carlow, the room that recalled us to who we really were, as a room where the slates of the roof had been prised apart and the glory allowed to filter through.

In his poem 'The Skylight', Seamus Heaney describes how he was resistant to the idea of inserting a skylight in the roof of the family home, and was not prepared for the transformation that followed;

> But when the slates came off, extravagant Sky entered and held
> surprise wide open, For days I felt like an
> inhabitant
> Of that house where the man sick of the palsy
> Was lowered through the roof, had his sins forgiven, Was healed,
> took up his
> bed and walked away.[10]

I like to think of the room at Carlow, the room that recalled us to who we really are, as a room where the slates of the roof had been prised apart and the glory of God's extravagance allowed to filter through.

10 Seamus Heaney, 'The Skylight' – the complete text can be found at: https://www.poetryireland. ie/publications/poetry-ireland-review/online-archive/view/the-skylight1.

The paper by Richard Hurley, 'The Eucharist Room at Carlow Liturgy Centre: The Search for Meaning' reprinted above, pp. 209-22, first appeared in *Worship* 42, 1 (Jan), 1996, and is used by permission of Liturgical Press.

Photo Credits
1,1: Thomas O'Loughlin. Used with permission.
1,2: James Corkery SJ. Used with permission.
1,3: Thomas O'Loughlin. Used with permission.
1,4: Colm Hayden. Used with permission.
1,5: Margaret Daly-Denton. Used with permission.
2,1: Bergmann. Taken from Wikimedia Commons. https://commons.wikimedia.org/w/index.php?search=chapel+of+light+Ando&title=Special:MediaSearch&go=Go&type=image
2,2-4: Christopher Irvine. Used with permission.
3,1-4: Thomas R. Whelan. Used with permission.
4,1: Michael J. Joyce. Used by permission.
4,2-5: Richard S. Vosko. Used with permission.
6,1: Thomas O'Loughlin. Used with permission.
9,1-9: Joseph Grayland. Used with permission.
10, 1: Linda Svarvar, Stiftelsen för Åbo Akademi – used with permission
10, 2-3: Nadine Minner – used with permission.
10,4: Zefram. Taken from Wikimedia Commons. https://commons.wikimedia.org/wiki/File:Paderborner_Dom_Dreihasenfenster.jpg
10,5: Alain Van den Hende. Taken from Wikimedia Commons. https://commons.wikimedia.org/wiki/File:Triskel-triskele-triquetre-triscel_VAN_DEN_HENDE_ALAIN_CC-BY-SA-40_0718_PDP_BG_007.jpg
10,6: Thomas O'Loughlin. Used with permission.
11,1-12: Anne Dixon. Used with permission.
12,1: Margaret Daly Denton. Used with permission.
13,1-5: George Guiver. Used with permission.
15,1-3: Valerie O'Sullivan. Used with permission.
16,1-2: Thomas O'Loughlin. Used with permission.
16,3: Richard Giles. Used with permission.
17,1-3: Gregory Burgess. Used with permission.
17,4-7: Allen Jack and Cottier. Used with permission.
17,8: Hamilton Lund Photography. Used with permission.
17,9: Peter Williams. Used with permission.
17,10-13: Julie Moran and the parish of St John the Baptist, Woy Woy. Used with permission.
17,14-16: Daren Kerr, courtesy of Dion Seminara Architecture. Used with permission.
18,1-3: Richard Giles. Used with permission.

Ancient, Patristic, Medieval and Liturgical Texts
Anon, *Didascalia Apostolorum* – see Stewart-Sykes (2009).
– *The Acts of Thomas* – see Attridge (2010).
Ambrose, *De Sacramentis* – see Faller (1955), and Deferrari (1962).
Augustine, *Sermo Dolbeau* 2 – see Dolbeau (1992).
Clement of Alexandria, *Stromata* – see *ANF* 2, 299-567.
Justin, *First Apology* – see Minns and Parvis (2009).
Menucius Felix, *Octavius* – see Rendall (1931).
Origen, *De oratione* – see Koetschau (1899); a translation by William A. Curtis can be found at https://www.tertullian.org/fathers/origen_on_prayer_02_text.htm
Second Vatican Council, various documents – see Flannery (1975).
Tertullian, *Apologeticum* – see Glover (1931).

Modern Authors
Anon (1928), 'Where Two Worlds Meet' *SSM Quarterly Paper* 28/105 (Christmas 1928), 101–4.
Assisi Papers (1957) [anon. ed.], *The Assisi Papers: Proceedings of the First International Congress of Pastoral Liturgy, Assisi-Rome, September 18–22, 1956*, Collegeville, MN.
Astley, Jeff (1992) 'Christian Worship and the Hidden Curriculum of Christian Learning', in Jeff Astley and David Day eds, *The Contours of Christian Education*, Great Wakering, 141–52.
Attridge, Harold W. (2010) *The Acts of Thomas*, Salem, MA.
Australian Catholic Bishops Conference (2014), *'And when Churches are to be built ... ': Preparation, Planning, and Construction of Places of Worship*, Brisbane.
– (2018) *Fit for Sacred Use. Stewardship and Renewal of Places of Worship*, Brisbane.
Baek, Jin (2009), *Nothingness: Tadao Ando's Christian Sacred Space*, Abingdon.
Baldovin, John F. (2008), *Reforming the Liturgy: A Response to the Critics*, Collegeville, MN.
Baker, Andrew (2018), 'Examining Ephemeral Ecclesiastical Architecture,' *Transpositions* [26 March 2018] https://www.transpositions.co.uk/examining-ephemeral-ecclesiastical-architecture/
Barna Group (2014), *Making Space for Millennials : A Blueprint for Your Culture, Ministry, Leadership and Facilities*, Ventura, CA.
Barrie, Thomas (1996), *Spiritual Path, Sacred Place: Myth, Ritual and Meaning in Architecture*, London.
Beard-Shouse, Melody Gabrielle (2010), 'The Circle Dance of the Cross in the Acts of John: An Early Christian Ritual' [thesis presented to the University of Kansas].
Benedict XVI (2007) *Summorum Pontificum*: https://www.vatican.va/content/benedict-xvi/en/motu_proprio/documents/hf_ben-xvi_motu-proprio_20070707_summorum-pontificum.html
Bohm, Paul (2014), 'Architecture and Worship: A Comment,' *SL* 44, 118–29.

Bonett, Helena (2008), *Vilhelm Hammershøi: The Poetry of Silence*, London. Download at: https://www.academia.edu/4210551/Vilhelm_Hammershøi_The_Poetry_of_Silence

Borgehammar, Stephan (1991), *How the Holy Cross Was Found: From Event to Medieval Legend*, Stockholm.

Bowe, Barbara Ellen (1999), 'Dancing Into the Divine: The Hymn of the Dance in the Acts of John', *JECS* 7, 83–104.

Bradshaw, Paul (ed.) (2001), *A Companion to Common Worship – 1*, London [*ACC* 78].

– (2001), *A Companion to Common Worship – 2*, London [*ACC* 81].

Britton, Karla Cavarra (ed.) (2010), *Constructing the Ineffable, Contemporary Sacred Architecture*, New Haven, CT.

– (2010a), 'The Case for Sacred Architecture', in Britton (2010), 12–23.

Brooke, Christopher (1971), 'Religious Sentiment in Church Design in the Late Middle Ages', in *Medieval Church and Society: Collected Essays*, London, 162–82.

Caruso, Adam, and Helen Thomas (eds) (2020), *Rudolf Schwarz and the Monumental Order of Things*, Zurich [second ed.].

Catechism of the Catholic Church (1994): https://www.vatican.va/archive/ENG0015/_INDEX.HTM

Coakley, Sarah (2002), *Powers and Submissions*, Oxford.

– (2023,) *God, Sexuality, and the Self : An Essay 'on the Trinity'*, Cambridge.

Collamati, A., R. Vosko, and A. Zenthoefer (2016), 'Preaching in a Digital Age', in E. Foley, C. Vincie, R. Fragomeni (eds), *A Handbook for Catholic Preaching*, Collegeville, MN.

Daelemans, Bert (2015), *Spiritus Loci: A Theological Method for Contemporary Church Architecture*, Leiden.

– (2022), 'The Need for Sacred Emptiness: Implementing Insights from Paul Tillich and Rudold Schwarz in Church Architecture Today', in *Religions* 13, 515. https://www.mdpi.com/2077–1444/13/6/515/htm

Delio, Ilia (2021), *The Hours of the Universe: Reflections on God, Science, and the Human Journey*, Maryknoll, NY.

Dickason, Kathryn (2021), *Ringleaders of Redemption: How Medieval Dance Became Sacred*, New York, NY.

Debuyst, Frédéric (1968), *Modern architecture and Christian celebration*, London [*ESW* 18].

Deferrari, Roy J. (1962), *Saint Ambrose: Theological and Dogmatic Works*, Washington, DC [*FC* 44 (the *De sacramentis* is to be found on 265–28)].

Dilley, Paul (2013), '*Christus Saltans* as Dionysios and David : The Dance of the Savior in Its Late-Antique Cultural Context,' in *Apocrypha* 24, 237–53.

Dirks, Jo (2021), 'Burg Rothenfels, Guardini and the Quickborn German Youth Movement,' in *AJL* 17, 138–50.

Dolbeau, François (1992) 'Nouveaux sermons de saint Augustin pour la conversion des païens et des donatistes', in *REA* 38, 50–79.

Eco, Umberto (1986), *Art and Beauty in the Middle Ages*, New Haven, CT.

Elich, Tom (2013), 'Full, Conscious and Active Participation', in Carmel Pilcher, David Orr, and Elizabeth Harrington (eds), *Vatican Council II: Reforming Liturgy*, Adelaide, 25–7.

Ellard, Gerard (1948), *The Mass of the Future*, Milwaukee, WI.

Faller, Otto (1955), *Ambrosius Mediolanensis: De sacramentis*, Vienna [*CSEL* 73, 13–85].

Flannery, Austin (1975), *Vatican II: The Conciliar and Post Conciliar Documents*, Dublin.

Francis, Pope (2015), *Laudato Si'*: https://www.vatican.va/content/francesco/en/encyclicals/documents/papa-francesco_20150524_enciclica-laudato-si.html
 – (2021), *Traditionis Custodes*: https://www.vatican.va/content/francesco/en/motu_proprio/documents/20210716-motu-proprio-traditionis-custodes.html
 – (2022), *Desiderio Desideravi*: https://www.vatican.va/content/francesco/en/apost_letters/documents/20220629-lettera-ap-desiderio-desideravi.html

Friedman, Richard Elliott (1992), 'Tabernacle', in D.N. Freedman et al. (eds), *The Anchor Bible Dictionary*, New York, NY, 6, 292–300.

Gagne, Ronald, Thomas Lane, and Robert Van Eecke (1984), *Introducing Dance in Christian Worship*, Washington DC.

Gilbert, Elizabeth (2009), 'Your elusive creative genius' [extract from a TED talk (https://www.ted.com/talks), delivered in February 2009 by the author of: *Eat, Pray, Love: One Woman's Search for Everything*, London 2007].

Giles, Richard (1997), *Re-Pitching the Tent: Re-ordering the church building for worship and mission in the new millennium*, Norwich [revised ed., 2004].

Glover, T. R. (1931), *Tertullian: Apology and De Spectaculis*, London [*LCL* 250].

Gotman, Kélina (2018), *Choreomania*, Oxford.

Goto, C. T. (2016), *The Grace of Playing: Pedagogies for Leaning Into God's New Creation*, Eugene, OR.

Gougaud, Louis (1914), 'La Danse Dans Les Eglisés', in *RHE* 15, 5–22.

Grayland, Joseph P. (2004), 'Standing the Posture of Participation in the Eucharist Prayer', in *ACR* 81/3, 336–50.

Grimes, Ronald L. (1988), 'Infelicitous Performances and Ritual Criticism', in *Semeia* 43, 103–22.
 – (2016), 'Ethnographic Studies in Christian Ritual', in *JCR* 31.3, 409–17.

Hackett, Stephen Paul (2011), 'The Architecture of Liturgy: Liturgical Ordering in Church Design; the Australian Experience in Perspective' [thesis presented to the University of New South Wales].

Hahne, Werner (1999), *Gottes Volksversammlung: die Liturgie als Ort lebendiger Erfahrung*, Freiburg-im-Breisgau.

Hammond, Peter (1960), *Liturgy and Architecture*, London.

– (1962), 'A Radical Approach to Church Architecture', in Hammond (1962), 15–37.

Hammond, Peter (ed.) (1962), *Towards a Church Architecture*, London.

Harries, Karsten (2010), 'Untimely meditations on the need for Sacred Architecture', in Britton (2010), 50–9.

Harris, Max (2003), *Carnival and Other Christian Festivals: Folk Theology and Folk Performance*, Austin, TX.

– (2010), *Aztecs, Moors, and Christians: Festivals of Reconquest in Mexico and Spain*, Austin, TX.

Hartford Institute for Religion Research (2021), *Exploring the Pandemic Impact on Congregations* (https://www.covidreligionresearch.org)

Hastings, Bill (1994), 'Review of St Mary's Abbey, Glencairn,' *IA* 101, p. 12.

Hayward, C. T. R. (1996), *The Jewish Temple: A non-biblical sourcebook*, London.

Hebert, Gabriel (1935), *Liturgy and Society*, London.

Head, Peter (2004), 'The Temple in Luke's Gospel', in T. Desmond Alexander and Simon Gathercole (eds), *Heaven on Earth: The Temple in Biblical Theology*, Carlisle, 101–19.

Heathcote, Edwin and Iona Spens (1997), *Church Builders,* Chichester.

Heathcote, Edwin, and Laura Moffatt (2007), *Contemporary Church Architecture*, Chichester.

Heiding, Fredrik (2020), *Lek För Guds Skull - Lekfullhetens Kreativitet, Dygder Och Laster*, Skellefteå.

– (2021), 'Hur Olika Är Gudomspersonerna? Treenighetens Mysterium Hos Thomas Av Aquino,' *SKO* 3, 21–9.

Hellsten, Laura (2016), 'Dance in the Early Church: Sources and Restrictions', in *AR* 6, 55–66.

– (2021a), *Through the Bone and Marrow: Re-Examining Theological Encounters With Dance in Medieval Europe*, Turnhout [*STT* 45].

(2021b), 'Dance in the Early Church – Re-Visiting the Sources', in *SP* 104, 65–84.

– (2021c), 'Dance as a Contemplative Practice – the Space of Distinction and Union', in *AR* 11, 117–34.

– (2022), 'Dance as an Agency of Change in an Age of Totalitarianism', in *AR* 12, 55–76.

Heschel, Abraham Joshua (1975), *The Prophets*, New York, NY.

Hikota, Riyako Cecilia (2022a), Beyond Metaphor: The Trinitarian Perichōrēsis and Dance', in *OT* 8, 50–63.

– (2022b), 'The Christological Perichōrēsis and Dance', in *OT* 8, 191–204.

Highley, Christopher (2016), 'Theatre, Church, and Neighbourhood in the Early Modern Blackfriars', in R. Malcolm Smuts (ed.), *The Oxford Handbook of the Age of Shakespeare*, Oxford, 616–32.

Hoffman, Lawrence A. (1991), *Sacred Places and the Pilgrimage of Life*, Chicago, IL.

Hollis, F. J. (1934), *The Archaeology of Herod's Temple*, London.

Hurley, Richard (1974), 'The Visual in Worship', in *NL* 3, 14–8.

– (1996), 'The Eucharist Room at Carlow Liturgy Centre: The Search for Meaning', in *Worship*, 42, 238–51.

– (1997), 'Cathedral of St Mary and St Anne, Cork', in *IA* 125, 29–34.

– (2001), *Irish Church Architecture in the Era of Vatican II*, Dublin.

IECL (1994), *The Place of Worship: Pastoral Directory on the Building and Reordering of Churches*, Dublin.

Irvine, Christopher (2013), *The Cross and Creation in Christian Liturgy and Art*, London.

– (2020), 'Canterbury and Becket Today', in Dee Dyas and John Jenkins (eds), *Pilgrimage and England's Cathedrals*, Cham.

Irwin, Kevin (2002), 'A Sacramental World-Sacramentality as the Primary Language for Sacraments', in *Worship* 76, 197–211.

Jenkins, Simon (1999), *England's Thousand Best Churches*, London.

Jensen, Robin (2015), 'Recovering Ancient Ecclesiology: The Place of the Altar and the Orientation of Prayer in the Early Latin Church', in *Worship* 89, 99–123.

Jones, Patrick (2011), 'Dr Richard P. Hurley (1932–2011): Tribute to an Outstanding Church Architect', in *NL* 151/152, 13–7.

Kavanagh, Aidan (1990), *Elements of Rite: A Handbook of Liturgical Style*, Collegeville, MN.

– (1984), *On Liturgical Theology*, New York, NY.

Kelly, Evadne (2019), *Dancing Spirit, Love, and War: Performing the Translocal Realities of Contemporary Fiji*, Madison, WI.

Kieckhefer, Richard (2004), *Theology in Stone: Church Architecture from Byzantium to Berkeley*, Oxford.

Klinghardt, Matthias (2014), 'The Ritual Dynamics of Inspiration: The Therapeutae's Dance', in Susan Marks and Hal Taussig (eds), *Meals in Early Judaism*, New York, NY, 139–61.

Knäble, Philip (2022), 'Canons & Choreographies. The Myth of the Medieval Church Adverse to Dancing', in Walz (ed.) (2022), 139–54.

Knibbe, Kim, and Helena Kupari (2020), 'Theorizing Lived Religion: Introduction', in *JCR* 35, 157–76.

Koenker, Ernest B. (1951), 'Objectives and Achievements of the Liturgical Movement in the Roman Catholic Church since World War II', in *CH* 20, 14–27.

Krosnicki, T. A. (1987), 'Dance Within the Liturgical Act', *Worship* 61, 349–57.

Koetschau, P. (1899), *Origenes Werke* II. *Buch V–VIII gegen Celsus, die Schrift vom Gebet*, Leipzig [*GCS* 3; the *De oratione* is to be found at 297-403].

Kuehn, Regina (1990), 'Romano Guardini: The Teacher of Teachers', in Robert L. Tuzik (ed.), *How Firm a Foundation: Leaders of the Early Liturgical Movement*, Chicago, 36–49.

LaMothe, Kimerer L. (2018), *A History of Theory and Method in the Study of Religion and Dance*, Leiden.

Lane, Belden C. (1988), *Landscapes of the Sacred: Geography and Narrative in American Spirituality*, Baltimore, MD.

Lang, Uwe Michael (2004), *Turning Towards the Lord: Orientation in Liturgical Prayer*, San Francisco, CA.

– (2007), 'The Direction of Liturgical Prayer', in Lang (ed.), *Ever Directed towards the Lord*, London, 90–107.

Lara, Jaime (2010), 'Visionaries or Lunatics? Architects of Sacred Space, even in Outer Space', in Britton (2010), 120–31.

Lathrop, Gordon W. (2022), *The Assembly: A Spirituality*, Minneapolis, MN.

Le Corbusier (1927), *Towards a New Architecture* [Facsimile ed.; Mansfield Center, CT, 2014].

Lewis, C. S. (1956), *The Last Battle*, London.

Lieber Gerson, Paula (1986), *Abbot Suger and Saint-Denis: A Symposium*, New York, NY.

Lin, Erika T. (2011), 'Popular Worship and Visual Paradigms in *Love's Labor's Lost*', in J. H. Degenhardt and E. Williamson (eds), *Religion and Drama in Early Modern England: The Performance of Religion on the Renaissance Stage*, Burlington, VT, 89–114.

Lloyd, Vincent (2011), *The Problem With Grace: Reconfiguring Political Theology*, Stanford, CA.

Lord, Joseph (1931), 'Some Churches and the Liturgical Movement', in *OR* 6, 66–75.

Loudovikos, Nikolaos (2019), *Analogical Identities: The Creation of the Christian Self – Beyond Spirituality and Mysticism in the Patristic Era*, Turnhout [*STT* 28].

Lukken, Gerard, and Mark Searle (1993), *Semiotics and Church Architecture: Applying the Semiotics of A. J. Greimas and the Paris School to the analysis of Church Buildings*, Kampen.

Martimort, Aimé Georges (ed.) (1992), *The Church at Prayer: An Introduction to the Liturgy*, Collegeville, MN [one volume ed.; translation based on revised editions of the original French texts].

McCarty, Robert, J., and John M. Vitek (2017), *Going, Going, Gone: The Dynamics of Disaffiliation in Young Catholics*, Winona, MN.

McKuen, Rod (1967), *Listen to the Warm*, New York, NY.

McNamara, Denis (2009), *Catholic Church Architecture and the Spirit of the Liturgy*, Chicago.

Maddison, John (2003), 'The Gothic Cathedral: New Building in a Historic Context', in Meadows and Ramsey (2003), 113–41.

Mauck, Marchita (1989), *Shaping a House for the Church*, Chicago, IL.

Meadows, Peter (2003), 'Cathedral Restoration: Fabric and Furnishings 1836–1980' in Meadows and Ramsey (2003), 305–32.

Meadows, Peter, and Nigel Ramsey eds (2003), *A History of Ely Cathedral*, Wood-

bridge.

Méndez Montoya, Ángel F. (2022), 'Flesh, Body, and Embodiment: Surplus of Corporeal Becoming. Theology and Dancing Bodies', in Walz (ed.) (2022), 291–304.

Meyers, Carol (1992), 'Temple, Jerusalem', in D. N. Freedman et al. (eds), *The Anchor Bible Dictionary*, New York, NY, 6,350–69.

Minns, Denis, and Paul Parvis (2009), *Justin, Philosopher and Martyr: Apologies*, Oxford.

Mogge, Winfried (2012), *'Dies uralt Haus auf Felsengrund …' – Rothenfels am Main: Geschichte und Gestalt einer unterfränkischen Burg*, Würzburg.

Nájera-Ramírez, Olga, Norma E. Cantú, and Brenda M. Romero (2009), *Dancing Across Borders: Danzas Y Bailes Mexicanos*, Champaign, IL.

Nichols, Bridget (2013), 'A Tune Beyond Us Yet Ourselves: Ordinary Worship and Ordinary Theology', in Jeff Astley and Leslie J. Francis (eds), *Exploring Ordinary Theology: Everyday Christian Believing and the Church*, Burlington, VT, 159–67.

O'Connell, J. B. (1955), *Church Building and Furnishing: The Church's Way*, London.

O'Donoghue, Neil Xavier (2017), *Liturgical Orientation: the Position of the President at the Eucharist*, Norwich [*JLS* 83].

O'Loughlin, Thomas (2014), 'Bede's View of the Place of the Eucharist in Anglo-Saxon Life: the Evidence of the *Historia ecclesiastica gentis Anglorum*', in S. Bhattacharji, R. Williams, and D. Mattos (eds) (2014), *Prayer and Thought in Monastic Tradition: Essays in Honour of Benedicta Ward S.L.G.*, London, 45–58.

– (2015), *The Eucharist: Origins and Contemporary Understandings*, London.

– (2019), *Bede and the Tabernacle: Where is the Tabernacle now? – A Problem for Bede and his Community*, Jarrow [The Jarrow Lecture 2019].

– (2020), 'Orientation in the Eucharistic Liturgy: A Note on its Sources', in *Anaphora* 14,2, 21–30.

– (2021), 'Liturgy, Inculturation and the reception of *Sacrosanctum concilium* 37–40: an on-going project for those who preside?' *NB* 102, 967-78.

– (2022), 'Time-Sensitivity as a Possible Way through Ecclesial Deadlock in Regard to the Eucharist', in *RES* 14, 30–40.

Pecklers, Keith F. (1998), *The Unread Vision: The Liturgical Movement in the United States of America, 1926–1955*, Collegeville, MN.

Peppard, Michael (2016), *The World's Oldest Church: Bible, Art, and Ritual at Dura-Europos, Syria*, New Haven, CT.

Proctor, Robert (2011), 'Modern church architect as ritual anthropologist: architecture and liturgy at Clifton Cathedral', in *ARQ* 15, 359–72.

– (2014), *Building the Modern Church: Roman Catholic Church Architecture in Britain, 1955 to 1975*, London.

Pulvenis de Séligny, Marie-Thérèse (2013), *Matisse: The Chapel at Vence*, London.

Rae, Murray A. (2017), *Architecture and Theology: the art of place*, Waco, TX.

Rahner, Hugo (1967), *Man At Play*, London.

Rahner, Karl (1992), 'Art against the Horizon of Theology and Piety' in *Theological Investigations XIII*, London, 162–8.

Ratzinger, Joseph (1986), *The Feast of Faith: Approaches to a Theology of the Liturgy*, San Francisco, CA.

– (2000), *The Spirit of the Liturgy*, San Francisco, CA.

Reid, Alcuin (ed.) (2003), *Looking Again at the Question of the Liturgy with Cardinal Ratzinger*, Farnborough.

Reinhold, H. A. (1937), 'A Revolution in Church Architecture', in *LA* 6, 122–33.

Rendall, G. H. (1931), *Menucius Felix*, London [*LCL* 250].

Rengel, Roberto J. (2007), *Shaping Interior Space*, New York, NY [second ed.].

Romero, Brenda Mae (1993), *The Matachines Music and Dance in San Juan Pueblo and Alcalde, New Mexico: Contexts and Meanings*, Los Angeles, CA.

Rooney, Marcel T. (1977), 'A Theology for Architecture. An Analysis for the Theological Principles applicable to Church Building in the Postconciliar Renewal' [thesis presented to Pontifical Liturgical Institute, Rome].

Rouet, Albert (1997), *Liturgy and the Arts*, Collegeville, MN.

Schlapbach, Karin (2022), 'Dancing With Gods Dance and Initiation in Ancient Greek Religious Practices', in Walz (ed.) (2022), 213–35.

Schloeder, Steven (1998) *Architecture in Communion: Implementing the Second Vatican Council Through Liturgy and Architecture*, San Francisco.

Schnütgen, Tatjana K. (2022), 'Dance and Gender in Churches in Germany Since the 20th Century. Insights and Conclusions for Church Dance Today', in Walz (ed.) (2022), 158–63.

Schwarz, Rudolf (1958), *The Church Incarnate: the Sacred Function of Church Architecture*, Chicago, IL [English tr. by Cynthia Harris of *Vom Bau der Kirche*, Heidelberg, 1938]. Download at: https://archive.org/details/churchincarnatet010224mbp

– *Kirchenbau: Welt vor der Schwelle*, Heidelberg.

Seasoltz, Kevin (2005), *A Sense of the Sacred: Theological Foundations of Christian Art and Architecture*, New York, NY.

Sequeira, A. Ronald. (1990), 'Gottesdienst als menschliche Ausdruckshandlung', in Han B. Meyer, Hansjörg Auf der Maur, Balthasar Fischer, Rupert Berger, Karl-Heinrich Bieritz and Johannes H. Emminghaus (eds), *Gottesdienst der Kirche: Handbuch der Liturgiewissenschaft*, Regensburg3, 7–39.

Serra, Dominic E. (2007), 'Theology of the Latin Text', in . E. Foley, J. Baldovin, M. Collins, and J. Pierce (eds), *A Commentary on the Order of Mass of the Roman Missal*, Collegeville, MN.

Sithole, Nkosinathi (2022), 'The Sacred Dance as a Miraculous Practice in Ibandla Lamanazaretha', in Walz (ed.)(2022), 175–94.

Sheldrake, Philip (1995), *Living Between Worlds: Place and Journey in Celtic Spirituality*, London.

Smith, James K. A. (2013), *Imagining the Kingdom: How Worship Works*, Grand Rap-

ids, MI.

– (2016), *You Are What You Love*, Grand Rapids, MI.

Smith, Steve (2016), *The fate of the Jerusalem Temple in Luke–Acts: An intertextual approach to Jesus' laments over Jerusalem and Stephen's speech*, London.

Spalding, Frances (2009), *John Piper Myfanwy Piper*, Oxford.

Sparrow, Anthony (1672), *A Rationale upon the Book of Common Prayer of the Church of England*, London.

Speer, Andreas (2006) 'Is there a theology of the Gothic Cathedral? A Re-reading of Abbot Suger's Writings on the Abbey Church of St. Denis', in Jeffrey F. Hamburger and Anne-Marie Bouche (eds), *The Mind's Eye: Art and Theological Argument in the Middle Ages*, Princeton, 65–83.

Spinks, Bryan D. (1991), *The Sanctus in the Eucharistic Prayer*, Cambridge.

Stevens, R. Paul (2000), *The Other Six Days: Vocation, Work, and Ministry in Biblical Perspective*, Grand Rapids, MI.

Steiner, George (1989), *Real Presences*, London.

Stevenson Kenneth W. (1991), 'Soft Points in the Eucharist', in Michael Perham ed., *Liturgy for a New Century*, London, 29–43.

Stewart-Sykes, Alistair (2009), *The Didascalia apostolorum: An English Version with Introduction and Annotation*, Turnhout [*STT* 1].

Stroik, Duncan (2012), *The Church Building as a Sacred Space: Beauty, Transcendence and the Eternal*, Chicago.

Stott, Frances (2017), *The Church of the Resurrection: a pictorial history*, Mirfield.

Susanka, Susan (2001) [with Kira Obolensky], *The Not So Big House: A Blueprint for the Way We Really Live*, Newtown [first ed. 1998].

– (2008), *The Not So Big Life: making room for what really matters*, New York, NY.

Swayne, Seán (1979), 'Jottings,' *NL* 21, 11–4.

– (1986), 'Jottings,' *NL* 50, 21.

Taylor, Margaret Fisk (2009), *A Time to Dance*, Eugene, OR.

Torgerson, Mark A. (2007), *An Architecture of Immanence: Architecture for Worship and Ministry Today*, Grand Rapids, MI.

Trapp, Waldamar (1940), *Vorgeschichte und Ursprung der liturgischen Bewegung*, Regensburg.

US Conference of Catholic Bishops (1978), *Environment and Art in Catholic Worship*, Washington, DC.

– (2000), *Built of Living Stones: Art, Architecture and Worship*, Washington, DC.

– (2018), *The Order of the Dedication of a Church and Altar*, Washington, DC.

Vad, Poul (1997) 'Vilhelm Hammershøi – An Introduction', in Anne-Birgitte Fonsmark and Mikael Wivel (eds), *Vilhelm Hammershøi 1864–1916: Danish Painter of Solitude and Light*, Copenhagen.

van Doren, D. R. (1931), 'La position du prêtre à l'autel', in *QLP* 16, 199–204.

van 't Spijker, Ineke (2022), *Homo Interior and Vita Socialis: Patristic and Twelfth-Cen-*

tury Reflections, Turnhout.

Vincie, Catherine (2007), 'The Mystagogical Implications', in E. Foley, J. Baldovin, M. Collins, and J. Pierce (eds), *A Commentary on the Order of Mass of the Roman Missal*, Collegeville, MN.

Volf, Miroslav (2010), 'Architecture, Memory and the Sacred', in Britton (2010), 60–5.

Vosko, Richard S. (2006), *God's House is Our House: Reimagining the Environment for Worship*, Collegeville, MN.

– (2019), *Art and Architecture for Congregational Worship: A Search for Common Ground*, Collegeville, MN.

Walz, Heike (ed.) (2022), *Dance as Third Space Interreligious, Intercultural, and Interdisciplinary Debates on Dance and Religion(s)*, Göttingen.

– (2022) 'Dance as Third Space. Interreligious, Intercultural and Interdisciplinary Debates on Dance and Religion(s) in the Perspective of Religious Studies and Intercultural Theology' in Walz (ed.) (2022), 27–68.

Wedig, Mark and Richard S. Vosko (2007), 'The Arrangement and Furnishings of Churches for the Celebration of the Eucharist', in E. Foley, N. Mitchell, and J. Pierce (eds), *A Commentary on the General Instruction of the Roman Missal*, Collegeville, MN.

Whyte, James A. (1962), 'The Theological Basis of Church Architecture', in Hammond (1962), 128–90.

Whyte, William (2015), 'The Ethics of the Empty Church: Anglicanism's Need for a Theology of Architecture', in *JAS* 13/2, 172–88.

– (2017), *Unlocking the Church: the lost secrets of Victorian sacred space*, Oxford.

Williams, Peter (2004), 'The First Australian Cathedral of the New Century' in *LN*, 34/1, 5.

Woolfenden, Gregory W. (2004), *Daily Liturgical Prayer: Origins and Theology*, Aldershot.

Yates, Nigel (2008), *Liturgical Space: Christian Worship and Church Buildings in Western Europe 1500–2000*, Aldershot.

Yingling, Erik (2013), 'Singing With the Savior: Reconstructing the Ritual Ring-Dance in the Gospel of the Savior', in *Apocrypha* 24, 255–79.

Zumthor, Peter (2006), *Atmospheres: Architectural Environments, Surrounding Objects*, Basel.

John F. Baldovin SJ is professor of historical and liturgical theology at the Boston College School of Theology and Ministry. He writes in the fields of liturgical history and sacramental/liturgical theology.

Paul F. Bradshaw is emeritus professor of liturgical studies at the University of Notre Dame, Indiana, USA. He is the author or editor of more than 40 books and 150 articles.

Eleanor Campion OCSO is a member of the Cistercian community, St Mary's Abbey, Glencairn, Co. Waterford. She currently serves at the Generalate of the Order in Rome.

Judith Courtney is a mother, grandmother, long-time leader of Church choirs, participant on parish liturgy committees and immediate past co-ordinator of the Auckland Diocesan Liturgy Centre.

Margaret Daly-Denton has taught and published in the fields of liturgy, church music and biblical studies. She has recently retired from teaching New Testament at Trinity College Dublin.

Anne Dixon is a founding partner of Green Tea Architects – a practice with a preferential option for sustainable architecture. She has an MA in pastoral theology from Heythrop College,University of London and seeks to combine these two disciplines in her work.

Tom Elich studied in Paris, taught liturgy at Brisbane College of Theology and the Australian Catholic University, and was national secretary for liturgy for the Australian Catholic Bishops Conference during the 1990s. He was parish priest at Bulimba, Brisbane, for fourteen years, and has been director of Liturgy Brisbane since 1989.

Richard Giles was formerly dean of Philadelphia Episcopal Cathedral and has written on transformative worship and the design of liturgical space.

Joseph P. Grayland is a parish priest in New Zealand. He has written on liturgical theology and culture.

George Guiver CR is a member of the Community of the Resurrection, Mirfield, and has written on liturgy and on monastic life.

Laura Hellsten is a post-doctoral researcher at the Polin Institute of Theological research at Åbo Akademi University, Finland. She is currently co-leading the research project Praxis of Social Imaginaries: Cosmologies, Othering and Liminality which studies both transdisciplinary research and the relationship between descriptions of dance and racialisation in medieval travelling accounts.

Richard Hurley (1932-2011) was an Irish architect who continued the tradition of those twentieth-century pioneers who combined their architectural work with theological reflection. He was associated in one capacity or another with over 120 church design projects in Ireland, Britain, Kenya and Australia.

Christopher Irvine is an honorary teaching fellow of St Augustine's College of Theology, and teaches for the Mirfield Liturgical Institute, College of the Resurrection (UK). He has written on the interface of art and liturgical theology, and is currently engaged in questions regarding creation and liturgy.

Peter Murphy is a diocesan priest of Auckland, New Zealand. He was parish priest of Papakura, South Auckland for eleven years and more recently spiritual formator at the national seminary. He is now retired.

Bridget Nichols lectures in Anglicanism and liturgy at the Church of Ireland Theological Institute. She has particular interests in Anglican liturgical books and in the language of worship.

Thomas O'Loughlin is professor emeritus of historical theology in the University of Nottingham. He has written on the history and theology of worship and currently teaches for the Mirfield Liturgical Institute.

James G. Sabak OFM is the director of worship for the Catholic Diocese of Raleigh, North Carolina, USA. He has written on the history and theological significance of keeping vigil in the liturgical life of the Church.

Richard S. Vosko is an internationally known liturgical designer and consultant for places of worship and has received many prestigious awards for his work. A Catholic priest, he is a frequent author on religion, art and architecture.

Thomas R. Whelan, Spiritan Missionary has taught liturgical and sacramental theology for over 30 years in West Africa and Ireland, and has guest lectured throughout Europe and in the USA. Over the last few decades, he has been involved in many design projects, small and large.